Feminism and Youth Culture

From 'Jackie' to 'Just Seventeen'

Angela McRobbie

MACMILLAN

© Angela McRobbie 1991

All rights reserved. No reproduction, copy or transmission of
this publication may be made without written permission.

No paragraph of this publication may be reproduced, copied or
transmitted save with written permission or in accordance with
the provisions of the Copyright, Designs and Patents Act 1988,
or under the terms of any licence permitting limited copying
issued by the Copyright Licensing Agency, 90 Tottenham Court
Road, London W1P 9HE.

Any person who does any unauthorised act in relation to this
publication may be liable to criminal prosecution and civil
claims for damages.

First published 1991 by
MACMILLAN EDUCATION LTD
Houndmills, Basingstoke, Hampshire RG21 2XS
and London
Companies and representatives
throughout the world

ISBN 0–333–45263–1 (hardcover)
ISBN 0–333–45264–X (paperback)

A catalogue record for this book is available
from the British Library

Printed in Hong Kong

Reprinted 1992

£9.99

CN 301.4315
AN 52241

YOUTH QUESTIONS

... question ... traditionally
been defined by social scientists and policy-makers, by the caring pro-
fessions and the mass media, as well as in 'common-sense' ideology. It
explores some of the new directions in research and practice which are
beginning to challenge existing patterns of knowledge and provision.
Each book examines a particular aspect of the youth question in depth.
All of them seek to connect their concerns to the major political and
intellectual debates that are now taking place about the present crisis
and future shape of our society. The series will be of interest to those
who deal professionally with young people, especially those concerned
with the development of socialist, feminist and anti-racist perspectives.
But it is also aimed at students and general readers who want a lively
and accessible introduction to some of the most awkward but important
issues of our time.

Published

Inge Bates, John Clarke, Philip Cohen, Dan Finn, Robert Moore and
Paul Willis
SCHOOLING FOR THE DOLE?
The New Vocationalism

Desmond Bell
ACTS OF UNION
Youth Culture and Sectarianism in Northern Ireland

Cynthia Cockburn
TWO-TRACK TRAINING
Sex Inequalities and the YTS

Philip Cohen and Harwant S. Bains (eds)
MULTI-RACIST BRITAIN

Andrew Dewdney and Martin Lister
YOUTH, CULTURE AND PHOTOGRAPHY

Dan Finn
TRAINING WITHOUT JOBS: NEW DEALS AND BROKEN PROMISES
From Raising the School-Leaving Age to the Youth Training Scheme

Robert G. Hollands
THE LONG TRANSITION
Class, Culture and Youth Training

Northern College
Library

NC04502

CANCELLED

Angela McRobbie
FEMINISM AND YOUTH CULTURE
From *Jackie* to *Just Seventeen*

Angela McRobbie (ed.)
ZOOT SUITS AND SECOND-HAND DRESSES
An Anthology of Fashion and Music

Angela McRobbie and Mica Nava (eds)
GENDER AND GENERATION

Forthcoming

Philip Cohen and Graham Murdock (eds)
THE MAKING OF THE YOUTH QUESTION

Series Standing Order
If you would like to receive future titles in this series as they are published, you can make use of our standing order facility. To place a standing order please contact your bookseller or, in case of difficulty, write to us at the address below with your name and address and the name of the series. Please state with which title you wish to begin your standing order. (If you live outside the United Kingdom we may not have the rights for your area, in which case we will forward your order to the publisher concerned.)

Customer Services Department, Macmillan Distribution Ltd, Houndmills, Basingstoke, Hampshire RG21 2XS, England.

For Hanna

Contents

Acknowledgements

The author and publishers would like to thank *Feminist Review* and *Screen Education* for permission to reprint two of the chapters in this collection. Thanks also to Lucy Bland, Charlotte Brunsdon, Erica Carter, Martin Chalmers, Simon Frith and Mica Nava.

Introduction

The essays in this collection have been written over a period of almost thirteen years. The first five pieces were all written during my time at the Centre for Contemporary Cultural Studies (CCCS) in Birmingham and have appeared in a number of forms in some of the books and journals which were associated with the Birmingham Centre in the late 1970s. However many of these are now out of print and it seemed to me a useful project to make this work available in one volume. The concluding three essays mark a shift in my own personal geography from Birmingham to London, though they too bear the marks of that time and those intellectual influences which have come to be linked with the emergent field of cultural studies.

Three themes appear repeatedly in this context. The first of these refers to the terrain of *lived experience*, the second is concerned with *popular culture* and the third with *subcultures*. When I first became interested in the sociology of youth in the mid–1970s there was an impressive body of work emerging in that field which was influenced by radical deviancy theory and by that brand of Marxism which looked to culture and everyday life for signs of class conflict and resistance. Much of this work – by Taylor, Walton and Young, by Paul Willis, Simon Frith, and Paul Corrigan – converged on the question of how young people, including delinquents, football hooligans, drug-takers, music fans, or simply young stylists, 'made sense' of the situation within which they found themselves.[1] There was also that developing body of work which emphasised the structural constraints on the lives of young people, and there were the structuralist readings of the meanings created by working-class youth as they interacted with a number of goods and consumer items transforming them into symbolic statements about themselves.[2] Part of

my early project was to shift this interest back to the living subjects themselves, to shift the emphasis away from an almost exclusive interest in boys, and to see how teenage girls interpreted some of the structural determinations of age, class, and gender in the context of their own lived experience.

Because the existing work spanned such a wide area and such a diverse set of interests, and because there was no equivalent work at that time which looked at young women or which highlighted gender, I was immediately faced with the difficult question of which aspect of female experience to concentrate on. A broad-based study of girls' culture in the context of the school, the home and leisure would run the risk of being so general as to tell us little more than what we already knew from common sense. The alternative was to set up a small-scale study of a self-defined set of young girls who came together through some shared interest in music, in drugs, or in a particular style or subculture.

As it transpired I opted for a more general study which would act as a kind of response or reply to Paul Willis's influential *Learning to Labour* but which was less ambitious in scale.[3] This allowed me to concentrate on the dynamics of class and gender and on the way these two factors came together in the day-to-day lives of a small group of girls living in the same estate in south Birmingham. It may well be that the merit of this small scale and perhaps clumsily ethnographic study was that it had not been done before. In the past, where groups of teenage girls had for some reason come under the scrutiny of social researchers, it had been under the guise of some specific 'concern' often articulated by a number of self-appointed moral guardians who then went on to problematise these girls for failing to adhere to a narrowly middle-class notion of 'ladylike behaviour'. (Pearl Jephcott was a notable exception to this tradition. A full critical assessment of her work – which was carried out in some isolation from the late 1940s to the early 1960s – has yet to be done. However Jephcott was neither an anthropologist nor a sociologist and her work, strongly influenced by the tradition of social observation veers towards being over-descriptive, with her own presence, her values and her methodological procedures unexamined.[4])

My own work in this field steered clear of moral judgement

and instead listened to the girls' own accounts of their perception of the world of school, the home and the family and the pressures these institutions put on them to adhere to normative gender and class expectations. This work had the positive effect of prompting a series of further investigations by other women sociologists and social psychologists. Suddenly the complete absence of interest in girls in a vast range of academic studies could no longer be ignored. Anne Campbell had already embarked on her pioneering work on female delinquency and Carol Smart had just published a more wide-ranging study of women and crime.[5] In Sue Lees, *Losing Out: Sexuality and Adolescent Girls*, the way in which the sexual double standard effects the outlooks and the experience of a group of North London schoolgirls is explored in depth, in such a way as both to refute and refine some of my own ideas and in Chris Griffin's, *Invisible Girls*, there is a carefully constructed and methodologically precise attempt to track a group of Birmingham school-leavers through from school to work.[6]

The problem which remains in this field and one which I experienced but failed to come to grips with was the choice between aspiring towards an interactive mode of research where a great deal depends on the quality of the relationship between the subjects and the researcher, or opting instead for a more investigative approach where the mode of research is more impersonal, where the subjects remain more or less anonymous respondents, where the procedure involves structured interviews supplemented with often short periods of observation and the whole process takes on a more documentary character. In practice it is the former which has produced the most 'classic' and most widely consulted and quoted works of sociology and the latter which has fed into what has come to be known as 'social research'. Constrained by my inexperience (as an MA student on a small budget with limited research time) I vacillated uneasily between the two.

In the second part of this volume my interest in lived experience is sustained and incorporated into a chapter on teenage mothers. Set once again in Birmingham this short study concluded my work carried out in the West Midlands. I have presented this work with less emphasis on the interactive mode. I wanted to concentrate instead on the way in which the material

conditions in which these girls were living deeply determined the range of choices open to them and in effect presented early motherhood as the only real choice which coincided with the dominant expectations of gender in the context in which they had grown up. I attempt to show how for a group of twelve young women, early motherhood in a small and overlooked pocket of poverty in south Birmingham which was still, in the early 1980s, suffering the direct effects of the recession of the 1970s, was the first step in a process leading directly to the 'feminisation of poverty'. To these girls I was a neighbour and a young mother myself. However the class divide between us was too great to lead to anything more than an occasional and friendly relationship. As a result the work described in that chapter was by necessity not so much drawn on interviews, and prolonged social interaction as on 'chats' (they knew I was a researcher) and on observation. For these reasons I have omitted both my own voice and that of the girls themselves from this chapter.

It is a great pity that both ethnographic work and 'social research' have been the casualties of cut-backs in funding for social science research. The few graduate students there now are in sociology are being channelled towards policy-oriented research. This means that the whole tradition here and in the USA, which is an established part of the sociology undergraduate curriculum is not being renewed, updated or revised. Open-ended experiential research in the *Learning to Labour* tradition, and even community studies in the early tradition of John Rex or Wilmott and Young are in deep danger of dying out altogether.[7]

There are many subjects close to my own concerns which I would like to see studied in more depth. I would like to see a qualitative study of female drug-users; a comparative study of girls in single-sex schools with those in mixed-sex schools; an interactive study of girls as TV-viewers in relation to family life, and more research of this type which concentrated on race and ethnicity (an element which is unfortunately missing in my own work).

Without studies of this sort sociology remains a dry and unexciting subject given over either to empiricism and the presentation of social facts and statistics in the style of journals and publications like *Social Trends*, or to the development of broad structuralist accounts of the objective conditions of existence in

the UK today, or else to the long march of 'social theory'. In contrast, 'lived experience' studies in the late 1960s through to the mid-1970s made sociology an exciting and engaged discipline. These studies also created their own theoretical insights and produced their own theoretical paradigms. They represent an important and too easily neglected tradition.

The second key interest which emerges from the body of work presented in this collection focuses on popular culture. The intellectual legacy of this concept lies firmly within the cultural studies tradition marked out by Raymond Williams and Richard Hoggart. With the massive growth of media studies in the past fifteen years, it is now extremely difficult to mark out where the concern of media studies stops and where popular culture begins. As is often the case with such closely linked concepts, institutions define their area of interest against other competing institutions. Thus in the 1980s popular culture spanned the CCCS in Birmingham and the Open University's popular culture U203 course. Media studies, including the analysis of the texts and institutions of film and television, has been connected with *Screen* magazine and the British Film Institute's Education Department and following that, with a number of polytechnic courses up and down the country. Popular culture is by now difficult to define with any precision. It points to a set of practices or texts or activities frequently associated with the field of leisure and 'enjoyed' by large numbers of people. As a result the study of popular culture has been less exclusively concerned with texts and readings than has the study of film and television. It has had a more historical and a more interactive dimension than media studies and has been less influenced by structuralism and semiology.

In this sense the study of popular culture retains closer connections with sociology than might be imagined. Simon Frith's work on popular music is important in this context. It should also be remembered that much of Raymond William's work can also be seen as a sociology of culture.[8] My earliest interest in this field developed out of a sociology of art and literature course which I followed as an undergraduate in the early 1970s at Glasgow University. The track we took moved through from the theoretical writings of Lukacs and Goldman to Brecht and Walter Benjamin, and to Hans Magnus Ensenzberger's important 'Constituents Towards a Theory of the Media'.[9] From this exposition of

the new possibilities opened up by the technology of the mass media, and from the idea of attempting to introduce radical ideas to a mass audience, it was possible to move towards more detailed studies of the mechanisms and attractions of popular culture.

At Birmingham this interest was developed further through Richard Hoggart's immensely influential *Uses of Literacy* which considered mass culture in all its complex relations to and with working-class culture.[10] In the late 1980s the very term 'working-class culture' has an anachronistic ring about it, but in the mid–1970s when I first set about the task of analysing the girls' magazine, *Jackie*, it was this term which was uppermost in my own 'framing' vocabulary. In fact *Jackie*'s readership in those days went well beyond those girls who could be described as working class. Class entered into my argument through the back door as it were. For working-class girls who did not receive the kind of encouragement which their middle-class counterparts (also *Jackie* readers) received in terms of academic achievement, jobs and economic independence, *Jackie*'s message was doubly pernicious. It bound them to a future which evolved round finding, as soon as possible, and holding onto, 'a fella', since life without such a person was synonymous with failure.

As *Jackie* has moved down-market in the 1980s and *Just Seventeen* has taken its place as the most popular weekly magazine, important changes can be seen on the pages of the new girls' magazines. *Just Seventeen* has, as I argue at length in Chapter 6, almost completely abandoned the old commitment to romance and has replaced this with fashion, pop, problems and personal self-realisation. The self is at the heart of *Just Seventeen* and this self is more self-confident, more independent, more fun than her old *Jackie* equivalent. Boys and sex still play a major role in the landscape of teenage femininity but there is less sentiment, less romance and a greater degree of frankness and realism. *Just Seventeen* emphasises fun and excitement and remains as a result, firmly within the field of 'entertainment'. However, without compromising its commitment to femininity (and feminine consumerism) it also addresses a new kind of girl who is less obsessed by the presence or absence of a 'steady' and whose future is defined by a different tempo and a different set of interests from those found in *Jackie*.

The third and final concept which finds continual expression in this book is subculture. Aspects of subcultural experience, particularly music, have entered deeply into the texture of my own everyday life, and it may be apposite here to mention some of these.

There are two reasons why I have been so interested in subcultures: first, because they have always appeared to me (against the grain of cultural studies analysis) as popular aesthetic movements, or 'constellations' (to borrow the term from Raulet)[11] and second, because in a small way they have seemed to possess the capacity to change the direction of young people's lives, or at least to sharpen their focus by confirming some felt, but as yet unexpressed intent or desire. Subcultures are aesthetic movements whose raw materials are, by definition, 'popular', in that they are drawn from the world of the popular mass media. It is not necessary to have an education in the *avant garde* or to know the history of surrealism to enjoy the Sex Pistols or to recognise the influence of Vivienne Westwood's fashion. This kind of knowledge (of pop music or fashion images) is relatively easy to come by and very different from the knowledge of the high arts or the literary canon found in the academy. At school and then later at university I was introduced to these 'high culture' forms and I remember being overwhelmed by French new wave cinema, by writers as diverse as Faulkner and Camus, Samuel Richardson and Nathaniel Hawthorne, by Brecht and by James Joyce. Reading these kinds of novels and becoming familiar with European art cinema was far removed from the culture in which I had grown up. To embrace one I had to battle against the other. In contrast, however, fashion, style and music of the type associated with youth subcultures and with the world of pop consumerism, were quite permissible. These were in one sense in conflict with the kind of values represented by my family and the lower middle-class Catholic culture in which I lived. (Some pop or rock music was rebellious and overtly sexual, some fashion images were too extreme.) Yet, because they were popular, because these images and sounds were products of the mass media they also possessed a legitimacy. Listening to pop or to r 'n' b late at night on the radio was a much less 'foreign' experience than tuning into Radio Three and listening to Debussy, just

as flicking through *Vogue* was more 'normal' than going to the Glasgow Art galleries to whizz past the Whistlers.

The kind of pop, fashion and style which emerged from the subcultures of the 1960s, from Mod to hippy, therefore, played a kind of intermediary and directive role. They brought together widely available and – in lower middle-class terms – culturally acceptable items such as mini-skirts and make-up and certain kinds of hair-style, with a set of creative self-expressive forms, particularly music and dance. They celebrated the popular while simultaneously looking 'up' towards the arts. Mod culture (in relation to which I could only claim to be a bystander) made black soul music available in the context of 'teenage nightlife', celebrating it as the sound of the city. A few years later, when the hippie underground emerged, its overlap with the cultural *avante garde* was self-evident. This subculture meant poetry readings, arts labs, literature and drama as well as hair-styles (again), drugs and long flowing cheesecloth skirts.

By the time punk emerged I was living in Birmingham and six months pregnant. In fashion terms it was not the best time to be expecting a baby. But soon I was able to return to my favourite pastime of gigs and live concerts. From then on my academic interests merged completely with my night-time leisure. The Birmingham Centre faded into the background as a new set of interactions between left and feminist students, punk musicians, film makers, photographers and others emerged. Rock Against Racism brought visiting bands to the weekly gigs which grew up around the Au Pairs, UB 40, Rankin' Roger, and the various Birmingham reggae outfits. Dick Hebdige was an occasional doorman at the wonderful Shoop disco; Paul Gilroy dj-ed at Digbeth City Hall; Talking Heads played at Barbarellas, The Gang of Four played the Odeon and Ian Curtis with Joy Division appeared at the Rum Runner on the Hagley Road.

All this took place within the embrace of punk. Long after the moment of punk style had passed, a wider subcultural field had installed itself in the dreary blighted heartland of the West Midlands producing a sense of a 'continuous present'. This was so forceful and so captivating that it gathered people up in an endless whirl of events, which blocked out the depressed economic present by creating a local utopia, a Birmingham bohemia.

Some of the contents of this volume I have already mentioned.

The others need only a few brief words of introduction. The first essay, *Girls and Subcultures* was co-written with Jenny Garber within months of our arrival as graduate students in Birmingham. Being plunged in at the deep end was both daunting and exciting. The piece was intended as a kind of running commentary on the absence of girls in the work on subcultures which was being published in the Centre and elsewhere at that time. In a sense it tried to do too much in one go. The aim was both to comp-lement and extend, and at the same time to be a critique of what later came to be known as subcultural theory, which was best summarised in the long introduction to *Resistance Through Rituals*.[12] Alongside this critical aim there was also an attempt to put things right by writing in that history 'Where were/are the girls?', but all that was possible at that moment, under con-straints of time, was a brief, speculative sketch. Perhaps the important thing about *Girls and Subcultures* (first published in 1977) was that it turned away from subcultures to the terrain of domestic life, arguing that if we wanted to know about teenage femininity or about female youth culture, this was where we might begin.

This chapter is followed by an account of the ethnographic work which I then went on to do in order to pursue this aim of knowing something more about the ordinary everyday lives of working-class teenage girls. '*Working-Class Girls*' (first published in 1979) argues that the culture of femininity which is made available to girls through the intimate world of magazines can be used by girls as a means of creating their own space in the school, the youth club or even in the home. At the same time, despite this small capacity for signalling discontent or dissatis-faction with those institutions and their expectations of what teenage working-class girls should be like, they none the less serve to secure girls even tighter to an unchanging message. This is one which stresses the importance of finding a steady boyfriend and potential husband at all cost and preferably as soon as possible. The future and the entire economic well-being of the girl depends on this. While the girls in this small study do indeed draw on these items and cultural commodities (make-up, maga-zines, fashion) to distance themselves from the regime of the school or from the organised activities of the youth club – or even to oppose them – none of the girls envisage a life for

themselves which in any way departs from the prescribed expectations of becoming a wife and mother who is financially dependent on her husband. A good job for these girls was one which would help them to pave the way to setting up home.

This chapter is followed by a piece (*The Politics of Feminist Research*) which emerged from a series of debates in feminism on the way that feminist research is or should be conducted when it involves using human subjects (in this case teenage girls) as the source for data. It was written (and published in 1982) partly in defence of the kind of work I had been doing, partly in defence of the sociological procedures of participant observation, and partly as an attempt to justify the role of the researcher as someone who can represent groups of often powerless people by describing and offering an explanation of the material conditions and constraints within which they are forced to live. The argument which gained ground in feminist circles at that time was that research of this sort should be directed back towards the subjects so that they might gain something concrete from it. While admirable in intent, I argue that this is often neither practical nor possible. The results, for example, of my study of teenage mothers (Chapter 8) could hardly have been of direct use to those girls who were suffering from so many deprivations and disadvantages as to be barely able to cope from one day to the next, never mind take part in academic exchanges. This fact should not, however, invalidate such research projects. The aim of this kind of research is precisely to feed into wider discussions which can lead to changes in public policy. Research can help to make a kind of 'clamour' which in turn can be used to challenge widespread misconceptions (e.g. 'welfare mothers are scroungers').

'Settling the Accounts with Subcultures' was published in 1982 in *Screen Education* and it represented a continuation of the debate which emerged from my earlier critique of subcultural writing (found here in Chapter 1). The focus in this instance was on the two most influential books which had recently appeared in the field – Willis's *Learning to Labour* and Hebdige's *Subculture: The Meaning of Style*.[13] In retrospect it seems to me that in my eagerness to argue the feminist case I failed perhaps to remind the reader of the great importance of these volumes and the extent to which they had both thoroughly influenced and

helped to form my own outlook and views. If I did not say it then, I can now. These books have rightly held their place on the reading lists of numerous degree and other courses up and down the country. They are also as readable outside the academy as they are within.

Most of '*Jackie*: Romantic Individualism and the Teenage Girl' appeared as a stencilled paper published by the CCCS University of Birmingham in 1980. However I have also gone back to the original work from which it was drawn and have re-edited the original for publication including some material which has not as yet appeared in print.

This chapter is followed in the second part of the book by three essays which have all been written much more recently. I began to work on '*Jackie* and *Just Seventeen*' in 1987, along with '*Fame, Flashdance* and Narratives of Achievement' (a re-written extension of a piece which appeared in *Gender and Generation*),[14] and 'Teenage Mothers: A New Social State?' It has taken me two full years to complete the writing of these chapters. There were several other essays I had planned to include here. The omission of an article which proclaimed *Desperately Seeking Susan* as the best and most powerful recent narrative of pre-teenage femininity, is a sad one. I can only urge the reader to watch the film again. I would also like to have completed a chapter on the social context of fashion photography and on why fashion photographs exert such an influence on girls and young women. Unfortunately these will have to wait for another time.

Angela McRobbie

Notes and references

1. I. Taylor, P. Walton and J. Young, *The New Criminology*, London, Routledge & Kegan Paul, 1973; P. Willis, *Learning to Labour*, Aldershot, Saxon House, 1977; S. Frith, *Sound Effects*, London, Constable, 1981; P. Corrigan, *Schooling the Smash Street Kids*, London, Macmillan, 1979.
2. D. Hebdige, *Subculture: The Meaning of Style*, London, Methuen, 1979.
3. Willis, *Learning to Labour*.
4. P. Jephcott, *Girls Growing Up*, London, Faber, 1942, and *Rising Twenty*; Faber, 1946.

5. A. Campbell, *Girl Delinquents*, Oxford, Basil Blackwell; 1981; C. Smart, *Women, Crime and Criminology*, London, Routledge & Kegan Paul, 1979.
6. S. Lees, *Losing Out: Sexuality and Adolescent Girls*, London, Hutchinson, 1986; C. Griffin, *Invisible Girls*, London, Routledge & Kegan Paul, 1980.
7. J. Rex and J. Moore, *Race, Community, Conflict*, Oxford, Oxford University Press, 1964; P. Willmott and M. Young, *Family and Kinship in Bethnal Green*, Harmondsworth, Penguin, 1966.
8. Frith, *Sound Effects*.
9. H. M. Ensenzberger, 'Constituents towards a Theory of the Media', *New Left Review*, 1964.
10. R. Hoggart, *Uses of Literacy*, Harmondsworth, Penguin, 1957 and 1984.
11. G. Raulet, *Gehennte Zukunft*, Luchterhand, 1986.
12. S. Hall (ed.) *Resistance through Rituals*, London, Hutchinson, 1978.
13. Willis, *Learning to Labour*; Hebdige, *Subculture*.
14. A. McRobbie, 'Dance and Social Fantasy' in A. McRobbie and M. Nava (eds) *Gender and Generation*, London, Macmillan, 1984.

1

Girls and Subcultures*
(co-written with Jenny Garber)

Very little seems to have been written about the role of girls in youth cultural groupings. They are absent from the classic subcultural ethnographic studies, the pop histories, the personal accounts and the journalistic surveys of the field. When girls do appear, it is either in ways which uncritically reinforce the stereotypical image of women with which we are now so familiar . . . for example, Fyvel's reference, in his study of teddy boys,[1] to 'dumb, passive teenage girls, crudely painted' . . . or else they are fleetingly and marginally presented:

> It is as if everything that relates only to us comes out in footnotes to the main text, as worthy of the odd reference. We come on the agenda somewhere between 'Youth' and 'Any Other Business'. We encounter ourselves in men's cultures as 'by the way' and peripheral. According to all the reflections we are not really there.[2]

How do we make sense of this invisibility? Are girls really not present in youth subcultures? Or is it something in the way this kind of research is carried out that renders them invisible? When girls are acknowledged in the literature, it tends to be in terms of their sexual attractiveness. But this, too, is difficult to interpret. For example, Paul Willis comments on the unattached girls who hung around with the motor-bike boys he was studying, as follows: 'What seemed to unite them was a common desire for an attachment to a male and a common inability to attract a

*This article originally appeared in *Resistance through Rituals*, ed. Stuart Hall, London, Hutchinson, 1978.

man to a long-term relationship. They tended to be scruffier and less attractive than the attached girls.'[3]

Is this simply a typically dismissive treatment of girls reflecting the natural rapport between a masculine researcher and his male respondents? Or is it that the researcher who is, after all, studying the motor-bike boys, finds it difficult not to take the boys' attitudes to and evaluation of the girls, seriously? He therefore reflects this in his descriptive language and he unconsciously adopts it in the context of the research situation. Willis later comments on the girls' responses to his questions. They are unforthcoming, unwilling to talk and they retreat, in giggles, into the background . . . Are these responses to the man as a researcher or are they the result of the girls' recognition that 'he' identifies primarily with 'them'? Is this characteristic of the way in which girls customarily negotiate the spaces provided for them in a male-dominated and male-defined culture? And does this predispose them to retreat, especially when it is also a situation in which they are being assessed and labelled according to their sexual attributes?

It is certainly the case that girls do not behave in this way in all mixed-sex situations. In the classroom, for example, girls will often display a great show of feminine strength from which men and boys will retreat. It may well be that in Willis's case the girls simply felt awkward and self-conscious about being asked questions in a situation where they did not feel particularly powerful or important, especially if they were not the steady girlfriends of the boys in question.

What follows is a tentative attempt to sketch some of the ways we might think about and research the relationship between girls and subcultures. Many of the concepts utilised in the study of male subcultures are retained: for example, the centrality of class, the importance of school, work, leisure and the family: the general social context within which the subcultures have emerged, and the structural changes in post-war British society which partially define the different subcultures. Added to these issues are the important questions of sex and gender. The crucial question is: How does this dimension reshape the field of youth cultural studies as it has come to be defined?

It has been argued recently for example that class is a critical variable in defining the different subcultural options available to

middle-class and working-class boys. Middle-class subcultures offer more full-time careers, whereas working-class subcultures tend to be restricted to the leisure sphere. This structuring of needs and options must also work at some level for girls. It might be easier for middle-class hippie girls, for example, to find an 'alternative' career in the counter-culture than it would be for working-class skinhead girls to find a job in that culture. Some subcultural patterns are therefore true for both boys and girls, while others are much more gender-divergent.

It might even be the case that girls are not just marginal to the post-war youth cultures but located structurally in an altogether different position. If women are marginal to the male cultures of work, it is because they are central and pivotal to a subordinate sphere. They are marginal to work because they are central to the family. The marginality of girls in these 'spectacular' male-focused subcultures might redirect our attention away from this arena towards more immediately recognisable teenage and pre-teenage female spheres like those forming around teenybop stars and the pop-music industry.

Bearing this in mind it is possible to identify a number of key questions to which subsequent work can be addressed:

- Are they present but invisible?
- Where present and visible, are their roles the same, but more marginal than boys, or are they quite different?
- Is the position of girls specific to the subcultural option, or do their roles reflect the more general social subordination of women in mainstream culture?
- If subcultural options are not readily available to girls, what are the different but complementary ways in which girls organise their cultural life?
- Are these, in their own terms, subcultural?

Girls' subcultures may have become invisible because the very term 'subculture' has acquired such strong masculine overtones.

Are girls really absent from subcultures?

The most obvious factor which makes this question difficult to answer is the domination of sociological work (as is true of most areas of scholarship) by men. Paradoxically, the exclusion of women was as characteristic of the new radical theories of deviance and delinquency as it had been of traditional criminology. The editors of *Critical Criminology* argue that the new deviancy theory often amounted to a 'celebration rather than an analysis of the deviant form with which the deviant theorist could vicariously identify – an identification by powerless intellectuals with deviants who appeared more successful in controlling events.'[4] With the possible exception of sexual deviance, women constituted an uncelebrated social category, for radical and critical theorists. This general invisibility was of course cemented by the social reaction to the more extreme manifestations of youth subcultures. The popular press and media concentrated on the sensational incidents associated with each subculture (for example, the teddy-boy killings, the Margate clashes between mods and rockers). One direct consequence of the fact that it is always the violent aspects of a phenomenon which qualify as newsworthy is that these are precisely the areas of subcultural activity from which women have tended to be excluded. The objective and popular image of a subculture is likely to be one which emphasises male membership, male focal concerns and masculine values. When women appear within the broad framework of a moral panic it is usually in more innocuous roles. The fears of rampant promiscuity which emerged with the hippy culture brought to the fore the involvement of girls and women in the 'love-ins' and 'orgies'. While this was roundly condemned and taken as a sign of declining moral values as well as of personal degradation and irresponsibility, the 'entertainment value', taken together with the lingering resonances of 1960s' sexual liberalism, balanced out and even blunted the hard edge of the cries of horror of the moral guardians.

Are girls present but invisible?

For all these reasons, female invisibility or partial visibility in youth subcultures takes on the qualities of the self-fulfilling

prophecy. Perhaps women and girls have played only a minor role in these groupings. The exclusive attention paid to male expressions and male styles none the less reinforces and amplifies this image of the subculture as a male formation. Texts and images suggest, for example, that girls were involved with and considered themselves as part of the teddy-boy subculture. Girls can be seen in footage from the 1950s dancing with teddy-boys at the Elephant and Castle; they can also be seen in the background in the news pictures taken during the Notting Hill race riots of 1958. There are however many reasons why, to working-class girls in the late 1950s, this was not a particularly attractive option.

Though girls participated in the general rise in the disposable income available to youth in the 1950s, girls' wages were not as high as those of boys.[5] Patterns of spending were also structured in a different direction. Girls' magazines emphasised a particularly feminine mode of consumption and the working-class girl, though actively participating in the world of work, remained more focused on home and marriage than her male counterpart. Teddy-boy culture was an escape from the claustrophobia of the family, into the street and 'caff'. While many girls might adopt an appropriate way of dressing, complementary to the teds, they would be much less likely to spend the same amount of time hanging about on the streets. Girls had to be careful not to 'get into trouble' and excessive loitering on street corners might be taken as a sexual invitation to the boys. The double standard was probably more rigidly maintained in the 1950s than in any other time since then. The difficulty in obtaining effective contraception, the few opportunities to spend time unsupervised with members of the opposite sex, the financial dependency of the working-class woman on her husband, meant that a good reputation mattered above everything else. As countless novels of the moment record, neighbourhoods flourished on rumours and gossip and girls who spent too much time on the street were assumed to be promiscuous.[6]

At the same time the expanding leisure industries were directing their attention to *both* boys and girls. Girls were as much the subject of attention as their male peers when it came to pin-up pictures, records, and magazines. Girls could use these items and activities in a different context from those in which boys

used them. Cosmetics of course were to be worn outside the home, at work and on the street, as well as in the dance-hall. But the rituals of trying on clothes, and experimenting with hair-styles and make-up were home-based activities. It might be suggested that girls' culture of the time operated within the vicinity of the home, or the friends' home. There was room for a great deal of the new teenage consumer culture within the confines of the girls' bedrooms. Teenage girls did participate in the new public sphere afforded by the growth of the leisure industries, but they could also consume at home, upstairs in their bedrooms.

The involvement of girls in the teddy-boy subculture was sustained therefore by a complementary but different pattern. What girls who considered themselves 'teddy-girls', did, and how they acted, was possibly exactly the same as their more conventional non-subcultural friends. It is gender therefore which structures differences rather than subcultural attachment. The same process can be seen at work in the emergence of rock and pop music. Girls and boys, in or out of subcultures, responded differently to this phenomenon. Boys tended to have a more participative and a more technically-informed relationship with pop, where girls in contrast became fans and readers of pop-influenced love comics.

This pattern accelerates within the subcultures. If we look at a hard, male-oriented working-class subculture like the skinheads of the 1970s, we can see small groups of girls on the sidelines, as girlfriends or hangers-on. There is no evidence to suggest that these girls are as involved in 'aggro' as their male peers, even though their feminine image is a great deal more aggressive and less feminine than that of the teddy-girls was, some fifteen years earlier. If we follow the skinheads through their various evolutions, revivals and attachments up and down the country, the picture that emerges is one of an overwhelmingly male grouping. The recognition in the popular press that girls were present in some of the skinhead skirmishes tells us more about the increasing visibility of women in general in society, than it does about an upsurge in female violence.

What broad factors might have created a situation where girls could find subcultural involvement an attractive possibility? The emergence of a softer more feminised subculture in the 1960s,

might well have opened the doors to female participation. There were certainly thousands of 'mod' girls who made their appearance in the nightclubs, on the streets, at work and even on the fringes of the clashes between the mods and rockers during the various Bank-holiday weekends throughout the mid–1960s (and remembered in the film, *Quadrophenia*). It may well be that the mod preoccupation with style and the emergence of the unisex look and the 'effeminate' mod man, gave girls a more legitimate place in the subculture than had previously been the case.

This trend was confirmed and extended as mod moved towards the consumerist mainstream, and as it began to give way simultaneously to the hippy underground and psychedelia. In this space, inhabited largely though not exclusively by middle-class youth, we also find women taking on a much higher profile. As 1960s unisex gave way to hippie sexual ambiguity and then to mid–1970s high-camp glitter rock, we can see that both girls themselves and femininity as a representational form became more acceptable within the prevailing vocabulary of youth subcultures. However the feminising of the male image as seen in the iconography of Bowie or Jagger or even Gary Glitter, should not blind us to the asymmetry which remains in relation to the feminine image. There is much less sexual fluidity permitted to girls. The girl is by definition 'forever feminine'.

In short, the evidence about how active and present girls are in the main post-war subcultures is difficult to interpret conclusively. It seems to be the case that girls organise their social life as an alternative to the kinds of risks and qualifications involved in entering into the mainstream of male subcultural life.

Where girls are visible, what are their roles and do these reflect the general subordination of women in culture?

Three selected images – the motor-bike girl, the 'mod' girl, and the hippy – will have to do here: where girls are present, but where the way they are present suggests that their cultural subordination is retained and reproduced.

Motor-bike girl

The motor-bike girl, leather-clad, a sort of subcultural pin-up heralding – as it appeared in the press – a new and threatening sort of sexuality. This image was often used as a symbol of the new permissive sexuality of the 1960s and was encapsulated in the figure of Brigitte Bardot astride a motor-bike with her tousled hair flying behind her. More mundanely this image encoded female sexuality in a modern, bold and abrasive way. With matte pan-stick lips, an insolent expression on her eyelined eyes and an unzipped jacket, the model looked sexual, numbed and unfeeling, almost expressionless. This was an image therefore at odds with conventional femininity and suggestive of sexual deviance. At the same time this very image was utilised in advertising and in soft pornography, an example of how – within the repertoire of subcultural representations – girls and women have always been located nearer to the point of consumerism than to the 'ritual of resistance'.

In rocker or motor-bike culture this sexualised image of a girl riding a bike remained a fantasy rather than a reality. Girls were rarely if ever seen as the handles and instead were ritualistically installed on the back seat. If Paul Willis is right, few girls ever penetrated to the symbolic heart of the culture – to the detailed knowledge of the machine, to the camaraderie and competition between the riders.[7] A girl's membership seemed to depend entirely on whose girlfriend she was. In the Hell's Angels groups, where the dynamics of the subculture were even more strenuously masculine, girls occupied particular, institutionalised roles. Hunter Thompson suggests that the Angels treated their women primarily as sexual objects. If they were not objects of the gangbang' the only other role open to them was that of a 'Mama'.[8]

The mod girl

Mod culture offers a more complex subcultural opportunity for girls, if for no other reason than that it was located in and sprang from the mainstream of working-class teenage consumerism. In the mid- to late 1960s there were more teenage girls at work and there were new occupations in the distribution and service sector, particularly in the urban centres. Jobs in the new bou-

tiques, in the beauty business and in clothing as well as in the white-collar sector all involved some degree of dressing up. It was from the mid–1960s onwards that the girls behind the counter in the new boutiques were expected to reflect the image of the shop and thus provide a kind of model or prototype for the young consumer. Glamour and status in these fields often compensated for long hours and low wages. Full employment and freedom to 'look the part' at work, encouraged greater freedom in domestic life. Tom Wolfe's accurate and vivid account of mod girls in London describes how many of these girls were living in flats and bedsits, a pattern hitherto unknown for working-class girls.[9] These factors made it more likely that girls got involved in mod culture than might otherwise have been the case.

Because mod style was in a sense quietly imperceptible to those unaware of its fine nuances, involvement was more easily accommodated into the normal routines of home, school and work. There was less likelihood of provoking an angry parental reaction since the dominant look was neat, tidy and apparently unthreatening. Parents and teachers knew that girls looked 'rather odd these days, with their white drawn faces and cropped hair', but as Dave Laing noted 'there was something in the way they moved which adults couldn't make out'.[10] The fluidity and ambiguity of the subculture meant that a girl could be around, could be a 'face' without necessarily being attached to a boy. Participation was almost wholly reliant on wearing the right clothes, having the right hair-style and going to the right clubs. With this combination right, the girl was a mod. Like her male counterpart, the mod girl demonstrated the same fussiness for detail in clothes, the same over-attention to appearance. Facial styles emphasised huge, darkened eyes and body-style demanded thinness.

It may be that mod girls came to the attention of the commentators and journalists because of the general 'unisex' connotations of the subculture. The much mentioned effeminacy of the boys drew attention to the boyish femininity of the girls, best exemplified in the early fashion shots of Twiggy. An absence of exaggerated masculinity like that displayed in the rocker subculture or by Willis's motor-bike boys, made the mod subculture both exciting and accessible to girls. Like their female counterparts, these boys were more likely to be employed in white-collar office work

than in unskilled manual jobs. This greater visibility of girls in the subculture, single or attached, has also got to be seen in terms of the increasing visibility and confidence of teenage girls in the 1960s, working-class and middle-class. Mod culture tippled easily into 'Swinging London' whose favourite image was the 'liberated' dolly-bird. The Brooke clinics opened in 1964 making the pill available to single girls and this facility also affected the sexual confidence not just of the middle-class girls in the universities but also of the working-class girls living in London's bedsitter-land.

However this new prominence and confidence should not be interpreted too loosely. The presence of 'girls' in the urban panoramas of trendy fashion photography, the new-found autonomy and sexual freedom, have got to be set alongside the other material factors which still shaped and determined their lives. This independence reflected short-term rather than long-term affluence. The jobs which provided the extra cash afforded immediate access to consumer goods, but few opportunities for promotion or further training. There is nothing to suggest that participation in the mod subculture changed the social expectations of girls, or loosened the bonds between mothers and daughters, even if they were temporarily living in flats. These girls had been educated under the shadow of the Newsom Report and had therefore been encouraged to consider marriage their real careers.[11]

The hippy

The term 'hippy' is of course an umbrella term, covering a variety of diverse groupings and tendencies. However it is most likely that girls would have entered this subculture through the social life afforded by the universities in the late 1960s and early 1970s. Access to prolonged higher education gives the middle-class girl the space, by right, which her working-class counterpart is denied or else gains only through following a more illegitimate route. The flat or the room in the hall of residence provides the female student with space to experiment, time of her own, and relatively unsupervised leisure. She also has three or four years during which marriage is pushed into the background. The lack of strict demarcation between work and leisure also allows for – indeed

encourages – the development of a more uniquely personal style. The middle-class girl can express herself in dress without having to take into account the restrictions of work.

None the less, traditional sex roles prevailed in the hippy subculture as numerous feminist authors have described. Femininity moved imperceptibly between the 'earth-mother', the pre-Raphaelite mystic, the kind of 'goddess' serenaded by Bob Dylan, and the dreamy fragility of Marianne Faithful. Media representations and especially visual images, of course, have to be read and interpreted with care. Moral panics around 'dirty hippies' frequently drew attention to the presence of girls and to the sexual immorality of commune-living. The images which linger tend also to suggest excessive femininity and 'quiet restraint' as demonstrated in the figure of Joni Mitchell. A still more dramatic rejection of the feminine image in the early 1970s carried a self-destructive element in it, as the addiction and eventual death of Janis Joplin shows. Although the range of available and acceptable images of femininity tended to confirm already-existing stereotypes, none the less the hippy underground, set against a background of widespread social protest and youthful revolt, also represented an empowering space for women. Within its confines and even on the pages of the underground press, the first murmerings of feminism were heard.[12]

Do girls have alternative ways of organising their cultural life?

The important question may not be the absence or presence of girls in male subcultures, but the complementary ways in which young girls interact among themselves and with each other to form a distinctive culture of their own, one which is recognised by and catered to in the girls' weekly comics and magazines. For example 'teeny-bopper' culture, based round an endless flow of young male pop stars, is a long-standing feature of post-war girls' culture. Where this kind of cultural form is markedly different from the male subcultures, is in its commercial origins. It is an almost totally packaged cultural commodity. It emerges from within the heart of the pop-music business and relies on the magazines, on radio and TV for its wide appeal. As a result it seems to carry less of the creative elements associated with the

working-class youth subcultures considered by male sociologists like those mentioned above. However, teenybopper stars carry socially exclusive connotations and opportunities for their fans. The more other sectors of the population, including teenage boys, older adolescents, and parents, dislike and even despise these bland and pretty-looking young men, the more 11–13-year-old girls love them. The teenybopper phenomenon of the 1970s grew up around this very young age group who, it seemed, were not being addressed by the pop mainstream. At the same time the attraction of stars like David Cassidy for the media industries lay not just in the profits from songs but from the rights film and TV companies held over TV series and film appearances. Teenybopper was, and has been, big business from the start.

Mainstream taste like that evidenced in the popularity of stars like Cassidy and the Osmonds and, in Britain, the Bay City Rollers, could easily be seen as reflective therefore of a kind of cultural conservatism. Girls may be easy customers to please, they are happy to go along with the easiest, least aggressive, least rebellious and most manufactured kind of pop culture. This however is a much too simplistic way of accounting for what is in fact a much less passive, (and much ridiculed) form of hero-worship. There is more to teenybopper culture than mere gazing in adoration at *Jackie* pin-ups. Even in so manufactured a form of pop culture we can locate a variety of negotiative processes at work:

1. Young pre-teen girls have access to less freedom than their brothers. Because they are deemed to be more at risk on the streets from attack, assault, or even abduction, parents tend to be more protective of their daughters than they are of their sons (who, after all have to learn to defend themselves at some point, as men). Teeny-bopper culture takes these restrictions into account. Participation is not reliant on being able to spend time outside the home on the streets. Instead teeny-bopper styles can quite easily be accommodated into school-time or leisure-time spent in the home. Being a Cassidy fan or a Bay City Roller fan requires only occasional trips to live concerts (most of which finish conveniently early to allow the fans to get home).

2. There are few restrictions in relation to joining this main-

stream and commercially-based subculture. It carries no strict rules and requires no special commitment to internally generated ideas of 'cool'. Nor does it rely on a lot of money. Its uniforms are cheap, its magazines are well within the pocket-money weekly budget, its records are affordable and its concerts are sufficiently rare to be regarded as treats.

3. Membership carries relatively few personal risks. For girls of this age real boys remain a threatening and unknown quantity. Sexual experience is something most girls of all social classes want to hold off for some time in the future. They know, however, that going out with boys invariably carries the possibility of being expected to kiss, or 'pet'. The fantasy boys of pop make no such demands. They 'love' their fans without asking anything in return. The pictures which adorn bedroom walls invite these girls to look, and even stare at length, at male images (many of which emphasise the whole masculine physique, especially the crotch). These pin-ups offer one of the few opportunities to stare at boys and to get to know what they look like. While boys can quite legitimately look at girls on the street and in school, it is not acceptable for girls to do the same back. Hence the attraction of the long uninterrupted gaze at the life-size 'Donny Osmond Special'.

4. The kind of fantasies which girls construct around these figures play the same kind of role as ordinary daydreams. Narrative fantasies about bumping into David Cassidy in the supermarket, or being chosen out by him from the front row of a concert, both carry a strongly sexual element, and are also means of being distracted from the demands of work or school or other aspects of experience which might be perceived as boring or unrewarding.

5. Girls who define themselves actively within these teenybopper subcultures are indeed being *active*, even though the familiar iconography seems to reproduce traditional gender stereotypes with the girl as the passive fan, and the star as the active male. These girls are making statements about themselves as consumers of music, for example. If the next record is boring or simply bad, the future of the star is in jeopardy. If the stars are seen to disregard the fans, they are likely to lose their place in both the charts and the

popularity stakes. Finally and most importantly, teenybopper culture offers girls a chance to define themselves as different from and apart from both their younger and their older counterparts. They are no longer little girls and not yet teenage girls. Yet this potentially awkward and anonymous space can be, and is transformed into a site of active feminine identity.

Conclusion

Female participation in youth cultures can best be understood by moving away from the 'classic' subcultural terrain marked out as oppositional and creative by numerous sociologists. Girls negotiate a different leisure space and different personal spaces from those inhabited by boys. These in turn offer them different possibilities for 'resistance', if indeed that is the right word to use. Some of the cultural forms associated with pre-teenage girls, for example, can be viewed as responses to their perceived status as girls and to their anxieties about moving into the world of teenage sexual interaction. One aspect of this can be seen in the extremely tight-knit friendship groups formed by girls. A function of the social exclusiveness of such groupings is to gain private, inaccessible space. This in turn allows pre-pubetal girls, to remain seemingly inscrutible to the outside world of parents, teachers, youth workers and boys as well. Teenybopper subcultures could be interpreted as ways of buying time, within the commercial mainstream, from the real world of sexual encounters while at the same time imagining these encounters, with the help of the images and commodities supplied by the commercial mainstream, from the safe space of the all-female friendship group.

Notes and references

1. T. R. Fyvel, *The Insecure Offenders*, London, Chatto & Windus, 1963.
2. S. Rowbotham, *Woman's Consciousness, Man's World*, Harmondsworth, Pelican, 1973,
3. P. Willis, *Profane Culture*, London, Chatto & Windus, 1977,

4. I. Taylor, P. Walton and J. Young (eds) *Critical Criminology*, London, Routledge & Kegan Paul, 1975.
5. M. Abrams, *The Teenage Consumer*, London, Press Exchange, 1959,
6. See, for example, A. Sillitoe, *Saturday Night and Sunday Morning*, Harmondsworth, Penguin, 1959.
7. Willis, *Profane Culture*.
8. H. Thompson, *Hell's Angels*, Harmondsworth, Penguin, 1967.
9. T. Wolfe, 'The Noonday Underground' in *The Pump House Gang*, Bantam Books, New York, 1968.
10. D. Laing, *The Sound of Our Time*, London, Sheed & Ward, 1969.
11. J. H. Newsom, *Half Our Future: A Report*, London, HMSO, 1963.
12. See, for example, issues of *Black Dwarf*.

2

Settling Accounts with Subculture: A Feminist Critique*

Although 'youth culture' and the 'sociology of youth' – and particularly critical and Marxist perspectives on them – have been central strands in the development of cultural studies over the past fifteen years, the emphasis from the earliest work of the National Deviancy Conference (NDC) onwards has remained consistently on *male* youth cultural forms.[1] There have been studies of the relation of male youth to class and class culture, to the machinery of the State, and to the school, community and workplace. Football has been analysed as a male sport, drinking as a male form of leisure, the law and the police as patriarchal structures concerned with young male (potential) offenders. I do not know of a study that considers, never mind prioritises, *youth* and the family. This failure by subcultural theorists to dislodge the male connotations of 'youth' inevitably poses problems for those who are involved in teaching about those questions. As they cannot use the existing texts 'straight,' what other options do they have?

One is to dismiss the existing literature as irrevocably male-biased and to shift attention towards the alternative terrain of girls' culture, to the construction of ideologies about girlhood as articulated in and through various institutions and cultural forms – in schools, in the family, in law and in the popular media.[2] The danger of this course is that the opportunity may be missed of grappling with questions which, examined from a feminist perspective, can increase our understanding of masculinity, male

*This article originally appeared in *Screen Education*, Spring 1980, no.39.

16

culture and sexuality, and their place within class culture. This then is the other option: to combine a clear commitment to the analysis of girls' culture with a direct engagement with youth culture as it is constructed in sociological and cultural studies. Rather than simply being dismissed, the subcultural 'classics' should be re-read critically so that questions hitherto ignored or waved aside in embarrassment become central. An examination of their weaknesses and shortcomings can raise questions of immediate political relevance for feminists. What, for example, is the nature of women's and girls' leisure? What role do hedonism, fantasy escapes and imaginary solutions play in their lives? What access to these spheres and symbols do women have anyway?

In this article I am going to explore some questions about youth culture and subcultures by attempting this sort of feminist re-reading of two recent books, Paul Willis's *Learning to Labour* and Dick Hebdige's *Subculture*. The point, therefore, is not to condemn them – they represent the most sophisticated accounts to date of youth culture and style – but to read 'across' them to see what they say (or fail to say) about working-class male sexuality, bravado and the sexual ambiguity of style. Willis investigates the relation, for a group of 'lads' between working-class-youth cultural gestures and the places to which they are allocated in production. The expressions of resistance and opposition which characterise this relation are fraught with contradiction. Willis suggests that the vocabulary articulating their distance from structures of authority in school and workplace simultaneously binds the 'lads' to the basically rigid positions they occupy in these spheres; their rowdy shouts of disaffiliation quickly become cries of frustration and incorporation. A particular mode of class culture is thus seen in a complex way to serve two masters . . . capital *and* labour. The emphasis of Hebdige's *Subculture* is quite different. He focuses elliptically on subcultural style as *signifier* rather than as a series of distinct cultural expressions. Style, he claims, takes place several steps away from the material conditions of its followers' existence and continually resists precise historical analysis. One of its objectives, then, is to be forever out of joint with mainstream dominant culture: it evaporates just as it crystallises.

Willis and Hebdige both show how male adolescents take already-coded materials from their everyday landscapes (and, though

this is not spelt out, from their fantasies) and mould them into desirable shapes, into social practices and stylish postures. Both accounts draw on the notion that control and creativity are exercised from within subordinate class positions and that, as a result of this subordination, cultural gestures often appear in partial, contradictory and even amputated forms. These insights can be taken further by focusing on the language of adolescent male sexuality embedded in these texts. Questions around sexism and working-class youth and around sexual violence make it possible to see how class and patriarchal relations work together, sometimes with an astonishing brutality and at other times in the 'teeth-gritting harmony' of romance, love and marriage. One of Willis's 'lads' says of his girlfriend, 'She loves doing fucking housework. Trousers I brought up yesterday, I took 'em up last night and her turned 'em up for me. She's as good as gold and I wanna get married as soon as I can.'[3] Until we come to grips with such expressions as they appear across the subcultural field, our portrayal of girls' culture will remain one-sided and youth culture will continue to 'mean' in uncritically masculine terms. Questions about girls, sexual relations and femininity in youth will continue to be defused or marginalised in the ghetto of Women's Studies.

Silences

One of the central tenets of the women's movement has been that the personal is political. Feminists recognise the close links between personal experience and the areas chosen for study – autobiographies invade and inform a great deal of what is written. Even if the personal voice of the author is not apparent throughout the text, she will at least announce her interest in, and commitment to, her subject in an introduction or foreword. Although few radical (male) sociologists would deny the importance of the personal in precipitating social and political awareness, to admit how their own experience has influenced their choice of subject-matter (the politics of selection) seems more or less taboo. This silence is particularly grating in the literature on the hippie and drug countercultures, where it seems to have

been stage-managed only through a suspiciously exaggerated amount of methodological justification.[4]

It is not my intention here to read between the lines of writing about subcultures and unravel the half-written references, the elliptical allusions and the 1960s rock lyrics. The point is that this absence of self (this is quite different from the authorial 'I' or 'we') and the invalidating of personal experience in the name of the more objective social sciences goes hand in hand with the silencing of other areas, which are for feminists of the greatest importance. It is no coincidence, for example, that while the sociologies of deviance and youth were blooming in the early 1970s, the sociology of the family – still steeped in the structural-functionalism of Talcott Parsons – was everybody's least favourite option. If we look for the structured absences in this youth literature, it is the sphere of family and domestic life that is missing. No commentary on the hippies dealt with the countercultural sexual division of labour, let alone the hypocrisies of 'free love'; few writers seemed interested in what happened when a mod went home after a weekend on speed. Only what happened on the streets mattered.

Perhaps these absences should be understood historically. The sociology of crime/deviance/youth culture was one of the first areas from which the hegemony of Parsonianism was challenged. Many of the radical young sociologists in the vanguard of this attack were recruited from the New Left, from the student movement of the late 1960s and even from the hippie counterculture. At this time, before the emergence of the women's movement in the early 1970s, the notions of escaping from the family, the bourgeois commitments of children and the whole sphere of family consumption formed a distinct strand in left politics. Sheila Rowbotham has described how women were seen in some left-wing circles as a temptation provided by 'capital' to divert workers and militants alike from the real business of revolution, and she has also shown how hypocritical these anti-family, anti-women platitudes were.[5] Clearly things have changed since then but, although the work of the feminists has enabled studies of the family to transcend functionalism, the literature on subcultures and youth culture has scarcely begun to deal with the contradictions that patterns of cultural resistance pose in relation to women. The writers, having defined themselves as against the

family and the trap of romance as well as against the boredom of the meaningless labour, seem to be drawn to look at other, largely working-class, groups who appear to be doing the same thing.

In documenting the temporary flights of the teds, mods or rockers, however, they fail to show that it is much more difficult for women to escape (even temporarily) and that these symbolic flights have often been at the expense of women (especially mothers) and girls. The lads may get by with each other alone on the streets but they did not eat, sleep or make love there. Their peer-group consciousness and pleasure frequently seem to hinge on a collective disregard for women and the sexual exploitation of girls. And in the literary sensibility of urban romanticism that resonates across most youth cultural discourses, girls are allowed little more than the back seat on a draughty motor bike:

> Just wrap your legs around these velvet rims
> And strap your hands across my engines
> We'll run till we drop baby we'll never go back
> I'm just a scared and lonely rider
> But I gotta know how it feels.[6]

Writing about subcultures is not the same thing as being in one. Nonetheless, it is easy to see how it would be possible in sharing some of the same symbols – the liberating release of rock music, the thrill of speed, of alcohol or even of football – to be blinded in some of their more oppressive features.

I have oversimplified in this account, of course – there is a whole range of complicating factors. First, feminists also oppose the same oppressive structures as the radical sociologists and have visions of alternative modes of organising domestic life – although ones which are *primarily* less oppressive of women, because historically women have always suffered the greatest exploitation, the greatest isolation in the home. Second, to make sense of the literature on subculture *purely* in terms of male left identification with male working-class-youth groups would mean devaluing the real political commitment behind the work and ignoring its many theoretical achievements. The attempts to explain the ways in which class fears on the part of the dominant

class have been inflected during the post-war period onto sectors of working-class youth – and dealt with at this level – remains of vital significance; also important has been the ascription of a sense of dignity and purpose, an integrity and a rationale, to that section of youth commonly labelled 'animals' in the popular media. Third there have been political and theoretical developments. The NDC of the late 1960s grew out of a libertarianism which rejected both reformist and old left politics in favour of 'grass-roots' politics (especially cultural and 'alternative' politics) and which emphasised the importance of community work and action research.[7] Many of these ideas have since been refined in an engagement with the work of Althusser and of Gramsci.

Yet the question of sexual division still remains more or less unexplored. In *Learning to Labour*, Paul Willis convincingly argues that the culture which the lads bring to the school and workplace and its consequent relation to the position they occupy in the labour hierarchy provides the key to many of the more contradictory aspects of male working-class culture. But what do these expressions mean for girls and female working-class culture? One striking feature of Willis's study is how unambiguously degrading to women is the language of aggressive masculinity through which the lads kick against the oppressive structures they inhabit – the text is littered with references of the utmost brutality. One teacher's authority is undermined by her being labelled a 'cunt'. Boredom in the classroom is alleviated by the mimed masturbating of a giant penis and by replacing the teacher's official language with a litany of sexual 'obscenities'. The lads demonstrate their disgust for and fear of menstruation by substituting 'jam rag' for towel at every opportunity. What Willis fails to confront. I think, is the violence underpinning such imagery and evident in one lad's description of sexual intercourse as having 'a good maul on her'. He does not comment on the extreme cruelty of the lads' sexual double standard or tease out in sufficient detail how images of sexual power and domination are used as a kind of last defensive resort. It is in these terms that the book's closing lines can best be understood. When Paul Willis gently questions Joey about his future, he replies 'I don't know, the only thing I'm interested in his fucking as many women as I can if you really want to know.'

Although Willis shows how male manual work has come to

depend on the elaboration of certain values – the cultural repro-
duction of machismo from father to son, the male pride in physi-
cal labour and contempt for 'pen-pushing' – he does not integrate
these observations on masculinity and patriarchal culture into the
context of the working-class-family. The family is the obverse
face of hard, working-class culture, the softer sphere in which
fathers, sons and boy-friends expect to be, and are, emotionally
serviced. It is this link between the lads' hard outer image and
their private experiences – relations with parents, siblings and
girl-friends – that still needs to be explored. Willis's emphasis
on the cohesion of the tight-knit groups tends to blind us to the
ways that the lads' immersion in and expression of working-class
culture also takes place outside the public sphere. It happens as
much around the breakfast table and in the bedroom as in the
school and the workplace.

Shop-floor culture may have developed a toughness and resili-
ence to deal with the brutality of capitalist productive relations,
but these same 'values' can be used internally. They are evident,
for example, in the cruel rituals to which the older manual
workers subject school-leavers newly entering production.[8] They
can also be used, and often are, against women and girls in the
form of both wife and girlfriend-battering. A full *sexed* notion
of working-class culture would have to consider such features
more centrally.

Discourses of disrespect

Because it constantly avoids reduction to one essential meaning
and because its theses are almost entirely decentred, it is not
easy to contain Dick Hebdige's *Subculture* within the normal
confines of a critical review. Ostensibly his argument is that it is
on the concrete and symbolic meeting-ground of black and white
(implicitly male) youth that we have to understand the emerg-
ence and form of subcultural style, its syncopations and cadences.
From an account of the 'Black Experience', he works outwards
to the ways in which this culture has been taken up and paid
homage to by white male intellectuals and by sections of working-
class youth. At the heart of this process he places rock music –
black soul and reggae, white rock (especially the music and style

of David Bowie) and, of course, the 'mess' of punk. Acknowledging – and fleetingly pleading guilty to – the tendency to romanticism in such subcultural tributes, Hebdige stresses the danger that such hagiography can overlook the unmitigated ferocity of the oppression and exploitation which have created black culture as it is. He does not try to prove his case with a barrage of empirical facts, but presents his reading of style as one which the reader can take or leave. Yet the sheer partiality of extrapolating race as signifier *par excellence* makes that which he chooses *not* to deal with all the more shocking. Despite his emphasis on the neglect of race and racism in youth and subcultural work, he seems oblivious to the equal neglect of sexuality and sexism.

His book twists and winds its way around a variety of themes. At some moments it goes off into flights of densely referenced semi-sociological stream of consciousness. At others it addresses itself with forceful clarity to mainstream theoretical debates on youth culture: two of his arguments here are worth dwelling on in that a feminist critique would demand that they be pushed further than he is willing to do. From the start Hebdige acknowledges his debt to the theoretical overview in *Resistance through Rituals*, in particular its application of Gramsci's concept of 'hegemony' to the question of youth in post-war Britain, and places his own work broadly within the parameters defined by John Clarke's essay on 'Style' in that collection. The problem is that Hebdige's assumptions actually run counter to those of *Resistance through Rituals*. Briefly, he posits that the youth subculture is the sum of those attempts to define it, explain it away, vilify it, romanticise it and penalise it. The moral panic and smear campaign construct what the subculture 'becomes' just as much as the kids on the street. Linked to this is his important recognition that there is no necessary relation between the peculiarities of subcultural style and the area of (presumably) working-class life from which it is drawn, that 'one should not expect the subcultural response . . . to be even necessarily in touch, in any immediate sense, with its material position in the capitalist system'.[9] Working-class self-images are just as constricted by the limitations and historical specificities of available codes as youth cultures. Their 'raw materials' may be material but they are never completely 'uncooked'.

In one of the most perceptive and exciting parts of the book.

Hebdige uses punk to illustrate this. It is here, in spelling out his argument that punk was a response to already articulated 'noises' (especially in the popular press) of panic and crisis, that he contradicts the logic of the *Resistance through Rituals* position, which argued for the *deconstruction* of the ideological debris and clutter about youth and for the reconstruction from these ruins of a more adequately theorised account. The important point is that, precisely because it used a phenomenal forms/real relations model, *Resistance through Rituals* was unable to engage directly with the sort of concepts at play in Hebdige's account. The significance of 'outsider mythology', for example, or of representations of youth in film, literature or music, would have been consigned to the sphere of ideology or (worse) 'idealism', given the same logical, if not political, status as the 'moral panic' and therefore also in need of 'deconstruction'.

Hebdige, in contrast, argues that ultimately the radical/Marxist account is logically no more true than any other: it is valuable to the extent that it engages critically not only with the phenomenon in question but also with the inadequacies of the different existing accounts. Although its 'politics' cannot be read off – it may have little to say about youth politics in the activist sense – it nevertheless has a material political force in that it disrupts commonsense wisdoms about youth and their more respectable academic revisions. Whereas in *Resistance through Rituals* it is class that provides the key to unlocking subcultural meanings (though not, the authors stress, in a reductionist way) in *Subculture* style and race are selected as the organising principles for prising them open. Although neither book takes us very far in understanding youth and gender, Hebdige's account at least makes it possible to explore the theme without continual recourse to class and so may disrupt (in a positive sense) some of our own commonsense wisdoms about class and class culture. But although his method draws on the work of feminists like Kristeva and is one widely used by feminists working in media studies, Hebdige by and large reproduces yet another 'silence'. The pity is that he thereby misses the opportunity to come to grips with subculture's best-kept secret, its claiming of style as a male but never unambiguously masculine prerogative. This is not to say that women are denied style, rather that the style of a subculture is primarily that of its men. Linked to this are the collective

celebrations of itself through its rituals of stylish public self-display and of its (at least temporary) sexual self-sufficiency. As a well known ex-mod put it, 'You don't need to get too heavily into sex or pulling chicks, or sorts as they were called . . . Women were just the people who were dancing over in the corners by the speakers.[10] If only he had pushed his analysis of style further, Hebdige might well have unravelled the question of sexuality, masculinity and the apparent redundancy of women in most subcultures.

What is clear, though, is that Hebdige revels in style. For him it is a desirable mode of narcissistic differentiation – 'You're still doing things I gave up years ago'. as Lou Reed put it. There's nothing inherently wrong with that; the problem is that as a signifier of desire, as the starting-point for innumerable fantasies or simply as a way of sorting friends from enemies, Hebdige's usage of 'style' structurally excludes women. This is ironic, for in mainstream popular culture it is accepted as primarily a female or feminine interest.[11] What is more, women are so obviously inscribed (marginalised, abused) within subcultures as static objects (girlfriends, whores or 'faghags') that access to its thrills, to hard fast rock music, to drugs, alcohol and 'style', would hardly be compensation even for the most adventurous teenage girl. The signs and codes subverted and reassembled in the 'semiotic guerilla warfare' conducted through style do not really speak to women at all. The attractions of a subculture – its fluidity, the shifts in the minutiae of its styles, the details of its combative bricolage – are offset by an unchanging and exploitative view of women.

Homages to masculinity

Rather than just cataloguing the 'absences' in *Subculture*, I want to deal with three questions raised by a feminist reading: the extent to which subcultural bricoleurs draw on patriarchal meanings, the implications of ambiguous sexuality for youth cultures, and the question of gender and the moral panic.

Dick Hebdige claims that style breaks rules and that its refusals are complex amalgams taken from a range of existing signs and meanings. Their menace lies in the extent to which they threaten

these meanings by demonstrating their frailty and the ease with which they can be thrown into disorder. But just as the agents who carry on this sartorial terrorism are inscribed as subjects within patriarchal as well as class structures, so too are the meanings to which they have recourse. These historical, cultural configurations cannot be free of features oppressive to women. Machismo suffuses the rebel archetypes in Jamaican culture which, Hebdige claims, young British blacks plunder for suitable images. The teds turned to the style of Edwardian gents. The mods, locating themselves within the 'modernism' of the new white-collar working class, looted its wardrobe as well as that of smart young blacks around town. The skins, similarly, turned simultaneously to both black style and that of their fathers and grandfathers. More tangentially, punks appropriated the 'illicit iconography of pornography', the male-defined discourse *par excellence*. Of course, it would be ludicrous to expect anything different. The point I am stressing is how highly differentiated according to gender, style (mainstream or subcultural) is – it is punk girls who wear the suspenders, after all.

If, following Eco's dictum,[12] we speak through our clothes, then we still do so in the accents of our sex. Although Hebdige does fleetingly mention sexual ambiguity in relation to style (and especially to the various personae of David Bowie), he does not consider it as a central feature right across the subcultural spectrum – for him subcultural style *is* Sta-prest trousers, Ben Sherman shirts or pork-pie hats. I am not suggesting that all subcultures value transvestism – but that subcultural formations and the inflections of their various 'movements' raise questions about sexual identity which Hebdige avoids. Does subcultural elevation of style threaten the official masculinity of straight society which regards such fussiness as cissy? Does the skinheads' pathological hatred of 'queers' betray an uneasiness about their own fiercely defended male culture and style? Are subcultures providing relatively safe frameworks within which boys and young men can escape the pressures of heterosexuality?[13]

For feminists the main political problem is to assess the significance of this for women. If subculture offers escape from the demands of traditional sex roles, then the absence of predominantly girl subcultures – their denial of access to such 'solutions' – is evidence of their deeper oppression and of the monolithic

heterosexual norms which surround them and find expression in the ideology of romantic love. Whereas men who 'play around' with femininity are nowadays credited with some degree of power to choose, gender experimentation, sexual ambiguity and homosexuality among girls are viewed differently. Nobody explains David Bowie's excursions into female personae (see the video accompanying his single *Boys Keep Swinging*) in terms of his inability to attract women. But any indication of such ambiguity in girls is still a sure sign that they couldn't make it in a man's world. Failure replaces choice; escape from heterosexual norms is still synonymous with rejection. (Even the fashionable bisexuality among the women of the Andy Warhol set is less willingly dealt with in the popular press.) My point, then, is not to label subcultures as potentially gay, but to show that the possibility of escaping oppressive aspects of adolescent heterosexuality within a youth culture or a gang with a clearly signalled identity, remains more or less unavailable to girls. For working-class girls especially, the road to 'straight' sexuality still permits few deviations.

Finally I want to comment on the way in which Hebdige deals with the processes of reaction and incorporation accompanying the subcultural leap into the limelight of the popular press and media. He exposes with great clarity the inadequacies of the old moral panic argument and suggests that the Barthesian notion of trivialisation/exoticisation/domestication offers a better account of how youth cultures are 'handled'.[14] But again, because his model is not gendered, he fails to recognise that these are gender-specific processes. Ultimately the shock of subcultures can be partially defused because they can be seen as, among other things, boys having fun. That is, reference can be made *back* to the idea that boys should 'sow their wild oats' – a privilege rarely accorded to young women. This does not mean that the 'menace' altogether disappears, but at least there are no surprises as far as gender is concerned. Even male sexual ambiguity can be dealt with to some extent in this way. (Boys with ear-rings, dyed hair and mascara? . . . They do it every week in *It Ain't 'Arf Hot, Mum*.) But if the Sex Pistols had been an all-female band spitting and swearing their way into the limelight, the response would have been more heated, the condemnation less tempered by indulgence. Such an event would

have been greeted in the popular press as evidence of a major moral breakdown and not just as a fairly common, if shocking, occurence.

Walking on the wild side – it is different for girls

Rather than dealing with more mainstream sociological criticisms of *Subculture* (its London-centredness, for example) or making my rather oversimplified comments on youth culture more specific (historically and in relation to such institutions as school, family and workplace), I now want to look briefly at some of the meanings ensconced within the objects and practices constituting the subcultural artillery.

Rock music has been so much part of post-war youth cultures that its presence has often just been noted by writers; the meanings signified by its various forms have not received the attention they deserve. Dick Hebdige does something to redress this, but again without developing a perspective sensitive to gender and sexual division. My points here are tentative and simple. Such a perspective would have to realise that rock does not signify alone, as pure sound. The music has to be placed within the discourses through which it is mediated to its audience and within which its meanings are articulated. Just as Elizabeth Cowie has shown how reviews construe the sense of a particular film in different ways,[15] so an album or concert review lays down the terms and the myths by which we come to recognise the music. One myth energetically sustained by the press is the overwhelming male-ness of the rock scene. Writers and editors seem unable to imagine that girls could make up a sizeable section of their readership. Although at a grass-roots level virulent sexism has been undermined by punk, Rock Against Racism and Rock Against Sexism, journalistic treatment remains unchanged. As the exception, women musicians are treated with a modicum of respect in the *New Musical Express* or *Melody Maker*, but women are dealt with more comfortably in the gossip column on the back page, as the wives or girlfriends of the more flamboyant rock figures.

The range of drug scenes characterising subcultures reveals a similar pattern. The inventory is familiar – alcohol for teds,

rockers and skins, speed and other pills for mods and punks, hallucinogenics for hippies, cocaine and to a lesser extent heroin for other groups closer to the rock scene. So intransigently male are the mythologies and rituals attached to regular drug-taking that few women feel the slightest interest in their literary, cine- matic or cultural expressions – from William Burroughs' cata- logues of destructive self-abuse and Jack Kerouac's stream-of- consciousness drinking sprees to Paul Willis's lads and their alcoholic bravado. It would be foolish to imagine that women do not take drugs – isolated young housewives are amongst the heaviest drug-users and girls in their late teens are one of the largest groups among attempted suicides by drug overdose. Instead I am suggesting that for a complex of reasons the imagin- ery solutions which drugs may offer boys do not have the same attraction for girls. One reason is probably the commonsense wisdom deeply inscribed in most women's consciousnesses – that boys do not like girls who drink, take speed and so on; that losing control spells sexual danger; and that drinking and taking drugs harm physical appearance. A more extreme example would be the way that the wasted male junkie in popular mythology, novels and films, can retain a helpless sexual attraction which places women in the role of potential nurse or social worker. Raddled, prematurely aged women on junk rarely prompt a reciprocal willingness.

The meanings that have sedimented around other objects, like motor-bikes or electronic musical equipment, have made them equally unavailable to women and girls. And although girls are more visible (both in numbers and popular representation) in punk than earlier subcultures, I have yet to come across the sight of a girl 'gobbing' (i.e. spitting). Underpinning this continual marginalisation is the central question of street visibility. It has always been on the street that most subcultural activity takes place (save perhaps for the more middle-class oriented hippies): it both proclaims the publicisation of the group and at the same time ensures its male dominance. For the street remains in some ways taboo for women (think of the unambiguous connotations of the term 'streetwalker'): 'morally dubious' women are the natural partners of steet heroes in movies like Walter Hill's *The Warriors* and in rock songs from the Rolling Stones to Thin Lizzy or Bruce Springsteen. Few working-class girls can afford flats

and so for them going out means either a date – an escort and a place to go – or else a disco, dance hall or pub. Younger girls tend to stay indoors or to congregate in youth clubs; those with literally nowhere else to go but the street frequently become pregnant within a year and disappear back into the home to be absorbed by child-care and domestic labour.

There are of course problems in such large-scale generalisations. Conceptually it is important to separate popular public images and stereotypes from lived experience, the range of ideological representations we come across daily from empirical observation and sociological data. But in practice the two sides feed off each other. Everyday life becomes at least partly comprehensible within the very terms and images offered by the media, popular culture, education and the arts, just as material life creates the preconditions for ideological and cultural representation. This complexity need not paralyse our critical faculties altogether, however. It is clear from my recent research, for example, that girls are reluctant to drink precisely because of the sexual dangers of drunkenness. This does not mean that girls do not drink. Most available data suggests that they will drink with more confidence and less tension only when they have a reliable steady boyfriend willing to protect them from more predatory, less scrupulous males. It is difficult to deal so schematically with drug usage, and especially involvement in hard-drug subcultures. Particularly interesting, however, are the warnings to girls against hard drugs in the West German media (the addiction rate there is much higher than in Britain). These are couched entirely in terms of the damage heroin can do to your looks, your body and your sexuality. They reinforce and spell out just how 'it is different for girls': a girl's self-evaluation is assumed to depend on the degree to which her body and sexuality are publicly assessed as valuable.

The politics of style – two steps beyond

I noted earlier that a 'politics of youth' cannot simply be read off from Dick Hebdige's book. Although this hesitancy is preferable to the sloganising with which much writing on youth culture ends, it still barely disguises the pessimism deeply rooted in all

structuralisms, the idea that codes may change but the scaffolding remains the same, apparently immutable. Hebdige's conclusion seems to point to a convergence between gloomy existentialism and critical Marxism as the gap between the 'mythologist' and the working class appears to expand. The sadness pervading the closing pages of *Subculture* hinges on this failure to communicate which, Hebdige claims, characterises the relation between intellectuals and the class about which they write. This facts need not lead to such pessimism. Instead we should develop a clearer idea of the sectors of 'youth' potentially responsive to Dick Hebdige's intervention (male ex-mods, hippies, skins and punks at Art Colleges, rock fans and young socialists . . . ?) and also a broader vision of our spheres of political competence.

Radical and feminist teachers could well, despite the usual resistances they encounter, popularise many of Hebdige's arguments (as well as some points of feminist critique). It is also conceivable that some young people may read the book unprompted by youth 'professionals' (teachers or community workers). After all, the *New Musical Express*, which sells over 200 000 copies, recently reviewed it in glowing terms and Hebdige's ideas have clearly influenced several of the paper's feature writers. So there is no doubt that, apart from being one of the most important books to date on the question of youth culture, it is also likely to reach, if often indirectly, an unprecedently wide audience. That is why its lack of attention to gender matters. It could have opened up questions of style *and* sexual politics. Also, had he addressed himself more directly to this potential audience, Hebdige might have made clearer the implications of the 'escape' from the working class into the subcultural Bohemia of an Art College or rock band, or simply into the independence of a rented flat. As it is, *Subculture* should become a landmark within the politics of culture inside the notoriously traditional Art Colleges because of its emphasis on style and image as *collective* rather than *individual* expression and its investigation of the *social* meaning of style. The problem is just that Hebdige implies that you have to choose either style *or* politics and that the two cannot really be reconciled.

My own guess is that to understand these questions about youth culture and politics more fully, it will be necessary to supplement the established conceptual triad of class, sex and race

52241

with three more concepts – *populism, leisure* and *pleasure*. It is not possible to develop a full-blown justification for that project here, however. And as I opened this article by condemning the self-effacement of male writers, it would perhaps be appropriate to end on a personal note about the ambivalence of my own responses to subcultures and the possible links between youth subcultures and feminist culture. Collective public expressions of disaffiliation from authority and the hegemony of the dominant classes (by either sex) have an unambiguous appeal. Despite their often exaggerated romanticism and their (frequently sexist) politics, the 'spectacle' of these symbolic gestures has a personally 'thrilling' effect. (Sitting on a train in West Germany, surrounded by carefully coiffeured businessman and well-manicured businesswoman, the sight of two 'Felliniesque' punks in the next compartment causes the sociologist to smile).

In a similar way, punk is central to an understanding of the resurgence of 'youth politics' in Britain over recent years. It is not a *deus ex machina* which will banish the unpopularity of left politics but, as a set of loosely linked gestures and forms, it has proved a mobilising and energising force which has helped to consolidate developments like Rock Against Racism. There have also been overlaps between the nuances of punk style and feminist style which are more than just coincidental. Although the stiletto heels, mini-skirts and suspenders will, despite their debunking connotations, remain unpalatable to many feminists, both punk girls and feminists want to overturn accepted ideas about what constitutes femininity. And they often end up using similar stylish devices to upset notions of 'public propriety'.

What this indicates is a mysterious symbiosis between aspects of subcultural life and style in post-war Britain and aspects of a 'new' left and even feminist culture. However precious or trivial the question of style may seem in contrast to concrete forms of oppression and exploitation (unemployment, for example, or the strengthening of the State apparatus), it cannot be hived off into the realm of personal hedonism. The sort of style Dick Hebdige describes is central to the contradictory nature of working-class male culture, and it plays a visible role in the resistances by youth in Britain today. The style of black youth is as much an assault on authority as outright confrontation. For many girls *escaping* from the family and its pressures to act like a 'nice'

girl, remains the first political experience. For us the objective is to make this flight possible for all girls, and on a long-term basis.

I am not arguing that if girls were doing the same as some boys (and subcultures are always minorities) all would be well. The 'freedom' to consume alcohol and chemicals, to sniff glue and hang about the street staking out only symbolic territories is scarcely less oppressive than the pressures keeping girls in the home. Yet the classic subculture does provide its members with a sense of oppositional sociality, an unambiguous pleasure in style, a disruptive public identity and a set of collective fantasies. As a pre-figurative form and set of social relations, I cannot help but think it could have a positive meaning for girls who are pushed from early adolescence into achieving their feminine status through acquiring a 'steady'. The working-class girl is encouraged to dress with stylish conventionality; she is taught to consider boyfriends more important than girlfriends and to aban-don the youth club or disco for the honour of spending her evenings watching television in her boyfriend's house, saving money for an engagement ring. Most significantly, she is forced to relinquish youth for the premature middle-age induced by childbirth and housework. It is not so much that girls do too much too young; rather, they have the opportunity of doing too little too late. To the extent that all-girl subcultures, where the commitment to the gang comes first, might forestall these pro-cesses and provide their members with a collective confidence which could transcend the need for 'boys', they could well signal an important progression in the politics of youth culture.

Notes and references

1. Among the more important books are: J. Young, *The Drugtakers: The Social Meaning of Drug Use*, London, Paladin, 1971; S. Cohen, *Folk Devils and Moral Panics: The Creation of the Mods and Rockers*, London, MacGibbon & Kee, 1972; S. Hall and T. Jefferson (eds) *Resistance through Rituals*, London, Hutchinson, 1976; D. Robbins and P. Cohen, *Knuckle Sandwich*, Harmond-sworth, Penguin, 1978; P. Corrigan, *Schooling the Smash Street Kids*, London, Macmillan, 1979; P. Willis, *Learning to Labour*,

Aldershot, Saxon House, 1977; D. Hebdige, *Subculture: The Meaning of Style*, London, Methuen, 1979.

2. See, for example, S. Sharpe, *Just Like a Girl*, Harmondsworth, Penguin, 1977; A. M. Wolpe, *Some Processes in Sexist Education*, London, WRRC Pamphlet, 1977; A. McRobbie, *The Culture of Working-Class Girls*, (see Chapter 2 of this volume) and CCCS Women's Studies Group (eds) *Women Take Issue*, London, Hutchinson, 1978; D. Wilson, 'Sexual Codes and Conduct' in C. Smart and B. Smart (eds) *Women, Sexuality and Social Control*, London, Routledge & Kegan Paul, 1978.

3. P. Willis, *Learning to Labour*, Aldershot, Saxon House, 1977.

4. See, for example, Willis, *Profane Culture*; and also 'The Cultural Meaning of Drug Use' in Hall *et al.* (eds) *Resistance through Rituals*.

5. S. Rowbotham, *Woman's Consciousness, Man's World*, Harmondsworth, Penguin, 1973.

6. *Born to Run*, B. Springsteen, copyright.

7. This is well-documented in I. Taylor, P. Walton and J. Young (eds) *Critical Criminology*, London, Routledge & Kegan Paul, 1975.

8. Willis, *Learning to Labour*.

9. See R. Coward's angry response to this debate, 'Culture and the Social Formation' in *Screen*, vol. 18, no. 1, Spring 1977.

10. Interview with P. Meaden, *New Musical Express*, 17 November 1979.

11. *Jackie* magazine, however, continues to warn girls against being too flamboyant in dress & personal style. See Chapter 6 of this volume.

12. Quoted in Hebdige, *Subculture*.

13. See, for example, N. Polsky *Hustlers, Beats and Others*, Harmondsworth, Penguin, 1971.

14. R. Barthes, *Mythologies*, London, Paladin, 1972, quoted in Hebdige, *Subcultures*.

15. E. Cowie, 'The Popular Film as a Progressive Text: A Discussion of Coma', Part I, in *M/F*, no. 3, 1979.

3

The Culture of Working-Class Girls*

This chapter addresses the question of working-class culture as lived and experienced by teenage girls. What are its most characteristic features, its constraints, its parameters? To attempt to answer these questions a number of girls aged between 13 and 16 were chosen as the subjects of an empirical study. The location for this piece of work was a youth club a few miles from Birmingham city centre in the outskirts of the Kings Heath area.

Before reporting on the main findings of this project, I should first say a few words about the concept of 'culture', and second about the methodological procedures employed. The question of girls' culture grew out of a recognition that there was a large gap in the study of youth culture. As was pointed out in chapter 1 of this volume, 'The absence of girls from the whole of the literature in this area is quite striking and demands explanation.'[1] The conclusion arrived at there was that despite the unreliability of sources, the role girls seemed to play in the youth cultural formations of the post-war years, appeared to be marginal.[2] But marginality as a concept was not especially useful for thinking through the position of girls in any detail. It implied that girls simply follow the same cultural trajectory as boys, but with less involvement, commitment or investment. They remain instead on the outskirts or periphery of male subcultures. Powell points out that such a mode of analysis, whilst it may have some descriptive purchase can tell us little about what girls actually do. Nor can it provide us with a springboard, for thinking through the

*This is an extract from 'Working-Class Girls and the Culture of Femininity', presented as an MA thesis, Centre for Contemporary Culture Studies, University of Birmingham, 1977.

35

position they occupy in society. 'It is rather like attempting to elaborate a model of the whole society from a study of skinheads.'³ Only by working away from the more transparent or indeed privileged site of youth subcultures, back towards mainstream youth and in this case working-class female youth, is it possible to piece together and understand girls' culture.

This clearly demands concrete, empirical investigation, and for the purposes of this study a Birmingham youth club attached to a large comprehensive school was chosen. What I was interested in was how the girls responded to the material restraints imposed on their lives. This meant looking not only at their own material position (i.e. their economic dependence on parents) but also at their responses to those ideologies carried in and through the material practices of the apparatuses which they daily inhabited.

What then is meant by the concept 'culture'? For sociologists of youth, the term has been used to refer to: 'the peculiar and distinctive "way of life" of the group or class, the meanings, values and ideas embodied in institutions, in social relations, in systems of belief, in mores and customs, in the uses of objects and material life.'⁴ That is, culture is about the pre-structured but still essentially expressive and creative capacities of the group in question. The forms which this expressivity takes are 'maps of meaning' which summarise and encapsulate their social and material life experiences. But these cultural artefacts or configurations, are not created out of nothing. Individuals are born into what are already constructed sets of social meanings which can then be worked on, developed and even transformed. 'Culture then embodies the trajectory of group life through history: always under conditions and with raw materials which cannot wholly be of its own making.'⁵ The 'cultural' is always a site for struggle and conflict. Here hegemony may be lost or won; it is an arena for class struggle. As the word hegemony implies, there is an attempt made by the dominant class to win the consent of the working class to the dominant order, at the *cultural* level and through, for example, the media, leisure, or consumption. Later on this volume I look at one important instance in this process, the 'teen' magazine. Here I am more concerned with the way the girls' culture takes shape, 'from below'.

Working-class girls are one of the most powerless sectors of society. Their lives are more highly structured than their male peers and their actions are closely monitored by the school, by youth leaders and by parents. The girls are firmly rooted in the home and local environment, and lack the social knowledge and expertise which derives from being able to visit and explore different parts of the city by themselves in the way boys can. Few of the girls I interviewed had been to London and many did not even know other parts of Birmingham very well. They were trapped in the safe, secure environment of the home, the club and the school, and they compensated for this lack of space by creating a culture based on each other, rather than on *doing things* together.

The main body of material on which this chapter is based, is drawn from an empirical study carried out over a period of six months in a Birmingham youth club. The aim was to try to come as close as possible to the lived experiences of this group of girls, recording what seemed to be their central preoccupations and observing how they negotiated their social life. Because of the absence of relevant literature on the subject, there were fewer pre-suppositions and assumptions upon which the project could be launched than is the case with most participant observation studies. Sociologists looking at male youth groupings can normally expect, for example, to find certain clearly visible features such as an orientation towards football, motor-bikes, fishing – even vandalism, or violence. But with the girls there existed no such focus. Given this situation, it was necessary, in carrying out the research, to be as reflexive as possible; this meant continually questioning the means by which the data was collected and checking, at every possible instance to make sure that what the girls actually said and meant was being clearly understood.

The methods used were as follows:

1. *Observation* Here special attention was paid to the girls' self-images and to their style. The ways in which they related to each other and to outsiders was also important.
2. *Questionnaires* These proved useful in providing an initial opportunity to get to know the girls in an informal way. 68 short questionnaires were distributed in all, and 56 were returned completed. This information provided all the facts

necessary to plot out the spending power of the girls, the occupations of their parents, size of family, favourite magazines, pop stars, etc.

3. *Interviews* From a group of twenty volunteers a series of taped interviews, eight with girls alone, and six with sets of best friends', were carried out. In most cases the interview followed a fairly structured plan and only occasionally was interrupted by one or more girls who wanted to talk about one subject in particular.

4. *Informal discussions* These were carried out with large numbers of girls, approximately 50 per cent of the 13–15-year-olds who attended the club, i.e. almost eighty girls. In fact these sessions proved to be the most successful of all the procedures used. Taping could provoke stiffness and formality or fooling about but when the girls did not feel they *had* to answer questions and say the right thing they were much more forthcoming. Moreover, on these occasions the girls themselves initiated the discussions, often when they had nothing else to do, and their conversations could easily be recorded by note-taking.

5. *Diaries* Ten girls kept a diary, listing exactly what they did at school, at home and in their leisure time every day for one week.

6. *Informal discussions* These were carried out with one teacher and three youth leaders.

Mill Lane is a large housing estate situated in South-west Birmingham. It consists of fourteen-storey tower-blocks and four-storey maisonettes. The majority of adult males living on this estate, which was completed in 1967, are employed either directly or indirectly in the car industry. The youth club was opened in 1970 and has an annual membership of approximately 500 youngsters with the girls constituting almost half of this figure. The majority of girls who took part in the study had mothers who worked, most of them in part-time or shift work. They all expected their daughters, by the time they were 14, to cook the family meal regularly, in return for which they were given £1 to £1.50 per week pocket-money.

The girls accepted this task without complaining. They did not

see it as a burden, and performed it quite willingly, recognising that it won them their freedom each evening. In the summer this meant spending each night out-of-doors, hanging about on the youth-club walls, listening to music, or watching the boys play football. Occasionally this pattern was interrupted by baby-sitting, or by bad weather (in which case they moved back into the club premises). Thus, during the hot weather the club was quite empty except on disco night. In winter this pattern was reversed and the club became a second home. On those nights that it was not open to them the girls were very much at a loss for something to do. The choice lay between staying in, going round to somebody's house, visiting an elder married sister, aunt, or cousin, or baby-sitting. Parents encouraged the girls not to wander the streets and indeed few seemed inclined to do so. They preferred the warmth and comfort of the club and it was here that their culture took shape. Unlike the boys who played table-tennis, snooker, football or volley ball, the girls were reluctant to take part in any sport. They preferred to sit about watching the boys play. Yet despite this unwillingness to participate, the club was strangely theirs. Their presence was indelibly stamped on the place, if only because they were always there, invariably doing nothing except hanging about, talking in groups of two, three or four, listening to records or flicking through magazines.

In fact this made it more difficult to gain entry as a researcher. The groups exuded an air of self-reliance. From the outside they seemed to be exclusive coteries whose membership fluctuated little over the period of investigation. Participant observation invariably poses problems in its initial stages, so it was not surprising that these problems were experienced even more acutely in this study. It was particularly difficult to make contacts and win the girls' confidence on an informal basis, and this did seem to have something to do with the ways in which the girls formed groups and passed their time sitting round the record-player. But more than this, it was clearly related to the girls' own self-images and the views they held of women in general. For example, throughout the period of research, in discussion and interview, the girls continually referred to women in terms of their place in the family:

'My engaged cousin, you know, the one I told you about before who got a ring off him when she was just turned 14.'

Jill

'My aunt – the one that's got three kids . . .'

Sharon

'My sister's been married for three year now and hasn't had a baby yet'

Chris

In contrast to this, men would be described in occupational terms:

'That boy down our way, the one that's in the Army . . .'

Debbie

'. . . but it's important that a boy gets a good job 'cos he's the one that's got to support you.'

Sally

and where women were 'known' in a similar capacity, they were invariably middle-class figures of authority – teachers, careers advisors, social workers and so on.

Not surprisingly a researcher, coming from outside the area, would automatically be categorised with this group despite attempts to be friendly and informal. What I am suggesting here is that, it *seems* that it is more difficult for a woman to be 'one of the girls' in this situation, than for a similarly aged male researcher to be 'one of the boys'. Another leader's experience in Mill Lane certainly bears this out. Anxious to build up a good relationship with the girls she tried to hang about with them and even dared to dance at the disco. The girls rightly saw this as an infringement of their private territory and made their hostility clear, so that eventually the woman in question gave up. The male leaders experienced no such difficulty in participating in the boys' activities.

It took a month of continual interaction and discussion before the girls finally stopped calling me 'Miss'. Eventually they

adopted the more informal first-name form with which they addressed the youth leaders. But this was clearly a result of my decision to adopt the persona of an unofficial youth leader. By serving coffee or by doing the cloakroom it was easier to talk to them than by simply hanging around. Yet suspicion did seem to be a general hallmark of their culture:

'The girls have been like that here ever since I started, and that was over two years ago now. Sometimes you get to know them quite well, at least you think you do. They tell you about their mum and dad and that. Then the next day they'll walk straight past you and give you a filthy look if you go up and ask them how they are. Likes of Kim over there, the coloured girl. One night she'll come rushing up to you begging a fag and telling you everything . . . The next day she'll give you a filthy look, doesn't want to know you.'

Evelyn, Youth Leader, aged 26.

Certainly for the club leaders the girls did constitute a problem. They refused to participate in organised games and the youth leaders saw it as a victory if they managed to involve them in any activity at all:

'I can't believe it, I actually got Allison and Sue to join in a game of table tennis. I don't know what came over them. Couldn't believe my eyes.'

Chris, Youth Leader, aged 30

As a researcher it did not take long to learn what not to do. It was important to observe discreetly, since looking was seen among the girls as a sign of aggression, and it was crucial to avoid talking to them on disco night when their energies were directed towards dancing, or towards the one or two boys who hung around in the corners.

Despite the fact that all the mothers and other older women in their community worked, they were known and understood, in terms of their domestic role. This indicates clearly that the girls implicitly accorded greater importance to this family role, than to any other. Their own culture, superficially, seemed to

display elements of cliquishness, insularity, and exclusiveness and this was compounded by their marked unwillingness to participate in any official organised activities. They rejected wholesale the 'team spirit' of the youth club:

> 'I must say I can't be bothered with the girls here. They're no use. You book a coach and arrange a trip to London. And not one girl puts her name on the list. I've never had a girl come on a day trip with me yet.'

> *Mike*, Youth Leader, aged 28.

These features are not unique to the Mill Lane Club. According to official youth reports they are typical of girls' behaviour in clubs up and down the country: 'There has been a tendency to locate the difficulty in catering for girls as a "problem" residing within the girl who is seen as having no interests, passive and unclubbable.'[6] But the problem of girls, frequently raised at youth leaders' conferences, is usually left unresolved.[7]

This feminine form of intransigence pervades every part of the girls' social lives and becomes a dominant mode of response to those outside their own culture. But it cannot be reduced to a simple reflex. Rather it is a complex cultural response, not an unqualified expression of opposition and resistance. It is a sign of boredom and of dissatisfaction which is articulated in a policy of quiet non-cooperation. The girls take part in these actions by elevating out of all proportion a distinctly feminine ideology. They prefer fashion, beauty and 'female' interests to the team spirit of the club. That is, their culture finds expression partly in and around the commodities focused directly on the teenage market where the interest is solely on aspects of femininity. They prefer these to the official youth club 'activities'.

But their immersion in what seems to be an overwhelmingly conservative, and traditionally female kind of culture is not simply a matter of choice. The girls have been directed towards this from early childhood. Moreover, their preferences are not so unproblematic. Adolescence for girls involves coming to grips with the demands of womanhood and with an emergent sexuality. Without doubt the most interesting moments in the research occurred when this process of individual and collective 'working

through' was revealed. Pop or commercial culture clearly has the advantage here because it at least confronts these issues. The school, in contrast re-defines sexuality as human biology and the club outlaws it altogether.[8] In each case the girls are left without any real source of support or advice and have to fall back on each other, and their 'teen' magazines.

Within the group of girls of similar ages attending the same school and youth club, there was no visible evidence of any sub-groups which set themselves apart from the mass of girls. Instead what was remarkable was their apparent homogeneity of style and appearance. The girls seemed quite happy to adopt whole-sale those images constructed in the market-place and presented to them as commodities. Yet despite this conformity and conventionality in dress the girls did make some attempt to invest these commodities with added cultural meanings. This was quite clear in the way they wore the school uniform. It was not that they flamboyantly broke the rules by wearing jeans or by smoking ostentatiously in uniform. Instead they merely 'expanded' the uniform to allow it to carry additional and implied connotations which to a certain extent worked in opposition to those traditional meanings already embedded in its 'uniformity'. This was done by buying the same clothes for school as they would for their leisure-wear except for the colour which transformed it, at least officially, into a uniform (i.e. mid-calf-length skirt, little 'tank' top or jumper, platforms and, completing the image, a shopping bag for carrying books).

By managing to make the uniform at least compatible with, if not indistinguishable from, what was currently fashionable, the girls could register their femininity in the classroom and even compete with the female teachers who were invariably ranked according to the style of the moment.

'We like Miss Jones. She wears ever such nice clothes. And her hair's nice as well.'

Caroline

Underpinning this was a clearly articulated demand that they be taken seriously not as children but as women. They were asserting that whereas at school they might be forced to wear a uniform

this did not mean they would be forced to abandon their 'grown-up' feminine appearance. And by bringing fashion clothes and make-up into the school, they were *gently* undermining its principles and indicating that they did not recognise the distinction between school and leisure. Symbolically at least, the school was transferred into an extension of their social life. And so, although the girls in this sample did not form themselves into youth subcultures, this is not to say that they were incapable of bestowing symbolic and additional meanings over and above those already built into the signifying systems which surrounded them.

School, family, leisure

What I want to look at now is the way in which the girls experience the school, the family and the youth club. The assumptions upon which this is based, is that each of these institutions attempts to mould and shape their subjects' lives in particular ways. One of their central functions is to reproduce the sexual division of labour so that girls come willingly to accept their subordinate status in society. This work is done primarily through ideologies which are rooted in and carried out in, the material practices specific to each of these institutions. The question here is how successful are they? To what extent do the girls concede to these ideological offensives and how do they respond to their demands?

The fact is that there is no simple answer. From the evidence of this piece of work, it can be argued that there is no mechanical acceptance of these ideologies on the part of the girls. This is not to say that their culture is one of opposition and resistance. Rather they do not accept *unquestioningly* the 'careers' mapped out for them. Althusser's claim that the ideological state apparatuses ensure 'subjection to the ruling ideology' is not so unproblematic.[9] For example, the girls' existence within them and experience of them, was clearly more a matter of 'gentle' undermining, subtle redefinition and occasionally of outright confrontation.

The school

The work of the school is not merely to reproduce skills, knowledge and abilities. It is also to inculcate values and ideals which are related to, and part of, the dominant ideology. Although these are, to all extents and purposes, invisible – that is, they are buried within the material practices of the school – none the less they do provide the school and the whole educational edifice with its rationale.

Working-class girls are taught to look forward to a 'feminine' career in the home. The pressures which are exerted on them particularly in the mass media, make contradictory demands, so that as they approach puberty and during the years of adolescence, working-class and middle class girls alike, begin to under-achieve, as 'romance' and boys take on an increased importance.[10]

But school ideologies are always being questioned and countered by both pupils and teachers. Although the working-class girls in this sample opposed the authority and discipline of the school, they accepted unquestioningly their traditional female roles within it. They had no objection to doing needlework or cookery rather than metal-work. In their eyes, both were equally boring. There is a conflict therefore between the school's definition of the female role and the girls' own conception of it. They use this unofficial and informal definition to oppose the oppressive structures of the school individually and collectively.

'We had this system. I would pay attention for 10 minutes and Joan. . .'

Liz

'I'd have that 10 minutes off. Then we'd swop. That way it passes quickly.'

Joan

In answer to the question 'What do you do in this time off?', the same girls replied:

'Nothing – I dunno' nothing much.'

Liz

'Carve names on my desk. Anything that comes into my head. Then when I've done that I start writing on my plimsolls.'

Joan

'Stare out of the window, comb my hair under the lid of my desk. That gets the teachers mad. Looking in my mirror.'

Liz

The girls rejected the school without violently confronting it. They preferred to sit about the school lavatories and have a smoke rather than play truant, which simply meant hanging about in the cold. By building up strong supportive networks of friends, the oppressive features of the school were minimised. Occasionally when something happened or when one teacher 'had it in for' a girl, her friends would rally round and defend her:

'Well, like, two months ago there was a spot of trouble with Mrs Cleaver. She had it in for us, specially Susan. We said enough's enough. So we started to stare at her all the time, every time we saw her we'd all stare. I think it scared her off.'

Ann

Much of the girls' energies seemed to be channelled into making school-life tolerable; somewhere they could 'have a laugh'. It was also the backdrop against which they could chat-up boys and develop new friendships with other girls. In the school they created their own, admittedly small, space; in the lavatories, the corridors, the stairways and the classrooms.

In answer to the question, 'What do you talk about at school?' most girls replied without hesitation, 'Boys', or 'What we've done the night before', and one girl expanded on this:

'Boys – pop stars – getting married. The future. I think most of my friends want to get married pretty soon y'know. Quite soon after they leave school. So we talk about that. We imagine what it'd be like.'

Fiona

The girls showed no interest in discussing their school subjects which were obviously of minimal importance to them. They did, however, seem to have a marked preference for English, which was expressed only after some degree of probing:

> 'We done D. H. Lawrence. I remember 'cos I liked that. What was the name of them poems we did with Mrs. Roberts about love and being on a bus-journey? They was good.'

> *Carol*

What seemed more telling was the way they collectively rated the teacher on the grounds of her personality and attractiveness:

> 'Miss Nicholls – "Janie" we call her – she's OK. Wears nice clothes. That kind of thing. She's the only teacher that wears things that are – the fashion.'

> *Rachel*

Their interest in 'feminity' did not, however, go unnoticed and one teacher described to me in some detail how she used her pupils' common interest in fashion, beauty and pop not only as a basis for developing a syllabus, but also as a means of control:

> Well, 4d is my worst class. There are some very naughty West Indian girls in it. So what I do with them is introduce them to ideas they're already familiar with, like, say, all the different ways you can do your hair. Then I suggest different kinds of fabrics and materials and get them to illustrate these styles on cardboard with wool and paper, that sort of thing.

She went on:

> Most of the girls are interested in pop so I get them to bring in photographs of their favourite stars, then we try to devise ways of . . .

But the results of this elicited only the following responses:

'I mean it's good to do things like that at first. But after a while it gets boring.'

Rachel

'It wouldn't be so bad if she let us play the radio. But she doesn't and she's always walking up and down seeing what you're doing. You don't get a moment to yourself.'

Carol

The 'trendy' teacher has then attempted to win them over with her feminity and interest in pop culture. She has assumed that their interests as women were *shared*, but the girls themselves realise that in fact their respective definitions of female culture and femininity are antagonistic.

'She's always on at you to tie your hair back and stand up straight. She talks to you like you was all babies. She's always saying how you shouldn't wear this kind of make-up.'

Rachel

Girls' tactics of silence, unambiguous boredom and immersion in their own private concerns have been commented on elsewhere:

Dumb insolence was always considered one of the most difficult crimes to define and punish; but today's teenagers have discovered another – truanting is relatively easy to deal with but lesson refusal can't effectively be dealt with by anyone . . . This hidden deviance . . . is restricted to urban schools and to a small minority of teenage girls. They come to school alright. It's warm there. You meet your friends. You can compare and swap clothes and gossip about last night's disco. They stand about the passages, wander round the field playground; take refuge if they want to smoke or even read, in the bogs. Teachers are irrelevant . . . The science master finds a couple of girls draped over the radiators in the passage outside his lab. 'Come on, girls', he says, 'you're not supposed to be in here.'

They look up at him and go on chatting and chewing gum.[11]

This description applies also to the Mill Lane girls. Talking was their favourite activity, and this included subjects like what to wear at a party, how somebody's sister's pregnancy is developing, what to do about parents and so on. Frequently a recent event would precipitate a whole round of discussion which would then be carried on for weeks at a time. During the period of research, for example, a 16-year-old girl got married and had to return to school until the end of term. The girls found her situation fascinating and talked about it endlessly:

'I mean I wouldn't like it for myself. But she's really happy. You can see it in her face. Last week I walked up to her and said "How's Billy?" Then I asked her what it's like to go to school and then go home to your husband. I mean it must be funny having to go home and get the dinner ready for him coming in.'

Jill

The fact that many of the girls themselves cooked the family meal was forgotten.

Finally, there was the way in which the school provided the girls with a social location within which they came to articulate 'class instincts'. Only in the school, did the girls come into contact with middle-class people. This included both teachers and the girls from the small area of private housing included in the catchment area. The automatic response of the working-class girls was competitiveness and thinly-veiled antagonism. 'They' were considered 'snobs' and were distinguished by their accents and their parents' wealth:

'You know them, "Daddy's got a yacht and we go sailing at the weekend", that's what they're like!'

Karen

This competitiveness was not fought out at the level of academic

performance or ability. Instead the girls saw it as themselves exposing the system for what it was, a complete waste of time. They enjoyed beating these girls and then disclaiming all interests in the competition, as the following incident demonstrates:

'Well it's a long story but see I was top of our class and so the head said I was to move up to the next class. When Linda's mum and dad found out they came up to see the head and said that their Linda was to move up as well. Anyway the head said no. She was to stay where she was. Well they went mad. Then I went to this other class and I really hated it. I missed me friends.'

Ray

'She cried every day for a week.'

Debbie

'It's true. I did. I wouldn't answer one question. And then they said I could move back down to be with my friends again. You should have seen Linda's face when I said I didn't like it there to her. I said I didn't like being up there with all the snobs.'

Ray

'The thing is, all of us here are really brainy. We know it. We don't need the teachers to tell us. But we like to have a good time. There's plenty of time to study when you're older. My dad would like me to study more. He wants me to get a good job. He's a shop steward and he's always telling me about his union and that. Getting me to read the papers. But I'm not interested now. I like going out every night. We like to have a good time at school. Play up the teachers, talk about the boys. They don't have any fun. I know they don't.'

Debbie

But this freedom is of course illusory. All it means is that, having worked for some hours in the home and after being at school all day, the girls were allowed to congregate in the youth club in the evening. If anything their middle-class peers had

fewer restrictions on their time and certainly had more opportunities to participate in a variety of leisure activities. They spent their evenings in an Arts Centre, doing drama, pottery, playing table tennis or watching films and it is most unlikely that they had to cook the evening meal.

In conclusion, the Mill Lane girls certainly did not conform to the rules and regulations set out by the school. Without resorting to violence in the classroom, or continual truancy, they undermined its authority. But they did this by elevating and living out their definition of 'femininity'. They replaced the official ideology of the school with their informal feminine culture, one which was organised round romance, pop, fashion, beauty and boys.

Family

All these interests indicate the importance of the family and domestic life for girls. School takes second place, even though marriage and what goes on in the home is often not the romantic idyll which teenage fiction leads them to believe. The girls recognised the home as a site of conflict, sometimes even of violence, but this did not stop them from being rooted in it, and all its daily melodramas. Family disputes, quarrels and violence merely led them to reflect all the more on its role and function:

'They've only been married for 6 months and he beats her up. If that's what it's like I don't want to know.'

Ann

Two sisters were puzzled by their elder sister's experience of married life:

'We all thought that Carol was just the one to get married. You know she'd keep a nice house that kind of thing. But I wouldn't have believed it. She's always hitting Dean and her house is a mess.'

Chris

Nonetheless it was here, rather than in the school, that the girls learnt a whole range of domestic skills. Cooking the family meal was recognised as a major responsibility and the girls assumed an air of self-importance when they talked about it. This status also accounted for the resigned but semi-indulgent way in which they complained about their brothers. After all, the home was 'naturally' their sphere:

> 'My brother doesn't do a thing in the house. He makes a mess and I clear up after him. He doesn't even make his bed. Waits for my Mum to make it when she gets back from her work.'

Maria

Apart from cooking and baking the girls also learnt a great deal about pregnancy, childbirth, and childcare. During the summer and at weekends they enjoyed taking babies and young children out for a walk and they kept a careful watch over their development. Their talk on these occasions was similar to that of any group of real mothers:

> 'He's coming on lovely isn't he? He'll soon be talking. They're lovely at that age, just beginning to do everything.'

Tina

This interest was compounded by their closeness to their mothers. Staying off school to look after an ill brother or sister was seen as doing her a favour, but it was also a sign of the girl's own maturity and responsibility. Mum stayed up waiting for her daughter to come in after a date or a party so that she could hear all about it. She also discussed with her such subjects as morality and the pill:

> 'My mum thinks its OK to be on the pill if you're engaged or you're just about to get married. She'd go mad if she thought I'd go on it just for anyone.'

Shirley

In general the girls went along with their parents' values. They

never went into town at night and were usually home by 10.30 each evening. They steered clear of local 'toughs' and avoided trouble with the police. Although they recognised that their mothers had unexciting, boring lives, and although they hoped not to duplicate exactly her experience, they envisaged themselves as married and as mothers:

> 'My mum never goes out. She stays in every night. Has her friends round or my aunts. I wouldn't want it to be like that. I'd want my husband to take me out a bit.'
>
> *Ann*

The glamour of having a child and the aura of importance which it bestowed upon the girl, was only partially disrupted by the recognition that it involved hard work:

> 'They have you on your feet all the time, never a break. I can see that with my sisters.'
>
> *Terry*

And this was, after all, rewarded by the pleasure of knowing that the child is well turned out.

Bad or negligent mothers were a common target of abuse. They were usually local girls who had got married young and had a child immediately:

> 'She's filthy. She really is. She won't change his nappy, she doesn't even use washing-up liquid. All his family know what she's like. He wants rid of her, he does.'
>
> *Wendy*

They accepted that following marriage 'he' would go out to the pub and that, as compensation, they would have their girlfriends round. In fact it was taken for granted that married couples did not spend much time together:

> ' "He goes his way and I go mine." That's how most of my

cousins are. They go out together now and then. I mean they take the kids to their nan's on Sundays. When I go round to baby-sit he's always going one place and she's going somewhere else.'

Lorraine

Since men worked during the day they had a right to spend their nights in the pub and this seemed to suit the girls who did not really like the thought of pub-going and claimed they would only go to find a boyfriend. They felt more comfortable in the home and, because they underestimated their mothers' work and their own future employment, they were quite prepared to accept that they would work in *two* spheres, although they hoped not to have to work in employment for too long after marriage:

'What most people I know do, is work for some things for the house and then after a year or so start a family.'

Debbie

Leaving home prior to marriage was out of the question, although the girls did, on occasion, threaten to run away. (Only one or two girls expressed a fleeting interest in travelling.) Leaving home meant, for them, moving into the married home and the more stifled or claustrophobic it was at home (sharing a bedroom with a sister, for instance) the greater was the desire to get married.

So, although the working-class girl may have few illusions about marriage it does still remain her destiny and being left single is an unambiguous sign of failure. As Mungham observes:

The girls themselves know full well what this meant. 'I've got this auntie – Auntie Elsie, she's ever so nice, but she never got married. So she misses out on a lot of things really. I mean she goes round with me mum and all the family and them, but – well – she just sort of has to watch. Know what I mean? I don't want to be like her.'[12]

Youth club

In a sense the girls would have been happy to transform the youth club into a home from home. The main point of tension in the youth club hinged round their unwillingness to participate and the fact that they were expected to do so. Their behaviour more or less forced the leaders into abandoning them and letting them do as they pleased. But this did give rise to hostility particularly amongst male leaders, as noted earlier.

Ironically, the sole activity which was thoroughly enjoyed by the girls was also the one to which the leaders were most opposed. To them, dancing was trivial, frivolous and incompatible with the aims of the club. More importantly, it was associated with potential immorality, a suspicion frequently voiced in the Youth Services:

> The activities girls say they like best, dancing and music, do not seem to be highly ranked by many in the Youth Service. The low rank assigned to dancing seems to be related to a distrust of potentially flirtatious encounters.[13]

Underpinning this distrust is a puritanical dislike of girls displaying their bodies in such an expressive way. This is, of course not surprising when we consider the religious, evangelical origins of the Youth Club movement. The early youth clubs were little more than platforms for moral training and until the present day, dancing has been seen generally as somehow dangerous:

> Modern ballroom dancing may easily degenerate into a sensuous form of entertainment, and if self-control is weakened with alcohol it is more than likely that it will do so, which might easily lead to unruly behaviour and not infrequently to sexual immorality.[14]

In fact the leaders, in this case, had little to worry about because no boys ever made an appearance on the dance-floor during the whole period of study. This is not, in itself, surprising. Cinema and public dance halls have traditionally been the two spheres of public leisure where women have always dominated. Robert

describing Salford in the 1920s considers the rituals surrounding mass dancing:

> Generally, men lined one side of the hall, women the other. A male made his choice, crossed over took a girl with the minimum of ceremony . . . when every available male had found a partner groups of girls either still flowered the walls or had paired themselves off in resignation to dance with each other.[15]

And Jules Henry comments on American high school dances:

> The procedure is generally for two boys to pick out a couple of girls that are dancing and cut in on them, each one taking a pre-arranged partner . . . Sam protested that Tony always wanted the prettiest girl and that he got stuck with the dog.[16]

Mungham in a recent piece on Mecca dance-halls goes further and describes the cruel ethos which dominates these rituals:

> the end-of-the-dance pick-up situation contains all the elements of a fascist universe. First choice is given to the best stock: physical excellence counts for much more than anything else. In this scheme of things the 'Plain Janes' have to make their own ways.[17]

But the Mill Lane girls managed to avoid these rituals by making the disco their activity alone. Wednesdays saw them dressed and made-up, lined up outside the club, eager and waiting to be let in. With a virtual absence of boys except for those three or four who hung about the coffee bar, the girls had no need to compete with each other. They did not feel self-conscious about dancing, nor did they need to adopt their more usual defensive strategies. In fact this was the one occasion when all the barriers were down. The girls were immersed in what was a thoroughly enjoyable activity. Much time and effort was spent in learning different routines to go with different records and the girls had perfected a number of styles to fit the different kinds of music the DJ played.

The whole atmosphere of the club was transformed on these evenings, when it was filled with loud music and the excited talk of the girls. Looking round the disco it was possible to isolate the different groups of girls by the way they looked and danced. On this night alone some older girls who – at least so they claimed – went dancing between four and five nights a week, turned up at the club. They wore more make-up and acted in a more sophisticated way than the younger girls who just wanted to look pretty. The majority of girls wore 'swirling' mid-calf skirts combined with 'tank tops' and 'platform' shoes, and the overall image was of extreme neatness. (The girls liked traditionally feminine clothes and wore frilled skirts and low-necked tee-shirts in the summer.) Skirts rather than trousers were their basic form of dress and their make-up consisted of blue eyeshadow, pink lipstick and powder.

This involvement in dancing represents one of the few opportunities which the girls had to participate in music. Dancing also consolidated their friendship groups so that the girls 'naturally' split into couples. There was also an element of fantasy evident in their dancing. Although they were perfectly happy to be dancing with each other and did not expect any boy to approach them – indeed would be surprised and shocked if someone asked them to dance – none the less it was clear that they were imagining what it would be like to be in a more romantic setting:

'There's never been boys here . . . still you can always live in hope! The boys round here think dancing's cissy, just for the girls. They've got to be drunk before they'd dance. Once you start going to pub discos, they come up and ask you to dance. After they've had a good few!'

Sally

Finally there was the physical distance and separation between the sexes in the youth club. This meant that interaction, when it did occur, inevitably had semi-sexual overtones, or at least that was how it was perceived. There was a great deal of laughing, joking and teasing in this respect, the kind that might be found in any similar context. What was lacking, however, was a common set of interests between boys and girls. There were no

activities in which they all participated spontaneously or 'naturally'. The use of space in the club was characterised by a sexual division of leisure.

Conclusions

The features mentioned above point to a series of anomalies or contradictions within girls' culture. While many of their concerns and interests were focused on boys and sexuality, in practice they set themselves apart from the boys. The reality of boys belonged to a later stage. This might be only a matter of months, but in the meantime a much more cohesive female culture based on friendship groups prevailed. Likewise in school, where they spent their weekdays all day with each other, sitting next to each other, hanging about at lunchtime together. They were *in* school but not *at* the school. It became their territory during the time spent there, but it was quickly forgotten when they got home. They found little in the school with which to identify actively. The ideas and values with which they preferred to identify were those of their mothers and other female members of the family. These were values which connected femininity with motherhood and the home. Although they also worked, many of their mothers were isolated in the home and did not have the leisure opportunities of their husbands or male relatives. The pleasure these girls got from each other and from hanging about in groups, the fact that these friendship patterns dominated their social and domestic lives at that moment in time, carried overtones, barely perceptible, that this was something which might not last. At a certain point the primacy of 'the couple' would demand that these feminine activities and rituals be given up. There was something of this in the excitement and pleasure of the weekly disco nights. This reflected exactly, many years after Richard Hoggart wrote about it, the 'brief flowering' of working-class girls, destined later to return to the much less public sphere of house and husband.[18]

Notes and References

1. A. McRobbie and J. Garber, 'Girls and Subcultures' in S. Hall and T. Jefferson (eds) *Resistance Through Rituals*, London, Hutchinson, 1976, p. 209. See also Chapter 1 of this volume.
2. See note 1. As noted in this piece, the problem was in coming to grips with the invisibility of girls in these formations. Did the researchers not *see* the girls because they were not really looking for them? Or were they, for various reasons, in fact absent from these groups?
3. R. Powell and J. Clarke, 'A Note on Marginality' in Hall and Jefferson (eds) *Resistance Through Rituals* p. 224.
4. J. Clarke, S. Hall, T. Jefferson, B. Roberts, 'Subcultures, Cultures and Class' in Hall and Jefferson (eds) *Resistance Through Rituals*, p. 10.
5. Ibid, p. 11.
6. J. Hammer and V. Marshall, *Girls and the Youth Service*, unpublished internal paper for the Youth Service.
7. This is at least partly because of the male focus in youth clubs which is compounded by the dominance of male youth leaders.

	Female	*Male*	*Total Work Force*
Youth/Community Workers	306	1564	1870
Community Centre Wardens	37	118	15
Joint Appointments	55	392	447
	398	2074	2472

Statistics from DES Register (31.12.73) reprinted in *Youth Servive 6* vol. 14, no 6 Jan/Feb. 1975. Titled 'Girls – a fair deal?' See also J. Hammer and V. Marshall, *Girls and the Youth Service*, especially, 'It is a poor youth club which does not offer at least football, plus tennis, darts, billiards, as the *basis* of its "activities" programme – whilst activities for girls (make-up demonstrations, good grooming – are about as unusual as the more obscure boys' activities (judo, weightlifting, basketball).'

8. That is to say, any display of affection or emotional attachment between the sexes was discouraged at Mill Lane. The leaders were pleased that no boys went to the disco because this meant that there was less possibility of sexual interaction.
9. L. Althusser 'Ideology and the State' in *Lenin and Philosophy and Other Essays*, London, New Left Books, 1971, p 163.
10. S. Sharpe *Just like a Girl*, Hammondsworth, Penguin, 1976.
11. 'Observations' *New Society*, January 1973.
12. G. Mungham 'Youth in Pursuit of Itself' in *Working Class Youth Culture*, G. Mungham and G. Pearson, London, Routledge & Kegan Paul, 1976.

13. J. Hammer, 'Girls At Leisure', an unpublished paper for the Youth Service.
14. B. Rowntree and G. Lavers, *English Life and Leisure*, Hammondsworth, Penguin 1951, p 282.
15. R. Roberts, *The Classic Slum*, Harmondsworth, Penguin, 1971.
16. J. Henry, *Culture Against Man*, Harmondsworth, Penguin, 1963.
17. G. Mungham, 'Youth in Pursuit of Itself'.
18. R. Hoggart, *Uses of Literacy*, Harmondsworth, Penguin, 1957.

4

The Politics of Feminist Research: Between Talk, Text and Action*

Forging a feminist culture

For feminists engaged in research; historical, anthropological, literary, sociological or otherwise, there is really no problem about answering the question, 'who do we do feminist research for?' Yet to state simply 'for women', is to obscure a whole range of issues which invariably rise to the surface in the course of a research project. Exactly how these issues are handled plays an important part in shaping the entire research procedure. That is to say, when a politics, its theory and aspects of its practice (in this case feminism) meet up with an already existing academic discipline, the convergence of the two is by no means unproblematic. Often the urgency and the polemic of politics, all the things about which we feel strongly and which we desperately want are quite at odds with the traditional requirements of the scholarly mode; the caution, the rigour and the measured tone in which one is supposed to present 'results' to the world. Frequently we worry about the extent to which we, unwittingly, impose our own culture-bound frame of reference on the data, and about how, so often, our personal preferences surface, as though by magic, as we write up the research.

My emphasis in this article is on a particular type of research, namely 'naturalistic' sociology, that branch of sociology which was, in many ways, appropriated by left academics in the early 1960s, and refashioned so as to become a kind of front line. Here accounts of how (mostly) working-class people made sense

*First published in *Feminist Review*, No 12, October 1982.

of their lives, jostled alongside the (often tortured) attempts of the sociologist as he too made sense. In fact this kind of sociology had a strong 'multicultural' heritage. It borrowed the term 'ethnography' from social anthropology; its methods, particularly 'participant observation', were strongly influenced by American sociologist Howard Becker; and its political force owed much to the work of E. P. Thompson and his 'history from below'. That is, the everyday histories of class resistance which mainstream 'History' otherwise condemns to silence. In fact feminist ethnographic sociology owes a great deal to this socialist tradition. What I want to single out for special attention here is the question of doing research *on* or *with* living human subjects, namely women or girls. But first some points which may well seem surprising but which I think warrant renewed attention.

In this country we take it very much for granted that research is based in and around the universities. Funding for research, regardless of where it comes from (the SSRC, DES, DHSS, EOC or the EEC) is almost invariably channelled through institutions of higher education. This means that, unlike in say West Germany, where research money is more often linked with grass-roots projects, feminist research here has had a strongly academic rather than a practical bias. I shall be arguing against precisely this kind of distinction later – but I want to stress that insofar as such a division does exist, its results have been by no means negative.

For a start, an increasingly large number of women students have been, over the last few years, enrolling for higher (post-graduate) degrees – all of which entail the setting up of a research project. Slowly this has generated a feminist 'intellectual' culture, or to put it another way, a strongly feminist critique has found its way into the orthodoxies of sociology, history, psychology, politics and so on. Feminist research networks have been set up nationally, as have resource centres. Research-oriented groups, initially academically based but open to all women, meet regularly, and of course it is within this context that the journal *Feminist Review* must also be seen. At the risk of seeming over-simplistic, I think it is worth stating that possibly the most important achievement in these developments within the system of higher education, has been precisely the revealing of some of women's hidden oppressions – both past and present. Nor do

the positive aspects of this drift towards educational establishments stop short at the point of producing interesting and politically valuable research. They also concern the way in which often 'mature' women – teachers, social workers and probation officers – are making use of the space which a period of time in education provides, in order to think through all those problems which tend to get dealt with automatically or hurriedly in the work situation. Gill Frith, an English teacher in a Coventry comprehensive school, for example, used her sabbatical year to consider more fully the sexual politics of teaching literature and – among other things – produced a definitive account of the way in which sexism pervades every aspect of literature teaching, from the choice of contents of the texts, to the achievements of the pupils (Frith, 1981).[1] Already this article is being consulted by other teachers grappling with the same problems. My own work on girls grew out of a commitment both to feminist politics in 1974, and to the value and usefulness of sociology as a discipline. I was also interested in 'history from below' and on how working people experience directly their own situation. My concern was with the way girls experienced all the pressures imposed on them to aspire to a model of femininity and how they lived this ideology on a day-to-day basis (McRobbie, 1978).[2]

But what is missing from all these research initiatives is the kind of locally-funded social-policy-oriented projects found in almost every German city and town. Living in Germany and meeting many women involved in this kind of work certainly forced me to think more critically about the way we do our research here, particularly the way in which research has not really been able to feed into strategies in the community, the school, the workplace, and so on. It is true that these projects in West Germany (women and girls in relation to drugs and drug addiction, action research on street prostitution, women in prison, etc.) have often lacked a rigorous theoretical framework, but this is more than compensated in terms of the visible achievements. Four years of intensive local work with girls from disadvantaged social backgrounds, by a group of women in West Berlin, has resulted in their being given, by the local council, a huge hundred-roomed tenement to be restored in order to provide long-term housing for women and girls. The Women's House in the Potsdamer Strasse is already much more than a

refuge or a hostel. In it prostitutes, delinquent girls, and battered wives mix with each other and with the women who set it up and who are increasingly able to play a much less directive role. However this is also, officially, a research project. It has strong links with the University – offering places to women's students, as well as having connections right through the network of local government. And its women workers are all involved in writing up annual reports, articles and proposals for further funding.

Wild strategies

No research is carried out in a vacuum. The very questions we ask are always informed by the historical moment we inhabit – not necessarily directly or unambiguously, but in more subtle ways. The terms within which we set up a project will most likely reflect, among other things, the current level of debate and argument within the Women's Movement. Because in so many ways British feminism grew out of a left legacy and, in academic terms, out of a Marxist social-science tradition, for a long time the key question hinged on the relation between capitalism and patriarchy. The aim of so many studies carried out in the 1970s was somehow to show definitively how the two were linked to each other – with both shouldering equal responsibility for women's oppression. Not only was such a search often fruitless, but there was clearly a desperate edge to it, as though this engagement was somehow necessary for women researchers to prove their intellectual credibility. I certainly capitulated to such pressure and went to great lengths to grapple with both class and gender in my early study of 14-year-old girls in Birmingham. I brought in class wherever I could in this study, often when it simply was not relevant. Perhaps I was just operating with an inadequate notion of class, but there certainly was a disparity between my 'wheeling in' class in my report and its almost complete absence from the girls' talk and general discourse. And this was something I did not really query. I felt that somehow my 'data' was refusing to do what I thought it should do. Being working-class meant little or nothing to these girls – but being a *girl* over-determined their every moment. Unable to grapple with this uncomfortable fact, I made sure that, in my account anyway,

class *did* count. If I had to go back and consider this problem now, I would go about it in a very different fashion. I would not harbour such a monolithic notion of class, and instead I would investigate how relations of power and powerlessness permeated the girls' lives – in the context of school, authority, language, job opportunities, the family, the community and sexuality. And from this I would begin once again, perhaps, to think about class. In many ways this marks exactly the shift which has taken place recently in feminist analysis; many radical feminist researchers have ditched class altogether, or else modified it out of recognition. One very positive result of this has been the space opened up to explore issues around class, rather than deal with it head-on. Recent feminist work has looked rather to the ways in which women are inscribed in unequal, passive and subordinate power relations – by the state, the law, and all those other spheres which have the ability to shape their subjects' lives for them.

Linked to this shift in priorities has to be our awareness of the changing function of research – the way it performs a vital role at certain moments, only to become outmoded the next (without of course being invalidated in the process). This happens when research is overtaken by events. For example, since the wide-scale setting up of girls' groups in schools and colleges, of girls' nights in youth clubs, of social work practice for girls and young women, the kind of research I did in 1975 is no longer reflective of gender relations in the school or in the youth service.[3] Research does not always have to be directly relevant or functional, but the chances are that we will nonetheless respond to current trends when we set up such a project. Thus in 1982 with massive youth unemployment, we are simply more likely to look to the meaning and consequences of unemployment for girls – than to seek out those girls *in work* and consider their situation. And yet I want to argue for the autonomy of research – it should not have to fit into agreed parameters of 'what is happening now'. Frequently the most exciting research flies in the face of convention; it asks new questions and applies wild strategies in a bid to force into action feminism's dynamic face. In retrospect now I can see how cautious I was in my own research initiatives. I was keen to be seen to be doing good sociology and I adopted often stilted and unhelpful tactics,

hoping to come up with the right kind of data. I walked a nervous tightrope between positivist social science (and thereby trying to be 'scientific') and the more radical naturalistic sociology with its emphasis on the flow of interaction between sociologist and subject. I did not feel comfortable with questionnaires and samples but I did not want to fall into the 'bourgeois individualism' of lengthy case-study-oriented profiles. At the same time I recognised that as a discipline sociology had a lot to offer and that many of its contemporary figures – Basil Bernstein and Stuart Hall, in Britain, and in America, Erving Goffman and Howard Becker had produced startlingly sensitive and intellectually rigorous work; work which could possibly provide a framework for looking at gender.

No longer is it necessary to define our research so tightly within an unreconstructed sociological framework. Feminism has changed the social sciences just as much as the social sciences have helped to form the frame of reference for many feminist projects. Equally, feminist writing outside academic social science has shown conclusively how feminist research can go beyond disciplinary boundaries without losing its drive and coherence.

From a feminist present to a feminist future

Research is historically located. This is true in terms of the questions it asks and the way it asks them. But how it is practised – and this includes all the social relations surrounding it – is much less clear. Many of its conventions – writing, archive work, interviewing or participant observant, and finally constructing arguments – go undiscussed or else are mystified as tricks of the trade. The points on which I want to concentrate here might seem simplistic and self-evident. Yet they continue to have real and complex implications for doing research.

Within feminism many of the resentments and hostilities between researchers and practitioners (youth and community workers, social workers and teachers) lie in the already existing division of labour where some skills and competencies are more highly regarded and carry higher status than others. Under this set of arrangements, those who have the privilege of 'stating'; those who write, those who discuss publicly and make pro-

nouncements – these women are frequently subjected to recrimination by other feminist activists. They are criticised for 'representing' a movement which has no such official representatives. They are also accused of participating in a sphere of 'male' intellectual discourses whilst others are working every day in the 'real world' of practical problems to which some sort of solutions have to be found.

In fact there are multiple problems raised by such a seemingly straightforward distinction. First there is the contradiction for women between the wish to gain themselves a career, a professional identity on a par with men and a right to earn their own living – whether as a university researcher or a community worker – and the more general feminist commitment to breaking down status hierarchies and changing the ways in which men have used their occupations as a way of competing with each other and of exercising power. Second, there is the problem of how we communicate. Which media do we use and on what terms? To maintain a continual flow of ideas, a cross-fertilisation of analysis and an ongoing exchange of descriptions, experiences and feelings, we need *words*. This may be in the form of rhetoric, feminist polemic or intellectual debate, journalism, research writing or official reporting. We need writing, printing, magazines, journals, pamphlets, books.

In the use of words, the tension arises between the anarchy and all-pervasiveness of talk and the order and formality of written words. We *all* talk, *all* the time. Few of us distil from all our discussions and arguments, the theories and analyses presented in print. Of course the two (talk and text) are absolutely interdependent. We know that to participate in the public sphere of politics, action goes hand in hand with the power of the written word. It is a vital part of attracting more women to the ideas of the women's movement and also of challenging the male dominance of the media, education, the law and all the other apparatuses of the State. We need words to 'speak' across institutions and structures and to address women (and men) both directly and through the medium of print, music or whatever.

The irony is that it is access to these very forms which have consistently been denied us. It is only recently that women have been demanding the right to acquire the skills necessary to communicate in this multiplicity of ways. This is a political struggle

in itself. It amounts to an attempt to break out of the confines of talk, which is a comfortable but ultimately restricting ghetto. It is a form, called 'gossip', where women have been located throughout history. However, it is a particularly contradictory route outwards from the privatised local sphere of feminism to full-scale engagement in the public sphere. We have had to set up our own publishing networks, film cooperatives, magazines, pamphlets and resource centres, and this process is never simply a matter of making a grab for the necessary raw materials. Rather it involves continual engagements with the State (often the provider of both funds and employment), with education, the commercial media and the culture industry. And this often means operating on their terms. We want and need these resources, but frequently they demand walking an uneasy tight-rope between capitulating to their established structures and values (it might mean becoming a 'star', a 'professional' an 'artist') and holding on to a commitment to those feminist values which oppose these statuses. If we are honest we probably want all of these things at once. In the meantime, we try to create a space to be effective and a work identity for ourselves, just as we try to democratise the structures which surround us in order to make them available for many more women and girls. Yet the distinction is made between those who are primarily involved in, and committed to, on the one hand 'the practical' and on the other 'the intellectual'. Women whose work involves periods of intense privatised labour, like writing, painting or reading, are seen as less committed than those who spend the entire working day, and often more, working with other women – battered women, delinquent girls, schoolgirls or isolated housewives.

So where do we meet? At what points are these disagreements overcome? I think it is when we recognise our shared interests. It is when our mutual dependence on each other is forced to the surface. A clear example is when a feminist project looks towards the future. Be it a hostel for runaway girls or setting up an older women's group in a community centre, its progress will be documented and charted, whether it is a resounding success or a dismal failure. If this is made available for wider circulation than only the women involved in setting it up, it can contribute to the 'noise' made by the women's movement, and to our effectiveness. These records – articles, reports and theses – make

the difference between a small-scale feminist present and a wider female future.

But it is important not to ignore the differences within feminism. At what point do the areas of contention and dispute arise, for example, in the passage from local to national or from the private to the public feminist sphere? Frequently dissension arises at the point of representing the particular project or intervention. The 'account' cannot be objective. It is a political product, its construction comprising a set of explicitly ideological moves. To put it briefly, *representations* are *interpretations*. They can never be pure mirror images. Rather they employ a whole set of selective devices, such as highlighting, editing, cutting, transcribing and inflecting. Regardless of medium, literary or visual, these invariably produce new permutations of meaning. From this perspective, it is understandable that researcher visiting a girls' project regularly and talking to the girls as a researcher, will come up with a different account of the girls and of the project, than would the full-time worker. This is intrinsically neither good nor bad, but it does have consequences that must be recognised.

Failure to recognise the partiality of any account can lead to acrimonious disputes over who has got it right. In such cases often the girls or women themselves are used as arbiters, thus shifting the responsibility in the name of 'letting the girls speak out' and the spurious authenticity attached to this idea. Here again I am questioning the idea that what they say is somehow 'pure' or 'definitive'. True, there is something direct, immediate and concrete about such an account, but the girls or women themselves are a part of the social relations of the project. And even then, recorded speech goes through a number of transformations before it reaches its readers. The fact that it is 'uncommented on text' carries particular connotations, seeming the more 'pure' the less it is edited. In this way the intermediary processes fade into the background and fail to be recognised for what they are: activities which are as ideologically loaded and as saturated with 'the subjective factor' as anything else. My points, in summary, are these. First there is no such thing as 'pure' printed speech. By acting upon speech, it is invariably shaped in one way or another. Second, this directedness is not necessarily a bad thing which we should try to wipe out as if it is evidence of 'bias'. There are a range of distinct political pos-

itions within feminism and we must recognise them and work from there.

But perhaps my account disguises the most sensitive issue at stake – that is, the nature of the relationship between the researcher and the researched, a relationship paralleling in its unequal power that of social worker and client, or teacher and pupil. Feminists have been particularly aware of the exploitative or patronising propensity of these relationships and have asserted continuously that we must avoid such possibilities at all costs. It has also been argued that our shared gender, anyway, cuts across other divisions, uniting us on at least some counts. More directly we have all witnessed the way in which male sociologists have patronised their working-class client populations. Often in the name of research they have produced highly romanticised, even exoticised accounts, but depart from the 'field' leaving behind them only confusion, distrust or straightforward bewilderment. Frequently we have suspected such commentators of prioritising 'intellectual work' – the eventual book, or even the *a priori* theory and its fit with the material – over the politics of the situation they leave behind. We have, in short, accused them of flirting with working-class culture from the comfort and safety of the university environment. There has never really been any doubt about their status. A researcher is a researcher is a researcher and, we imagine, they have lost no sleep over their dealings with the school teachers, youth workers, social workers, and all those who mediate between them and their 'subjects'.

Feminist research which has concentrated on living human subjects has sought to subvert this academicism. Instead we have sought to treat our 'subjects' with respect and equality. We have studiously avoided entering 'their' culture, savouring it and then presenting it to the outside world as a subject for speculation. Feminism forces us to locate our own autobiographies and our experience inside the questions we might want to ask, so that we continually do *feel* with the women we are studying. So our own self-respect is caught up in our research relations with women and girls and also with other women field-workers. That said, feminism should not be taken as a password misleading us into a false notion of 'oneness' with all women purely on the grounds of gender. No matter how much our past personal experience figures and feeds into the research programme, we

the difference between a small-scale feminist present and a wider female future.

But it is important not to ignore the differences within feminism. At what point do the areas of contention and dispute arise, for example, in the passage from local to national or from the private to the public feminist sphere? Frequently dissension arises at the point of representing the particular project or intervention. The 'account' cannot be objective. It is a political product, its construction comprising a set of explicitly ideological moves. To put it briefly, *representations* are *interpretations*. They can never be pure mirror images. Rather they employ a whole set of selective devices, such as highlighting, editing, cutting, transcribing and inflecting. Regardless of medium, literary or visual, these invariably produce new permutations of meaning. From this perspective, it is understandable that researcher visiting a girls' project regularly and talking to the girls as a researcher, will come up with a different account of the girls and of the project, than would the full-time worker. This is intrinsically neither good nor bad, but it does have consequences that must be recognised.

Failure to recognise the partiality of any account can lead to acrimonious disputes over who has got it right. In such cases often the girls or women themselves are used as arbiters, thus shifting the responsibility in the name of 'letting the girls speak out' and the spurious authenticity attached to this idea. Here again I am questioning the idea that what they say is somehow 'pure' or 'definitive'. True, there is something direct, immediate and concrete about such an account, but the girls or women themselves are a part of the social relations of the project. And even then, recorded speech goes through a number of transformations before it reaches its readers. The fact that it is 'uncommented on text' carries particular connotations, seeming the more 'pure' the less it is edited. In this way the intermediary processes fade into the background and fail to be recognised for what they are: activities which are as ideologically loaded and as saturated with 'the subjective factor' as anything else. My points, in summary, are these. First there is no such thing as 'pure' printed speech. By acting upon speech, it is invariably shaped in one way or another. Second, this directedness is not necessarily a bad thing which we should try to wipe out as if it is evidence of 'bias'. There are a range of distinct political pos-

itions within feminism and we must recognise them and work from there.

But perhaps my account disguises the most sensitive issue at stake – that is, the nature of the relationship between the researcher and the researched, a relationship paralleling in its unequal power that of social worker and client, or teacher and pupil. Feminists have been particularly aware of the exploitative or patronising propensity of these relationships and have asserted continuously that we must avoid such possibilities at all costs. It has also been argued that our shared gender, anyway, cuts across other divisions, uniting us on at least some counts. More directly we have all witnessed the way in which male sociologists have patronised their working-class client populations. Often in the name of research they have produced highly romanticised, even exoticised accounts, but depart from the 'field' leaving behind them only confusion, distrust or straightforward bewilderment. Frequently we have suspected such commentators of prioritising 'intellectual work' – the eventual book, or even the *a priori* theory and its fit with the material – over the politics of the situation they leave behind. We have, in short, accused them of flirting with working-class culture from the comfort and safety of the university environment. There has never really been any doubt about their status. A researcher is a researcher is a researcher and, we imagine, they have lost no sleep over their dealings with the school teachers, youth workers, social workers, and all those who mediate between them and their 'subjects'.

Feminist research which has concentrated on living human subjects has sought to subvert this academicism. Instead we have sought to treat our 'subjects' with respect and equality. We have studiously avoided entering 'their' culture, savouring it and then presenting it to the outside world as a subject for speculation. Feminism forces us to locate our own autobiographies and our experience inside the questions we might want to ask, so that we continually do *feel* with the women we are studying. So our own self-respect is caught up in our research relations with women and girls and also with other women field-workers. That said, feminism should not be taken as a password misleading us into a false notion of 'oneness' with all women purely on the grounds of gender. No matter how much our past personal experience figures and feeds into the research programme, we

cannot possibly assume that it necessarily corresponds in any way to that of the research 'subjects'. And is it desirable that research should be predicated on the often shaky notion of 'shared femininity'? Or the equally problematic objective of breaking down all barriers between women? For example, our project may be based on 'the girls' but why should we assume that we can actually *do* anything for *them*? Is this not an immensely patronising stance? How can *we* assume *they* need anything done for them in the first place? Or conversely that we have anything real to offer them? What then are the objectives of feminist research? Who do we do it for? Is there a case for arguing that some research works more effectively and avoids being condescending by addressing itself to, making demands of and challenging the institutions, structures and those who inhabit them, and occupy positions of power within them?

Pushing this line of argument one stage further we can question the making of assumptions about feminism which need not necessarily fit. How relevant is the contemporary women's movement to 'ordinary' women and girls? If feminism is not an evangelical cause, then our research objectives can never be purely 'recruitist' – as though feminism naturally can solve all women's problems. We have to proceed much more cautiously – age, class, culture and race do create real barriers which have real effects. Invariably women researchers experience vast spaces between themselves and those they may be 'studying' – be they 15-year-old girl delinquents, or 70-year-old working-class militants reminiscing about their past lives. And this is precisely why research continues to be such an important feature of feminist struggle. We cannot possibly scrutinise, update and revise feminist politics without exploring all those regions inhabited by women who are socially and politically 'silent'. And there is no reason why this process of discovery has to be exploitative to its subjects – or that it has to be conceptualised with the aim of doing something for them. This is inevitably a premature and preemptive claim. Research should first of all be directed towards existing feminist assumptions and practice. If we are to have any relevance to women and girls outside the movement today we have to learn what they are thinking about and how they experience a patriarchal and sexist society. It is vital that these women speak back to *us* who are sometimes over-comfortably placed in

a cosy feminist culture – about *their* discontents. It may well be that a whole range of our favourite principles and practices would be undermined if not wholly dislodged as a result.

To summarise: I have been suggesting that research is a historically-charged practice; that it can never present more than a *partial* portrait of the phenomenon under study. I have also described how this fact often generates tensions within teams of women researchers, workers and teachers in terms of which 'account' is more or less accurate than any other – and in turn which version becomes official. Equally I have argued that whilst feminism ensures thoughtfulness, sensitivity and sisterhood, it cannot bind all women together purely on the grounds of gender. Such a cohesion would surely be spurious, misleading and short-lived. And indeed how are we to know that feminism, in its present form, is in itself a suitable instrument for overcoming all those obstacles which divide women? To make such a claim is to overload the potential of the womens' movement and to underestimate the resources and capacities of 'ordinary' women and girls who occupy a different cultural and political space from us – by virtue of *age, class, race* and *culture* – to participate in their own struggles as women but quite autonomously.

In the next section I will be dealing more explicitly with the kinds of academic and political issues which arise in the course of research. Right now I will conclude here by mentioning some of the labels and misconceptions about feminist intellectual work which linger on. First there is the implication that such work involves purely *mental* labour, unlike work with girls in a youth club or centre which is thoroughly practical and even *manual*. This division in many ways reflects exactly the means by which different sectors of the traditional male working class were set apart from each other – the more skilled labour aristocracy, who often aspired to white-collar non-manual positions, from the manual, unskilled workers. As popular mythology has it, women lecturers and researchers spend a lot of time thinking, reading, talking with their students and drinking coffee. On top of this there remain all the old connotations of élitism attached to intellectual work. All these images are quite ungrounded. If anything, women workers in institutes of higher education find themselves more involved in the very practical work of supervising, teaching, tutoring and interviewing than in many other fields. For a start

ceptably intrusive and nosy. One woman in Birmingham who was doing a short study of how girls read magazines found herself quite unable to ask the girls in question what their parents did for a living and what kind of house they lived in. Being female undoubtedly sensitises us to the discomforts and small humiliations which doing research can provoke. Sometimes indeed it does feel like 'holidaying on other people's misery'. This happened to me recently when I interviewed a 19-year-old women whom I had know for some time in Birmingham, and who had been brought up in care. I was almost enjoying the interview, pleased it was going well and relieved that Carol felt relaxed and talkative. Yet there was Carol, her eyes filling up with tears as she recounted her life and how her mother had died and how desperate she was to find some man who would marry her and look after her. In fact two weeks after the interview Carol tried to commit suicide; a misunderstanding between her and her boyfriend prompted it. She recovered, is still waiting for him to propose, is unemployed and well aware that her chances of a job are slender, hence marriage and children become all the more urgent.

Sociology does not prepare us for the humility of powerless women, for their often totally deferential attitude to the researcher. 'Why are *you* interested in *me*. I'm only a housewife?' Or else the surprise on the part of girls that any adults could be really interested in what *they* had to say, or indeed that adult women outside their immediate environment could be 'normal', might swear, be quite nice or interesting and lead exciting lives. Almost all feminist researchers have reported this sense of flattery on the part of the women subjects, as though so rarely in their lives have they ever been singled out for attention by anybody.

Of course this also relates to the way that 'ordinary' people, men and women, are excluded from the public sphere, from the world of politics, of participation, of decision-making and of making news rather than just watching it. And it is in this context that we can understand the football 'hooligans' and 'rioters' of 1981 carrying with them, as a kind of emblem of their fame and notoriety, press photographs of themselves throwing a brick at the police, or putting the boot in another skinhead. These mementoes are highly treasured. They are symbols of a momentary

if fleeting engagement with society rather than a simple consumption of its goodies.

To those on the outside 'feminism' and 'research' represent precisely this more powerful arena. Funded by the state, representatives of higher education, well-spoken, self-confident and friendly as well, many women academics might as well be Martians. Unpleasant though it may be, we have not only to recognise this unequal distribution of privilege but also to draw out its consequences. Could it be that women are often such good research subjects because of their willingness to talk, which is in itself an index of their powerlessness? That, unlike men, they are never too busy. They can never *not* spare a moment, they never have such a pressing appointment, other than getting on with the housework or picking up the kids from school. And that even when interviewed in the workplace, they are more likely to squeeze in a quick chat with the researcher who is after all just doing her job? Or that, so used to caring for people, women are so bad at rejecting requests made of them to give themselves, are so bad at saying 'No, I'm sorry I'm not interested in talking to you.' And that class position also mediates in these patterns of deference and respect? After all middle-class career women are much more difficult to pin down for an interview than elderly cleaners and domestic servants.

This point is nicely illustrated in the recent work of Ann Oakley (Oakley, 1981).[6] In an extremely suggestive and stimulating study of women going through childbirth, Oakley shows vividly the limitations and absurdity of orthodox sociological methods. She quotes one source which warns the sociologist of being drawn into the research process in an unprofessional manner and then of being asked questions by the respondents who are, of course, only expected to answer questions. In this situation the researcher is advised to look puzzled, and say something like 'Well, that's a hard one!' and hope that the person in question is put off asking any more. Oakley shows just how patronising is this stance. She also shows how, were she to have adopted such a silent role, her research would have got nowhere fast. Not only did the women on whom she did her research continually present her with a barrage of questions, they also became her friends, invited her to visit after both the birth and the research, and in some cases formed long-standing friendships

with her. They also played an active role in the shaping of the research, discussing it in great detail as it was being written up.

But what I think Oakley fails to recognise is the way in which as a researcher she had everything going for her. At no time does she dwell on the question of their cooperation. She does not concern herself with the fact that pregnant, in hospital, often cut-off from family and relatives, the women were delighted to find a friendly, articulate, clever and knowledgeable woman to talk to about their experiences. Surrounded by distant and aloof doctors and over-worked nurses, their extreme involvement in the research could also be interpreted as yet another index of their powerlessness.

What does this mean? Are women better at oral history, because of their historic hegemony over talk? Is this kind of feminist research parasitic on women's entrapment in the ghettoes of gossip? Or is *our* way with words something we must celebrate, something which need not simply be indicative of our imprisonment, but something we can use as a weapon of political struggle, an armament where we have an unambiguous advantage over men?

And if all of this is the case, how can we mobilise around it? How can we make talk walk? Possibly only be being modest about our own importance both as *bona fide* feminists and as researchers, and by recognising both the value and the limitations of the kind of work we do. By hoping for ripple effects rather than waves of support. By arguing for the articulation between different forms of feminist practice rather than the intrinsic merits of one over the other. Research on women in this sense would be one of a set of involvements. Even if it only finds its way onto the reading list of Community Studies degree courses, this still does not mean that it has been a purely intellectual activity. Through talk, textual production and even translation, research can help to transform the relations which characteristically divide thinking from acting.

References

1. Gill Frith, 'Little Women, Good Wives: Is English Good for Girls?' in Angela McRobbie and Trisha McCabe (eds) *Feminism for Girls: An Adventure Story*, London, Routledge & Kegan Paul. 1981.

2. McRobbie, Angela (1978) (see Chapter 3 of this volume).
3. Ibid.
4. Willis, Paul 'Note on Method' in S. Hall *et al.* (eds) London, Hutchinson and CCCS.
5. R. Barthes *Image, Music, Text*, London, Fontana, 1980
6. Oakley, Ann, 'Interviewing Women: A Contradiction in Terms'. in Helen Roberts (ed.) *Doing Feminist Research*, London, Routledge & Kegan Paul, 1981.

5

Jackie Magazine: Romantic Individualism and the Teenage Girl*

Another useful expression though, is the pathetic appealing
look, which brings out a boy's protective instinct and has him
desperate to get you another drink/help you on with your
coat/give you a lift home. It's best done by opening your eyes
wide and dropping the mouth open a little, looking (hanging
your head slightly) directly into the eyes of the boy you're
talking to. Practice this.

Jackie, 15 February 1975

One of the main reasons for choosing *Jackie* for analysis is its
great success as a weekly magazine. Since it first appeared in
1964 its sales have risen from an initial average of 350 000 (with
a drop in 1965 to 250 000) to 451 000 in 1968 and 605 947 in
1976. This means that it has been Britain's biggest-selling teen
magazine for over ten years. *Boyfriend*, first published in 1959,
started off with sales figures averaging around 418 000 but had
fallen to 199 000 in 1965 when publication ceased. *Mirabelle*,
launched in 1956, sold over 540 000 copies each week, a reflection
of the 'teenage boom' of the mid–1950s, but by 1968 its sales
had declined to 175 000.[1]

The object of this study however, is not to grapple with those
factors upon which this success appears to be based. Instead it
will be to mount a systematic critique of *Jackie* as a system of
messages, a signifying system and a bearer of a certain ideology,

*A version of this chapter was first published as a CCCS Stencilled
Paper, University of Birmingham, titled '*Jackie*: An Ideology of Ado-
lescent Femininity'.

an ideology which deals with the construction of teenage femininity.

Jackie is one of a large range of magazines, newspapers and comics published by D. C. Thomson of Dundee. (Five newspapers in Scotland, thirty-two titles in all). With a history of vigorous anti-unionism, D. C. Thomson is not unlike other mass communication groups.[2] Like Walt Disney, for example, it produces for a young market and operates a strict code of censorship on content. But its conservatism is most evident in its newspapers. The *Sunday Post* with a reputed readership of around 3 million (i.e. 79 per cent of the entire population of Scotland over the age of 15) is comforting, reassuring, and parochial in tone. Consisting, in the main, of anecdotal incidents drawn to the attention of the reader in 'couthie' language, it serves as a Sunday entertainer, reminding its readers of the pleasure of belonging to a particular national culture.

One visible result of this success has been enviably high profit margins of 20 per cent or more, at all time of inflation and of crisis in the publishing world.[3] D. C. Thomson has also expanded into other associated fields with investments, for example, in the Clyde Paper Company and Southern TV3. Without adhering to a 'conspiracy plot' thesis, it would none the less be naive to imagine that the interests of such a company lie purely in the realisation of profit. In *Jackie* D. C. Thomson is not merely 'giving girls what they want'. Each magazine, newspaper or comic has its own conventions and its own style. But within these conventions, and through them, a concerted effort is nevertheless made to win and shape the consent of the readers to a particular set of values.

The work of this branch of the media involves framing the world for its readers, and through a variety of techniques endowing with importance those topics chosen for inclusion. The reader is invited to share this world with *Jackie*. It is no coincidence that the title is also a girl's name. This is a sign that the magazine is concerned with the 'category of the subject',[4] in particular the individual girl and the feminine persona. *Jackie* is both the magazine and the ideal girl. The short snappy name carries a string of connotations – British, fashionable (particularly in the 1960s), modern and cute. With the 'pet-form' abbreviated ending, it

sums up all those desired qualities which the reader is supposedly seeking.

This ideological work is also grounded on certain natural, even biological, categories. *Jackie* expresses the natural features of adolescence in much the same way as Disney comics capture the natural essence of childhood. As Dorfman and Mattelart writing on Disney point out, each has a 'virtually biologically captive predetermined audience'.[5] *Jackie* introduces the girl to adolescence, outlining its landmarks and characteristics in detail and stressing the problematic features as well as the fun. Of course *Jackie* is not solely responsible for nurturing this ideology of femininity. Nor would such an ideology cease to exist if *Jackie* disappeared.

Unlike other fields of mass culture, the magazines of teenage girls have not yet been subject to rigorous critical analysis, yet from the most cursory of readings it is clear that they too, like those other forms more immediately associated with the sociology of the media – the press, TV, film, radio – are powerful ideological forces. In fact, women's and girls' weeklies occupy a privileged position. Addressing themselves solely to a female market, their concern is with promoting a feminine culture for their readers. They define and shape the woman's world, spanning every stage from early childhood to old age. From *Mandy, Bunty, Judy* and *Jackie* to *House and Home*, the exact nature of the woman's role is spelt out in detail, according to her age and status. She progresses from adolescent romance where there are no explicitly sexual encounters, to the more sexual world of *19, Honey, or Over 21*, which in turn give way to marriage, childbirth, home-making, child-care and *Woman's Own*. There are no male equivalents to these products. Male magazines tend to be based on particular leisure pursuits or hobbies, motorcycling, fishing, cars or even pornography. There is no consistent attempt to link interests with age, nor is there a sense of natural or inevitable progression from one to another complementary to the life-cycle. Instead there are a variety of leisure options available, many of which involve participation outside the home.

It will be argued that the way *Jackie* addresses girls as a grouping – as do all the other magazines – serves to obscure differences of, for example, class or race, between women. *Jackie* asserts a class-less, race-less sameness, a kind of false unity which

assumes a common experience of womanhood or girlhood. By isolating a particular phase or age as the focus of interest, one which coincides roughly with that of its readers, the magazine is ascribing to age, certain ideological meanings. Adolescence comes to be synonymous with *Jackie*'s definition of it. The consensual totality of feminine adolescence means that all girls want to know how to catch a boy, lose weight, look their best and be able to cook. This allows few opportunities for other feminine modes, other kinds of adolescence. Dissatisfaction with the present is responded to in terms of looking forward to the next stage. In this respect girls are being invited to join a closed sorority of shared feminine values which actively excludes other possible values. Within the world of *Jackie* what we find is a cloyingly claustrophobic environment where the dominant emotions are fear, insecurity, competitiveness and even panic.

There are several ways in which we can approach *Jackie* magazine as part of the media and of mass culture in general. The first of these is the traditionalist thesis. In this, magazines are seen as belonging to popular or mass culture, something which is inherently inferior to high culture, or the arts. Cheap, superficial, exploitative and debasing, mass culture reduces its audience to a mass of mindless morons:

> the open sagging mouths and glazed eyes, the hands mindlessly drumming in time to the music, the broken stiletto heels, the shoddy, stereotyped 'with it' clothes: here apparently, is a collective portrait of a generation enslaved by a commercial machine.[6]

Alderson, writing explicitly on girls' weeklies takes a similar position. Claiming, correctly, that what they offer their readers is a narrow and restricted view of life, she proposed as an alternative, better literature, citing *Jane Eyre* as an example.[7]

The problems with such an approach are manifest. 'High' culture becomes a cure for all ills. It is, to quote Willis, 'a repository of quintessential human values',[8] playing a humanising role by elevating the emotions and purifying the spirit. What this arguments omits to mention are the material requirements necessary to purchase such culture. And underpinning it is an image of the deprived, working-class youngster (what Alderson calls the

'Newsom girl') somehow lacking in those qualities which contact with the arts engenders. Mass culture is seen as a manipulative, vulgar, profit-seeking industry offering cheap and inferior versions of the arts to the more impressionable and vulnerable sectors of the population. This concept of culture is inadequate because it is ahistorical, and is based on unquestioned qualitative judgements. It offers no explanations as to how these forms develop and are distributed. Nor does it explain why one form has a particular resonance for one class in society rather than another.

The second interpretation has much in common with this approach, although it is generally associated with more radical critics. This is the conspiracy thesis and it, too, sees mass culture as fodder for the masses; the result of a ruling-class plot whose objective it is to keep the working classes docile and subordinate and to divert them into entertainments. Writing on TV, Hall, Connell and Curti describe this approach, 'from this position the broadcaster is conceived of as nothing more than the ideological agent of his political masters'.[9]

Orwell, writing on boys' magazines in the 1930s, can be seen to take such a position, 'Naturally, the politics of the *Gem* and *Magnet* are Conservative . . . All fiction from the novels in the mushroom libraries downwards is censored in the interests of the ruling class.'[10] By this logic, *Jackie* is merely a mouthpiece for ruling-class ideology, focused on young adolescent girls. Again, mass culture is seen as worthless and manipulative. Not only is this argument also ahistorical, but it fails to locate the operations of different apparatuses in the social formation (politics, the media, the law, education, the family) each of which is relatively autonomous, has its own level and its own specific material practices. While private sectors of the economy do ultimately work together with the State, there is a necessary separation, between them. Each apparatus has its own uneven development and one cannot be collapsed with another.

The third argument reverses both the first two arguments, to the extent that it points to pop music and pop culture as meaningful activities: 'for most young people today . . . pop music and pop culture is their only expressive outlet.'[11] Such a position does have some relevance to our study of *Jackie*. It hinges on the assumption that this culture expresses and offers, albeit in con-

sumerist terms, those values and ideas held both by working-class youth and by sections of middle-class youth. Youth, that is, is defined in terms of values held, which are often in opposition to those held by the establishment, by their parents, the school, in work, and so on. Such a definition does not consider youth's relation to production, but to consumption, and it is this approach which has characterised that huge body of work, the sociology of culture and of youth subcultural theory, and delinquency theory.

To summarise a familiar argument which finds expression in most of these fields: working-class youth, denied access to other 'higher' forms of culture, and associating these in any case with 'authority' and with the middle classes, turns to those forms available on the market. Here they can at least exert some power in their choice of commodities. These commodities often come to be a hallmark of the subcultural group in question but not exactly in their original forms. The group subverts the original meaning by bestowing additional implied connotations to the object thereby extending the range of its signifying power. These new meanings undermine and can even negate the previous or established meanings so that the objects comes to represent an oppositional ideology linked to the subculture or youth grouping, in question. It then summarises for the outside observer, the group's disaffection from the wider society. This process of re-appropriation can be seen in, for example, the 'style' of the skinheads, the 'mod' suit, the 'rocker' motor-bike, or even the 'punk' safety-pin.[12]

But this approach, which hinges on explaining the choice of cultural artefacts – clothes, records or motor-bikes – is of limited usefulness when applied to teenage girls and their magazines. They play little, if any, role in shaping their own pop culture and their choice in consumption is materially extremely narrow. Indeed the forms made available to them make re-appropriation difficult. *Jackie* offers its readers no active 'presence' in which girls are invited to participate. The uses are, in short, prescribed by the 'map'. Yet this does not mean that *Jackie* cannot be used in subversive ways. Clearly girls do use it as a means of signalling their boredom and disaffection, in the school, for example. The point here is that despite these possible uses, the magazine itself

has a powerful ideological presence as a form, and as such demands analysis carried out apart from these uses or 'readings'.

The fourth and final interpretation is the one most often put forward by media practitioners themselves. Writing on the coverage of political affairs on TV, Stuart Hall *et al.* label this the *laissez-faire* thesis:

> Programming is conceived, simply, as a 'window' on the campaign; it reflects, and therefore, does not shape, or mould, the political debate. In short, the objectives of Television are to provide objective information . . . so that they – the public – may make up their own minds in a 'rational' manner.[13]

By this logic, *Jackie* instead of colouring the way girls think and act, merely reflects and accurately portrays their pre-existing interests, giving them 'what they want', and offering useful advice on the way.

While the argument made here will include strands from the positions outlined above, its central thrust will represent a substantial shift away from them. What I want to suggest is that *Jackie* occupies the sphere of the personal or private, what Gramsci calls 'Civil Society' ('the ensemble of organisms that are commonly called Private').[14] Hegemony is sought uncoercively on this terrain, which is relatively free of direct State interference. Consequently it is seen as an arena of 'freedom', of 'free choice' and of 'free time'. This sphere includes, 'not only associations and organisations like political parties and the press, but also the family, which combines ideological and economic functions'.[15] and as Hall, Lumley and McLennan observe, this distinctness from the State has 'pertinent effects – for example, in the manner in which different aspects of the class struggle are ideologically inflected.'[16] *Jackie* exists within a large, powerful, privately-owned publishing apparatus which produces a vast range of newspapers, magazines and comics. It is on this level of the magazine that teenage girls are subjected to an explicit attempt to win consent to the dominant order – in terms of femininity, leisure and consumption, i.e. at the level of culture.

The 'teen' magazine is a highly privileged 'site'. Here the girls' consent is sought uncoercively and in their leisure time. As Frith observes, 'The ideology of leisure in a capitalist society . . . is

that people work in order to be able to enjoy leisure. Leisure is their 'free' time and so the values and choices, expressed in leisure and independent of work – they are the result of ideological conditions.'[17] While there is a strongly coercive element to those other terrains which teenage girls inhabit – the school and the family – in her leisure time the girl is officially free to do as she pleases. It is on the open market that girls are least constrained by the display of social control. The only qualification here is the ability to buy a ticket, magazine or Bay City Roller T'shirt. Here they remain relatively free from interference by authority. Frith notes that there are three main purposes for capitalist society with regard to leisure:[18] 1. the reproduction of labour physically (food, rest, relaxation); 2. the reproduction of labour ideologically (so that the work-force will willingly return to work each day); 3. the provision of a market for the consumption of goods, thus the realisation of surplus value.

While *Jackie* readers are not yet involved in production, they are already being pushed in this direction ideologically, at school, in the home and in the youth club. *Jackie* as a commodity designed for leisure covers all three points noted above. It encourages good health and 'beauty sleep', and it is both a consumer object which encourages further consumption and a powerful ideological force.

So, using *Jackie* as an example, we can see that leisure and its exploitation in the commercial and private sector also provides capital with space to carry out ideological work. Further, it can be argued that the very way in which leisure is set up and defined is itself ideological. Work is a necessary evil, possibly dull and unrewarding. But its rationale is to allow the worker to look forward to his or her leisure as an escape. That is, leisure is equated with free choice and free time and exists in opposition to work, which is associated with necessity, coercion and authority. In this sphere of individual self-expression and relaxation, the State remains more or less hidden revealing itself only when it is deemed politically necessary (for example at football matches and rock concerts; through the laws relating to obscene publications and through licensing and loitering laws, etc.)

Commercial leisure enterprises with their illusion of freedom have, then, an attraction for youth. And this freedom is pursued, metaphorically, inside the covers of *Jackie*. With an average

readership age of 10 to 14, *Jackie* pre-figures girls' entry into the labour market as young workers and its pages are crammed full of the 'goodies' which this later freedom promises. (*Jackie* girls are never at school, they are enjoying the fruits of their labour on the open market. They live in large cities, frequently in flats shared with other young wage-earners like themselves.)

This image of freedom has a particular resonance for girls when it is located within and intersects with the longer and again ideologically constructed 'phase' they inhabit in the present. Leisure has a special importance in this period of 'brief flowering',[19] that is, in those years prior to marriage and settling down, after which they become dual labourers in the home and in production. Leisure in their 'single' years is especially important because it is here that their future is secured. It is in *this* sphere that they go about finding a husband and thereby sealing their fate.

In pursuit of this image of freedom and of free choice it is in the interests of capital that leisure be to some extent removed from direct contact with the State, despite the latter's welfare and leisure provisions for youth. Thus a whole range of consumer goods, pop music, pubs, discos and in this case teen magazines occupy a space which promise greater personal freedom for the consumer. *Jackie* exists in this private sphere. The product of a privately owned industry and the prime exponent of the world of the private or personal emotions. Frith makes the point that, 'The overall result for capital is that control of leisure has been exercised indirectly, leisure choices can't be determined but they do have to be limited – the problem is to ensure that workers' leisure activities don't affect their discipline, skill or willingness to work.'[20] That is, capital needs to provide this personal space for leisure, but it also needs to control it. This is clearly best done through consumption. Hence ultimately State and private spheres do function 'beneath the ruling ideology' but they also have different 'modes of insertion' on a day-to-day basis, which, as pointed out earlier, in turn produce '*pertinent effects*'. There is an *unspoken* consensus existing between those ideologies carried in State organised leisure, and those included in *Jackie*. The former is typically blunt in its concern with moral training, discipline, team spirit, patriotism, allowing the latter to dedicate itself to fun and romance!

What then are the key features which characterise *Jackie*? First there is a lightness of tone, a non-urgency, which holds true right through the magazine particularly in the use of colour, graphics and advertisements. It asks to be read at a leisurely pace indicating that its subject matter is not wholly serious, and is certainly not 'news'. Since entertainment and leisure goods are designed to arouse feelings of pleasure as well as interest, the appearance of the magazine is inviting, its front cover shows a pretty girl smiling happily. The dominance of the visual level, which is maintained throughout the magazine reinforces this notion of leisure. It is to be glanced through, looked at and only finally read. Published at weekly intervals, the reader has time to peruse each item at her own speed. She also has time to pass it round her friends or swap it for another magazine.

Rigid adherence to a certain style of lay-out and patterning of features ensures a familiarity with its structure(s). The reader can rely on *Jackie* to *cheer her up, entertain her, or solve or problems each week*. The style of the magazine once established, facilitates and encourages partial and uneven reading, in much the same way as newspapers also do. The girl can quickly turn to the centre page for the pin-up, glance at the fashion page and leave the problems and picture stories which are the main substance of the magazine, till she has more time.

Articles and features are carefully arranged to avoid one 'heavy' feature following another. The black-and-white-picture stories taking up between 2½ and 3 full pages are always broken up by a coloured advertisement or beauty feature, and the magazine opens and closes by inviting the reader to participate directly through the letters or the problem pages.

This sense of solidness and resistance to change (*Jackie*'s style has not been substantially altered since it began publication) is reflected and paralleled in its thematic content. Each feature consists of workings and re-workings of a relatively small repertoire of specific themes or concerns which sum up the girls' world. These topics saturate the magazine. Entering the world of *Jackie* means suspending interest in the real world of school, family or work, and participating in a sphere which is devoid of history and resistant to change.

Jackie deals primarily with the terrain of the personal and it marks a turning inwards to the sphere of the 'soul', the 'heart'

or the emotions. On the one hand, of course, certain features do change – fashion is itself predicated upon change and upon being 'up to date'. But the degree of change even here is qualified – certain features remain the same, e.g. the models' looks, poses, the style of drawing and its positioning within the magazine and so on.

Above all, *Jackie*, like the girl it symbolises is intended to be looked at. This overriding concern with visuals affects every feature. But its visual appearance and style also reflects the spending power of its readers. There is little of the extravagant or exotic in *Jackie*. The paper on which it is printed is thin and not glossy. The fashion and beauty pages show clothes priced within the girls' range and the advertisements are similarly focused on a low-budget market, featuring principally personal toiletries, tampons, shampoos and lipsticks, rather than larger consumer goods.

This is how the reader looks at *Jackie*, but how is it best analysed? How does the sociologist look at the magazine? Instead of drawing on the well-charted techniques of content analysis, I will be using approaches associated with *semiology*, the science of signs. However, this approach offers no fool-proof methodology. As a science it is still in its infancy, yet it has more to offer than traditional content analysis,[21] because it is not solely concerned with the numerative *appearance* of the content, but with the messages which such contents signify. Magazines are specific signifying systems where particularly messages are produced and articulated. Quantification is therefore rejected and replaced with understanding media messages as *structured wholes* and combinations of structures, polarities and oppositions are endowed with greater significance than their mere numerative existence.

Semiological analysis proceeds by isolating sets of codes around which the message is constructed. These conventions operate at several levels, visual and narrative, and also include sets of subcodes, such as those of fashion, beauty, romance, personal/domestic life and pop music. These codes constitute the 'rules' by which different meanings are produced and it is the identification and consideration of these in detail that provides the basis to the analysis. In short, semiology is concerned with

the internal structuring of a text or signifying system, with what Barthes calls 'immanent analysis':

> The relevance shown by semiological research centres by definition round the signification of the objects analysed: they are examined only in relation to the meaning which is theirs without bringing on – at least prematurely, that is, before the system is reconstituted as far as possible – the other determining factors of these objects (whether psychological, sociological or physical). These other factors must of course not be denied . . . The principle of relevance evidently has a consequence for the analyst, a situation of immanence; one observes a given system from the inside.[22]

How then do we apply such an analysis to *Jackie*? Given the absence of any definitive rules of procedure – an absence which stems from the polysemic qualities of the image, ('It is precisely this polysemy which invites interpretation and therefore makes the imposition of one dominant reading among the variants . . . possible)[23] my approach is necessarily exploratory. First then, I will attempt to locate the more general structural qualities of *Jackie*. Having described the nature and organisation of the codes which hold it together, I will then go on to consider these separately in some detail although in practice they rarely appear in such a 'pure' form.

One of the most immediate and outstanding features of *Jackie* as it is displayed on bookstalls, newspaper stands and counters, up and down the country, is its ability to look 'natural'. It takes its place easily within that whole range of women's magazines which rarely change their format and which (despite new arrivals which quickly achieve this solidness if they are to succeed) always seem to have been there. Its existence is taken for granted. Yet this front obscures the 'artificiality' of the magazine, its 'productness' and its existence as a commodity.

Jackie is the result of a certain kind of labour which involves the implementation and arrangement of a series of visual and narrative signs. Its meanings derive from the practice of encoding 'raw material' (or re-encoding already-coded material) which results in the creation of new meanings. These new meanings depend upon the specific organisation of different codes all of

which in turn involve different kinds of labour – photography, mounting, framing, drawing, headlining, etc.

There is nonetheless, a real problem as to what constitutes raw material. It can be argued that any such material by virtue of its existence within a set of social relations is already encoded. But does 'raw material' refer merely to the material existence of 13–15-year-old girls? Or does it recognise that they have already been in constant contact with various ideologies since early childhood? That is, does it assume an already existing culture of femininity? I would argue that it is the latter which is the case. For raw material we can read that pre-existent level of femininity which both working-class and middle-class girls can hardly avoid. As part of the dominant ideology it has saturated their lives, colouring the way they dress, the way they act and the way they talk to each other. This ideology is predicated upon their future roles as wives and mothers. Each of the codes combines within it, two separate levels: the denotative – the literal – and the connotative. It is this latter which is of the greater interest to the semiologist, 'connotative codes are the configurations of meaning which permit a sign to signify in addition to its denotative reference, other additional, implied meanings.'[24] Connotation then, 'refers subjects to social relations, social structures, to our routinised knowledge of the social formation'.[25] And as Barthes comments, 'As for the signified of connotation, its character is at once general, global and diffuse; it is, if you like, a fragment of ideology'.[26] Codes of connotation depend on prior social knowledge on the part of the reader, observer, or audience, they are 'cultural, conventionalised and historical'.[27]

A large range of codes operate in *Jackie* (see Figure 1), but for present purposes I have identified four subcodes, and organised the study around them.[28] These are: 1. the code of romance; 2. the code of personal/domestic life; 3. the code of fashion and beauty; 4. the code of pop music.

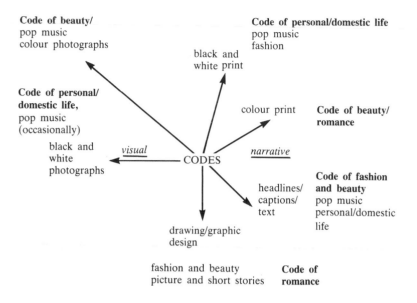

Figure 1 The codes operating in *Jackie*

The code of romance: the moment of bliss

> The hero of romance knows how to treat women. Flowers, little gifts, love-letters, maybe poems to her eyes and hair, candlelit meals on moonlit terraces and muted strings. Nothing hasty, physical. Some heavy breathing . . . Mystery, magic, champagne, ceremony . . . women never have enough of it.[29]

Jackie picture stories are similar in form to those comic strips, and tales of adventure, time travel, rivalry and intrigue which regularly fill the pages of children's weeklies. Yet there is something distinctive about these stories which indicates immediately their concern with romance. First, the titles clearly announce a concern with 'you, me, love and happiness'. Romantic connotations are conveyed through the relationship between titles and the names of 'pop' songs and ballads. *Jackie* however, does not use the older *Boyfriend* technique of using a well-known pop

song and its singer both to inspire the story and to give it moral weight!)

The title anchors the story it introduces. In our sample these include:

> 'The Happiest Xmas Ever',
> 'Meet Me On The Corner',
> 'As Long As I've Got You',
> 'Come Fly With Me',
> 'Where Have All The Flowers Gone?'

This concern with romance pervades every story and is built into them through the continued use of certain formal techniques and styles. For a start, the way the characters look indicates clearly that this is serious. They are all older and physically more mature than the intended reader. Each character conforms to a well-established and recognisable standard of beauty or handsomeness and they are all smart, fairly sophisticated young adults, rather than adolescents or teenagers.

The most characteristic feature of 'romance' in *Jackie* is the concern with the narrow and restricted world of the emotions. No attempt is made to fill out social events or backgrounds. The picture story is the realm, *par excellence*, of the individual. Each story revolves round one figure and the tiny web of social relationships surrounding him or, usually, her. Rarely are there more than two or three characters in each plot and where they do exist it is merely as part of the background or scenery – in the cafe, at the disco or in the street.

Unlike comic strips, where the subject is fun, excitement or adventure, these stories purport to deal with the more serious side of life – hence the semi-naturalistic style of the drawings and the use of black and white. This, along with the boldness of the drawings, the starkness of stroke and angularity of the figures, conspires to create an impression of realism and seriousness. The form of the stories alone tells us that romance is important, serious and relevant. Yet simultaneously in the content, we are told that it is fun; the essence and meaning of life; the key to happiness, etc. It is this blend which gives the *Jackie* romance its characteristic flavour. In general terms this is nothing new, these stories owe a great deal to popular cinema romances,

and to novelettes. The characters closely resemble the anony-mous but distinctive type of the film-star – dewy-eyed women and granite-jawed heroes. Their poses are equally soaked in the language of film – the clinch; the rejected lover alone by herself as the sun sets – the moon comes up – to name but a few. But this cinematic resemblance is based on more than just associ-ation. The very form of the comic strip has close links with the film. Strung together, in a series of clips, set out across and down the page – the stories rise to a climax and resolution, graphically illustrated in larger images erupting across the page.

From these clips we can see clearly that the emotional life is defined and lived in terms of *romance* which in turn is equated with great moments rather than long-term processes. Hence the centrality and visual impact of the clinch, the proposal, the wed-ding-day. Together these moments constitute a kind of orches-tration of time: through them the feminine career is constructed. The picture stories consist of a set of visual images composed and set within a series of frames laid out across the page to be 'read' like a text. But these frames communicate visually, resemble film-clips and tell the story by 'freezing' the action into sets of 'stills'. Unlike other comics (*Bunty* or *Judy*), *Jackie* stories do not conform to the convention of neatly mounted images set uniformly across the page. Instead, a whole range of loose frames indicating different kinds of situations or emotions are used. These produce a greater continuity between 'form' and 'content', so that as the pace of the story accelerates, the visuals erupt with the breathless emotional feelings, spilling out over the page.

Each separate image which makes up the story is 'anchored' with sets of verbal messages illuminating the action and climinat-ing ambiguity. This is necessary since 'all images are polysemic; they imply, underlying their signifiers, a "floating chain" of signi-fieds, among which the reader can choose a few and ignore the rest.'[30] But anchorage refers to only one part of the written message accompanying the image in the comic strip, i.e. the caption, title and statement of fact ('the next day', 'later that evening', etc.). The second function of the linguistic message here is 'relay'. Again quoting Barthes:

> words (most often a snippet of dialogue) and image stand in complementary relationship; the words like the images, are

thus fragments of a more general syntagma, and the unity of the message occurs at a superior level, the level of the story, anecdote, narrative . . . The two functions of the linguistic message can co-exist in an iconic group but the dominance of one or the other is not a matter of indifference for the general economy of the work . . . In some strips which are meant to be read quickly, the narrative is entrusted above all to the word, and the image gathers up the attributive, paradigmatic information (the stereotyped status of persons).[31]

Thus the moments of reading and looking are collapsed into one, and the reader is spared the boredom of having to read more lengthy descriptions; she merely 'takes it in' and hurries on to the next image. The techniques through which this relay operates are well-known – dialogue is indicated by the use of balloons issuing from the mouths of the speakers and filled with words, and thoughts are conveyed through a series of small bubbles which drift upwards away from the character's mouth – thinking being associated with a 'higher' level of discourse, an 'intellectual' pursuit.

The central and most dramatic incident in each story is specified by the spilling-out of one visual image over the page. This image sums up graphically the fraught nature of the moment; the moment when the timid shy heroine catches sight of her handsome boyfriend fascinated by her irresistible best-friend at a party to which she stupidly invited her: or when the girl, let down by her boy rushes out of the coffee bar across the street to be hit by a passing car . . . and so on.

Each frame represents a selection from the development of the plot, and is credited with an importance which those intervening moments are not. Thus the train, supermarket, and office have meaning, to the extent that they represent potential meeting-places where the girl could well bump into the prospective boyfriend, who lurks round every corner. It is this which determines their inclusion in the plot; the possibility that everyday life could be transformed into social life.

Within the frames themselves the way the figures look, act, and pose also contributes to the ideology of romance. For a start there is very little variation in types of physical appearance. This homogeneity hinges on a blend of modernity and conservatism

which typifies the *Jackie* look. The girls are 'mod' but neat and conventional, rarely are they 'way-out'. Boys may look acceptably scruffy and dishevelled by displaying a kind of managed untidiness.

The appearance is matched by language. Deriving seemingly from the days of the teenage commercial boom it has a particularly 1950s ring about it.[32] Bereft of accent, dialect, slang or vulgarity it remains the invention of the media – the language of pop, and of Radio 1 disc jockeys. Distinctly modern it is also quite unthreatening, peppered with phrases like: 'rave'; 'yacked'; 'zacked'; 'scrummy hunk'; 'dishy'; 'fare'; 'come-on, let's blow this place'; 'I'm the best mover in town' – all of which convey an image of youth 'on the move', of 'a whole scene going', and of 'wowee, dig the slick chick in the corner'; 'a nice piece of talent', teenagers 'doing their own thing'. But these teenagers are a strangely anonymous and unrecognisable grouping, similar only, perhaps, to the 'Young Generation' seen on TV variety shows or the young people in Coca-Cola or Levi Jeans advertisements. It is a language of action, of 'good times', of enjoyment and of consumerism. The characters in *Jackie* stories and in Coca-Cola TV advertisements at least seem to be getting things done. They are constantly seen 'raving it up' at discos, going for trips in boyfriends' cars, or else going on holiday. And yet, as we shall see, the female and male characters in *Jackie* are simultaneously doing nothing but pursuing each other, and far from being a pleasure-seeking *group* these stories in fact consist of isolated individuals, distrusting even their best-friends and in search of fulfilment only through a partner. The anonymity of the language, then, parallels the strangely amorphous *Jackie* girls. Marked by a rootlessness, lack of ties or sense of region, the reader is unable to 'locate' them in any social context. They are devoid of history. Bound together by an invisible 'generational consciousness' they inhabit a world where no disruptive values exist. At the 'heart' of this world is the individual girl looking for romance. But romance is not itself an unproblematic category and what I will be arguing here is that its central contradiction is glaringly clear and unavoidable even to the girl herself who is so devoted to its cause. This contradiction is based round the fact that the *romantic moment*, its central tenet, cannot be reconciled with its promise of *eternity*. The code of romance

realises, but cannot accept, that the man can adore, love, 'cherish' and be sexually attracted to his girlfriend and simultaneously be 'aroused' by other girls. It is the recognition of this fact that sets all girls against each other, and forms the central theme in the picture stories. Hence the girl constantly worries, as she is passionately embraced; 'can it last?' or 'how can I be sure his love is for ever?'

Earlier we asserted that *Jackie* was concerned with 'the category of the subject'.[33] with the constitution of the feminine personality. Indeed 'personality' itself forms an important organising category in the magazine. Each week there is some concern with 'your' personality, how to know it, change it or understand those of your friends, boyfriends, families.[34] In the picture stories 'personality' takes on an important role alongside looks. The characters depend for their meaning on well-known stereotypes. That is, to 'read' correctly the reader must possess previous cultural knowledge of the types of subjects which inhabit his or her social world.

Jackie boys falls into four categories. First, there is the fun-loving grinning, flirtatious boy who is irresistible to all girls; second, the tousled, scatterbrained 'zany' youth who inspires maternal feelings in girls; third, the emotional, shy, sensitive and even arty type; and fourth, the juvenile delinquent usually portrayed on his motor-bike looking wild and aggressive but sexy, and whom the girl must tame.

In every case the male figure is idealised and romanticised so that there is a real discrepancy between *Jackie* boys and those boys who are discussed on the Cathy and Claire page. The central point here is that *Jackie* boys are as interested in romance as the girls, 'Mm! I wish Santa would bring me that for Christmas . . . so how do we get together?' and this, as countless sociological studies, novels and studies of sexual behaviour indicate, simply does not ring true. Boys in contemporary capitalist society are socialised to be interested in sex although this does not mean they do not want to find the 'ideal' girl or wife.

Female characters, significantly, show even less variation in personality. In fact they can be summarised as three contrasting types. The blonde, quiet, timid, loving and trusting girl who either gets her boy in the end or is tragically abandoned; and the wild, fun-loving 'brunette' (often the blonde's best-friend)

who will resort to plotting and conniving to get the man she wants. This 'bitch' character is charming and irresistible to men although all women can immediately 'see through' her. Finally there is the non-character, the friendly, open, fun-loving 'ordinary' girl (who may perhaps be slightly scatty or absent-minded). She is remarkable in being normal and things tend to happen to her rather than at her instigation. Frequently she figures in stories focusing on the supernatural.

Most of these characters have changed little since the magazine first appeared in 1964. Their style is still rooted in the 'Swinging London' of the mid 1960s. The girls have large, heavily made-up eyes, pale lips and tousled hair, turned-up noses and tiny mouths. They wear clothes at least partly reminiscent of the 1960s, hipster skirts with large belts, polo-neck sweaters and, occasionally, 'flared' trousers. Despite the fact that several of these girls introduce themselves as plain, their claims are contradicted by the accompanying image indicating that they are, without exception, beautiful. Likewise the men (or boys) are ruggedly handsome, young versions of James Bond (to the extent that some even wear 1950s-style short raincoats with 'turned-up' collars). They have thick eyebrows smiling eyes, and granite jaws.

While some of the stories seem to be set in London, the majority give no indication of locale. The characters speak without an accent and are usually without family or community ties. They have all left school, but work hovers invisibly in the background as a necessary time-filler between one evening and the next, or may sometimes be a pathway to a glamour, fame or romance. Recognisable social backgrounds are rare. The small town – equated with boredom – is signified through the use of strangely anachronistic symbols – the coffee bar, the motor-bike and the narrow street. The country-side on the other hand, is where the girl escapes *to*, after a broken romance or an unhappy love affair. But when her problems are resolved, she invariably returns to the city where things really happen. But the city that these teenagers inhabit is strangely lacking in population. There are no foreigners, black teenagers, old people or children, no married couples and rarely any families or siblings. It is a world occupied almost solely by young adults on the brink of pairing-up as couples.

The messages which these images and stories together produce

are limited and unambiguous, and are repeated endlessly over the years. These are:

1. the girl has to fight to *get* and *keep* her man;
2. she can *never* trust another woman unless she is old and 'hideous' in which case she does not appear in these stories anyway;
3. despite this, romance, and being a girl, are fun.

No story ever ends with *two* girls alone together and enjoying each other's company. Occasionally the flat-mate or best-friend appears in a role as 'confidente' but these appearances are rare and by implication unimportant. A happy ending means a happy couple; a sad one – a single girl. Having eliminated the possibility of strong supportive relationships between girls themselves, and between people of different ages, *Jackie* stories must elevate to dizzy heights the supremacy of the heterosexual romantic partnership.

This is, it may be argued, unsurprising and predictable. But these stories do more than this. They cancel out completely the possibility of any relationship other than the romantic one between girl and boy. They make it impossible for any girl to talk to, or think about, a boy in terms other than those of romance. (A favourite story in both picture-form and as a short story, is the platonic relationship which the girl enjoys. She likes him as a friend – but when she is made jealous by his showing an interest in another girl, she realises that it is *really* love that she feels for him and their romance blossoms.)

Boys and men, then, are not sex objects but romantic objects. The code of romance neatly displaces that of sexuality which hovers somewhere in the background appearing fleetingly in the guise of passion, or the 'clinch'. Romance is about the public and *social* effects and implications of 'love' relationships. That is, it is concerned with impressing one's friends with a new handsome boyfriend, with being flattered by the attention and compliments lavished by admirers. It is about playing games which skirt about sexuality, and which include sexual innuendo, but which are somehow nicer, cleaner and less sordid. Romance is the girls' reply to male sexuality. It stands in opposition to their 'just being after the one thing', and consequently it makes

sex seem dirty, sordid, and unattractive. The girl's sexuality is understood and experienced not in terms of a physical need or her own body, but in terms of the romantic attachment. In depicting romantic partnerships, *Jackie* is therefore also constructing male and female roles ensuring that they are separate and as distinct as possible. They are as different as they look different and any interchange between the sexes invariably exudes *romantic* possibilities. What *Jackie* does is to map out all those *differences* which exist between the sexes but to assert that what they do *share* is a common interest – indeed devotion to – romance.

So far, I have outlined in some detail the organising principles around which this discourse (the picture-story) is structured. While I would not hold the separation of form and content as being either possible, or necessary, for analysis, there are a number of recurring themes which can be identified through a process of extrapolation from both the image and the accompanying text. Thus, temporarily holding constant the formal features of the picture-story; the 'balloon' form of dialogue; the action through 'relay'; and the style of illustration – we can go on to deal with the patterns, combinations and permutations of those stock situations which give *Jackie* its characteristic thematic unity.

The stories themselves can be categorised as follows:

1. the traditional 'love' story;
2. the romantic adventure serial:
3. the 'pop' special (where the story revolves around a famous pop star);
4. the 'zany' tale;
5. the historical romance.

But these story-types are worked through and expounded by the use of certain conventions or devices and it is through these that the thematic structure can be seem most clearly.

The convention of 'time' or of the temporal

Flashback Here the opening clips signify aloneness conveyed through images of isolation; a single figure against a rugged, beautiful, threatening, landscape. Along this same chain of signi-

fieds and following 'aloneness' comes the explanation – that is – 'alone-and-rejected-by-a-loved-one', or 'separated-from-a-loved-one'. Next comes the elucidation – what has caused such a state of unhappiness or misery, and this is classified and expounded upon through the use of the flashback – 'I remember only a year ago and it was all so . . .' 'But Dave was different from the others even then.' The reader is transported into the narrator's past and confronted with scenes of love, tenderness, excitement, etc. The difference between the past and present state is emphasised by changes of season, and particularly by changes of expression. Warm weather, for example, goes with smiling, happy faces gazing in mutual pleasure at one another.

From this point onwards different conventions intervene to carry the story along, and it is nearly concluded with a return to the present, and a magical or intentionally un-magical resolution. (The boy reappears, or does not reappear, or a new one takes his place. Through this device the reader is invited to interpret her life, past and present, in terms of romantic attachments – her life has meaning through him.)

The diary Again this allows the reader access to the innermost secrets of its writer, sometimes mediated through a guilty best-friend reading her friend's outpourings.

History This is the most popular device. By locating the characters in a specific period the scriptwriter and artist are provided immediately with a whole string of easy, and ideologically constructed, concepts with which they can fill out the plot. History means particular styles of clothing, quaint language, strange customs and rituals. Thus we have the Victorian heroine connoted through her dress and background dissatisfied with her life and bored by her persistent suitor. When she is transported – magically – into the present, she is, however, so horrified by liberated women (policewomen and girls in bikinis) that she is glad to return to her safe and secure environment. Thus, culturally-defined notions of the Victorian period, are used to glamorise the past and criticise the present which is, by implication, bereft of romance. At the same time, this story is incorporating popularised notions of present phenomena which might conceivably be seen as threatening the established moral order, and in doing so it is thereby diluting and ridiculing them. (This technique has been well documented elsewhere and is also described by Dorf-

man and Matelart discussing similar processes in Disney comics.)[35] Likewise the Edwardian period – again recognisable through costume and this time carrying connotations of more active women – is used to relate a simple love story, jealousy and reconciliation, with its participants (literally) carrying out their romances on bicycle saddles.

But history is not just novelty, it is also used to demonstrate the intransigence of much-hallowed social values, and 'natural resistance' to change. When a patrician (in the setting of Ancient Rome) falls for a slave girl he can only die for her thereby allowing her to escape with her slave boyfriend: he cannot escape or be paired off with her. Similarly when a flower-girl is attracted by a gentleman her thoughts only become romantic when she discovers that he is not really a gentleman but a rather Bohemian artist. A nineteenth-century woman and her child arrive at the doorstep on Christmas but are turned away. Two guests help them and it emerges that the woman is the disinherited daughter of a wealthy man . . . the messages are clear: love conquers poverty and simultaneously renders it unimportant. At any rate poverty only 'exists' in the past (and is thus contained and manageable). People marry into their own class and their own race. (When a nurse falls for a wounded German prisoner in wartime Britain she knows her love cannot be fulfilled . . . and the prisoner returns to Germany.) Similarly, social class – too controversial an issue to appear in stories set in the present – can be acknowledged as *having* existed in the past.

History then provides *Jackie* with a whole set of issues which are more safely dealt with in the past; social problems, social class, foreigners and war. But history also means unchanging eras characterised primarily be splendid costumes (the code of fashion), exoticism (language and customs) and adventure. And yet, despite this, the reader can derive reassurance which lingers on in a recognition of the sameness which links past and present. Underpinning all the adventures and historical tableaux is romance, the young girl in pursuit of it, or being pursued by it. Love, it is claimed, transcends time and is all-important, and history is, again, denied.

The seasons The importance of weather in reflecting moods and creating atmosphere is a feature throughout the stories. 'Love'

takes different forms at different times of the year, and holiday romances give way to autumnal 'blues'.

Convention of the exigencies of plot

The zany tale Here romance is blended with comedy. Here the drawings are less dramatic and are characterised by softer lines. The plots revolve around unusual, unlikely events and coincidences resulting in romantic meetings. At their centre is the zany boy whose bizarre hobbies lead him through a number of disasters until eventually he finds a steady girl who tames him. ('Now they're crazy about each other.') Zany girls of this type are rare. Girls are not really interested in anything outside the confines of femininity, and anyway no girl would willingly make a public comic spectacle of herself in this way.

Animals, always the subject of sentiment, often figure strongly in these stories. A camel escapes from the zoo, is caught by a young girl in the city centre who has to await the arrival of the handsome, young, zookeeper. Another favourite centres on the ritual of walking the dog and taking an evening stroll in the local park where numerous handsome young men are doing the same thing or are willing to be pestered by *her* dog – and so on: 'Hmm, funny names you call your cats.'

Again the message is clear – a 'zany' absent-minded boyfriend is a good bet. He is unlikely to spend his time chasing other girls and is indeed incapable of doing so, he is the lovable 'twit' who needs mothering as well as loving. He is a character most often found in television situation comedies like 'Some Mothers Do 'Ave 'Em' or 'It Ain't 'Arf Hot, Mum'.

The plot which depends on a recognisable social locale The hospital appears frequently and carries rich connotations of romance and drama. A girl, for example, is recovering from a throat operation and discovers her boyfriend is going out with someone else, but she overcomes her disappointment by meeting someone new in the hospital. In another story a dashing young man catches sight of a pretty girl and follows her to her place of work, a blood-bank. Terrified to sign up to give blood he thinks of ways of getting to know her . . .

Hospitals are not the only places where romance can happen – at the bus stop, on the bus, in the park, in the flat downstairs

– depending on luck, coincidence or 'stars'. 'He must be on day release . . . he's on the train Mondays and Wednesdays but not the rest of the week'. And there is a moral here, if love strikes, or simply happens 'out of the blue' then all the girl needs to do is look out for it, be alert without actively seeking it. In fact this allows her, once again, to remain passive, she certainly cannot approach somebody, only a coincidence may bring them together (though she may work on bringing about such a coincidence).

The convention of extending luck or coincidence by the introduction of supernatural devices

This way the reader is invited to share a fantasy, or a dream come true. These devices may include leprechauns, magic lamps and straightforward dreams. The dream or fantasy occupies a central place in the girls' life anyway – to an extent all the picture stories are fantasies, and escapist. Likewise real-life boys are frequently described as 'dreamy'. Daydreaming is an expected 'normal' activity on the part of girls, an adolescent phase. But dreaming of this sort is synomymous with passivity – and as we have already seen, romance is the language of passivity. The romantic girl, in contrast to the sexual man, is taken in a kiss, or embrace. Writing on the development of female sexuality in little girls, Mitchell describes their retreat into the Oedipus complex where the desire to be loved can be fulfilled in the comforting and secure environment of the family.[36] Likewise in *Jackie* stories the girl is chosen. 'Hmm, this mightn't be so bad after all – if I can get chatting to that little lady later'; *is taken* in an embrace, 'Hmm, I could enjoy teaching you, love . . . very, very much', and is herself *waiting to be loved*, 'I must be a nut! But I'm really crazy about Jay. If only I could make him care.'

The convention of personal or domestic life

Here the girl is at odds with her family and siblings (who rarely appear in person) and eventually is saved by the appearance of a boyfriend. Thus we have a twin, madly jealous of her pretty sister, who tries to steal the sister's boyfriend when the sister has to stay in bed with flu, 'Story of my life! Just Patsy's twin.

He doesn't even know my name, I bet. Just knows me as the other one. The quiet one.'

Another common theme (echoed in the problem page) is the girl with the clever family. In one case a handsome young man sees a girl reading Shakespeare in the park. When be begins to take her out she insists on going to art galleries and museums, but gives herself away when his clever friend shows that she does not know what she is talking about. Breaking down she admits to reading cheap romances insides the covers of highbrow drama! Through this humiliation and admission of inferiority she wins the love of the boy. All the girl needs is a good personality, looks and confidence. Besides, boys do not like feeling threatened by a 'brainy' girl.

Jackie asserts the absolute and natural separation of sex roles. Girls can take humiliation and be all the more attractive for it, as long as they are pretty and unassertive. Boys can *be* footballers, pop stars, even juvenile delinquents, but girls can only be feminine. The girl's life is defined through emotions – jealousy, possessiveness and devotion. Pervading the stories is a fundamental fear, fear of losing your boy, or of never getting one. Romance as a code or a way of life, precipitates individual neurosis and prohibits collective action as a means of dealing with it.

By displacing all vestiges or traces of adolescent sexuality and replacing it with concepts of love, passion and eternity, romance gets trapped within its own contradictions, and hence we have the 'problem page'.

Once declared and reciprocated this love is meant to be lasting, and is based on fidelity and premarital monogamy. But the girl knows that while she, in most cases, will submit to those, there is always the possibility that her boy's passion may be, roused by almost any attractive girl at the bus-stop, outside the home, etc. The way this paradox is handled is the introduction of terms like resignation, despair, fatalism – it's 'all in the game'. Love is a roulette and it has its losers, but for the girl who has lost, there is always the chance that it will happen again, this time with a more reliable boy. Girls do not fight back. Female flirts almost always come to a bad end. They are abandoned by their admirers who soon turn their attention back to the quiet, trusting girls who have always been content to sit in the background.

The code of personal life: the moments of anguish

Two sets of features can be categorised under the heading of 'personal life'. These are the 'Cathy and Claire' page and the 'Readers' True Experience'. In contrast with fun, fantasy and colour which pervades much of the rest of the magazine, this is the realm of realism and of actuality. This is announced clearly in the use of black-and-white photographs which occupy a prominent position in both these features.

These photographs indicate that the subject is 'real life'. They show real, and distinctly unglamorous people in ordinary settings, and they consequently display what Barthes calls the 'having-been-there' of all photographs.[37] This depends both on the form (black-and-white, connoting seriousness) and on the content (a couple together or a girl alone). Each figure looks ordinary, unlike the willowy drawings found on the fashion pages. The girl often has long, untidy hair and is heavily made up. The boy looks even more unkempt in frayed jeans. Their expressions indicate feelings of misery, anxiety or despair except when the photograph belongs to a past state when the girl in question was once happy.

The problem page itself depends on the dialogue between readers for its impact. They are invited to participate in a personal correspondence with each other as well as with Cathy and Claire. Yet this dialogue is, of course, not so open-ended. The readers are given an address to which to write and are encouraged to share their problems with 'Cathy and Claire'. But what appears on the page itself, and what, as a result, constitutes a problem is wholly in the hands of the editors. The tone is friendly and confidential:

'Sorry if this sounds big-headed'

'None of them have been serious yet, but I live in hope'.

and the replies, both jolly and supportive:

'But seriously love . . .'

'But we agree it's no joking matter'

'You don't want to stop going out with him, love, but you do want to cut down on seeing him so often.'

Cathy and Claire's collective image is one of informality. They are neither anonymous editors nor professional problem-solvers (usually introduced by their full names, e.g. Anna Raeburn, or Evelyn Home). They are, instead, like older sisters; young and trendy enough to understand the girls' problems but also experienced and wise enough to know how to deal with them. This experience is evident in the way they cross-refer between particular problems;

'You'd be surprised at how regularly we get letters like this in our post-bag.'

and also their knowledgeable tone:

'Unfortunately it's very true that a crowd of girls together tends to get bitchy.'

'We know it's an old line, but try to remember looks aren't everything y'know, an attractive personality is just as important.'

The problem itself is rooted in and understood in terms of the *personal* even when it is one which is shared by many girls. The situation is invariably an individual one and never involves organisation or discussion between girls. Like the letters page, the problem page is a symbol of women's and in this case, girls' isolation. Frequently letters begin, 'There's nobody I can talk to about this . . .' and the image presented is of the writer alone in her bedroom, like the housewife trapped at home. The Cathy and Claire page at once seeks to overcome this isolation through the correspondence and to maintain and nourish it. The personal solution is offered to the readers, regardless of the fact that they may all be experiencing the same problem. That is, the logic which informs the very existence of the problem page depends on problems being individual, not social, and their solution likewise revolves round the individual alone, not on girls organising together.

This page depends upon, exploits and offers a solution to the isolation of women. What actually constitutes a problem is never questioned. In fact problems, according to this definition, invariably stem from an inability to measure up to some standard or convention either in looks, popularity or with boys. The advice which is offered consists of suggestions as to how to avoid or remedy this situation and to conform to the norm. For example, one girl seeks advice about bringing a partner to a wedding. There is no question of encouraging her to go alone or with a girl friend! Instead she's encouraged to chat up a boy she fancies:

> 'You could say something like "I've been invited to this wedding and I've got to take a partner and I just don't know who to ask." Then you could look at him and smile sweetly.'

However, a whole range of topics, by virtue of their absence are deemed, by implication, either unproblematic or unacceptable as far as this age-group of girls is concerned. These include all references to sexuality as well as more social problems like having nowhere to go in the evening, or privacy at home, no job prospects or money, etc. (Sexual problems, when they do appear, are found under the 'Dear Doctor' column and are treated in purely clinical terms. Girls are reassured about irregular periods, pubic hair, weight and so on, but there is no mention of contraception or abortion).

This avoidance of sexuality is quite in keeping with the *Jackie* image. But when 'Cathy and Claire' are confronted with situations which could possibly give rise to promiscuity, their tone quickly becomes one of full-blown moralism. The girl is encouraged, for example, to concede to her parents' demands and stay with an aunt while they go on holiday rather than stay alone. Likewise she is persuaded to abandon all plans of going on a youth-hostelling holiday with her boyfriend if it is against her parents' wishes.

What Cathy and Claire are distributing is feminine knowledge. The discourse, or discussion, is carried out in a tone of secrecy, confidence and intimacy evoking a kind of female solidarity, a sense of mutual understanding and sympathy. But simultaneously the values maintained are wholly conservative and endorse uncritically the traditional female role. The problem page

invariably occupies the same place in all women's magazines, in the inside back page. Comfortably apart from the more light-hearted articles, and set amidst the less flamboyant and colourful small advertisements, it regenerates a flagging interest and also sums up the ideological content of the magazine. It hammers home, on the last but one page, all those ideas and values prevalent in the other sections, but this time in unambiguous black and white.

As with the picture stories, there are a limited number of themes which appear and reappear in slightly different combinations throughout the problem page and this applies to both questions and answers. Moreover, each page includes a *balanced* cross-section of each type of problem so that the 'one-off' reader gets an opportunity of witnessing the whole spectrum of issues deemed 'problematic'.

Ironically, the first of these is the *non-problem*. What typifies this category is that, within the definitions set up on the Cathy and Claire page regarding what constitutes a problem, the writer has no real problem and knows it. Hence the semi-apologetic tone in which it is written:

> 'I absolutely hate to admit this, but I'm rather pretty. Now you may think I'm lucky . . .'

The purpose of the reply is clearly moral. It is designed to bring the girl down to earth, show her that she is lucky, etc., whilst reminding her that looks aren't everything. Under this heading we have the girls whose best friend's brother fancies her, much to her consternation as she is not interested in him. Another girl is worried because, being pretty and attractive, she is accused of being a flirt. In both these cases the problem is over-success, and in each case the reply is similar. Be firm, say no, but in a friendly way.

Under this heading also, comes the oddball – the girl worried about not having developed an interest in boys, and who is instead devoted to some hobby. The reply to this deviation is reassuring. The girl is encouraged to wait, sooner or later it will happen and she will join that mass of girlhood, united in their pursuit of one goal – a boyfriend! Such an occurrence is so inevitable that there is no real problem, she simply has to wait:

'So don't let the opinions of some other schoolgirls upset you . . . However there is a danger that you could retreat a bit into your own little world, and cut yourself off from the outside.'

The second category of problems are those dealing with family life. This also marks the sole presence of the family in *Jackie* and here it is acknowledged that the girl will conceivably have difficulties. Cathy and Claire invariably side with authority and advise either submission, or compromise on the part of the girl. Dealing with the family, the discussion is couched in the language of sentiment and the girl in question made to feel guilty. When her career (university or college) is posed against the family needing her – she is advised to go to a local college or university.

The possibilities that the family throws up for conflict are seemingly endless. One girl's mother reads her diary, another's father acts as though he is jealous – one reader is being confronted with her parents' imminent divorce and does not like her prospective stepfather and another worries about her parents' extravagance and debt. It seems that family problems are a 'natural part of life and growing up'. Yet they seem to have a particular resonance for girls. It is after all they who have to carry the burden of extra housework or have to look after younger brothers and sisters if 'Mum' is ill. The girls' solid entrenchment in the heart of the family is registered in the extent to which she experiences all its problems. Moreover it represents the agent of social control, *par excellence*, for the girl, as the police do for boys. As such, in *Jackie*'s terms, parents are invariably right and their authority is to be accepted.

Not surprisingly, then, it is the family which bears the brunt of the girls rebellion against authority – as *Jackie* eloquently testifies. Year in, year out the Cathy and Claire page is littered with letters from the girls who have run away, hitched to London, or have gone to live in a flat. The family represents an unambiguous point of tension in the girls' lives.

As with the picture stories, every so often juvenile crime figures as a topic in the Cathy and Claire page. The focus of interest here is the rough boyfriend who rides a motorbike, has been in trouble and may even be in Borstal. One writer, for example, tells how she is frightened that her ex-boyfriend will be 'after'

her when he comes out of Borstal, as she is 'going' with someone else.

Although there are no female criminals in the picture stories, they do make an appearance on this page. But their crime is, by definition, less serious than the boys, consisting in the main of petty pilfering, shoplifting, and stealing from Mum's purse. No mention is ever made of female violence or of girl gangs.

That said, there is something unwieldy about the way in which *Jackie* handles the subject of crime. The images of the local 'tough' who comes from the wrong side of town, has a typically 1950s ring about it:

'My boyfriend comes from a rough area in town and he used to go around in a gang before he met me.'

The deviant is the exception, the pathological or sick individual who can't help it. Gangs are mentioned in passing but more often the focus is on the rough individual boy who can lead an innocent girl astray. The message here is clear; like the family the law must be obeyed. None the less, reverting to the vocabulary of romance, the wild character remains attractive, even irresistible:

'Warning – These Boys Mean Trouble! Bad, Bad, Boys and Why We Love Them.'

'your mum and dad don't like him . . . He's mad, bad and dangerous to know . . . but you think he's magnificent. And that's just the beginning of that fatal fascination for a bad boy.'

The delinquent, then, has something of the appearance of the rebellious pop star. The girl is admiring somebody for doing as he pleases and there is an element of vicariousness in this admiration. There is also a trace of masochism in her interest in such a figure:

'the worse he treated me, the more deeply I fell in love with him'

in fact it seems that part of his attraction lies in the threat of

sexual violence he represents; another example of the barely disguised rape fantasy so prevalent in *Jackie*. This is clearly illustrated in the way he looks and in the 'violent' objects which surrounds him – motor-bike, leather and so on.

But it is boyfriend problems which occupy the dominant position in the Cathy and Claire page each week, and the tensions which arise between best-friends and boyfriends are duplicated here. Under this heading come, for example, the pleas from the girl whose boyfriend is such a flirt, how can she keep him, get him back, or get over him? And the cry for help from a girl wracked by insecurity and unconfidence, whose boyfriend is so good-looking, attractive and friendly that all girls are after him. How can she overcome her feelings of inadequacy? Finally, there is the girl whose romance is continually being broken off by her indecisive boyfriend.

The stock reply is to become more independent and thus more confident. The girls in question are encouraged to have some 'pride', not to make fools of themselves and thereby become the *more* attractive to boys simply by not being *too* available:

> 'This should stop his hanky-panky, but if it doesn't then you must make an effort yourself. Don't submit to his affectionate kisses the next time he comes to see you – he'll soon realise that you meant what you say.

> 'Get out with other friends so that you have a life of your own, independent of Jake.'

The tone of the answers here are bluntly commonsensical. That is they represent the voice of a true friend, somebody who will tell the plain truth and not deceive the girl as even her best-friend may do. Likewise the girl who is pursued by a married bloke in the office is given short shrift – 'Hands off, he's someone else's property.'

The smart girl does not run after boys but traps them with more subtlety. The bad relationship, where the girl is clearly being exploited, is worse than no relationship at all: the girl is wasting her time on him, and there are always other boys available. The ideal boyfriend and the one all girls should aim at

catching is reliable, attentive, flattering, gallant, undemanding and 'willing to wait'.

But if, as seems the case, this type of boy is unfortunately rare, true friends are even more scarce. In *Jackie* problems, best-friends continually steal boyfriends, broadcast their friends' innermost secrets to the outside world, are bitchy and catty, have BO or else are so pretty that their friend does not have a look in where boys are concerned. It is up to the girl herself to fight her own battles. If a boy comes along, he takes priority over the best-friend who is relegated to the role of 'girlfriend' and is then seen on a more casual basis one night a week. Friendship makes little demands on the girl, involving only a degree of loyalty and characterised otherwise by convenience and selfishness:

> 'But now you don't need her so much, now that you're beginning to rebuild your own life . . .'

Finally there is a set of problems which refer to the girls' material situation or their work. These problems are never given priority but simply appear regularly, in one form or another, each week. One girl detests her Saturday job in a supermarket and is encouraged to find something less strenuous like baby-sitting. Several readers have problems affording clothes make-up and the latest fashion, and there is always the girl who does not like her full-time job. This usually stems not from the nature of the work, but from the social relationships of the work-place, for example, the bitchiness and cattiness of the office. In one case a girl complains of her workmates' jealousy, the result of her being a relative of the boss. She is encouraged to change jobs where she has no such advantages and thereby is promised the friendship of the other girls. The point here is that work is defined for the girl in terms of the agreeable social relationships which surround it and is never seen as problematic in itself.

In conclusion it can be argued that the problem page encourages conventional individualism and conformist independence. That is, the girl is channelled both toward traditional female (passive) behaviour *and* to having a mind of her own. She is warned of the dangers of following others blindly and is discouraged from wasting time at work, playing truant from school or gossiping. Problems, then, are to do with behaviour; with the

individual personality; and with the fact of going through a bio-
logical phase. They are never to do with *structures* or with factors
arising from social life outside the world of the teenage girl, such
as, for example, class relations.

Operating under the same code as the problems are the 'Cathy
and Claire Specials' and the 'Readers' True Experience' features.
These latter take the form of cautionary tales; confessions culmi-
nating in an admission of guilt and a warning to other readers.
This in fact, allows certain problems to be dealt with in depth,
under the guise of the slightly spicy story. These issues duplicate
exactly those dealt with more briefly in the problem page. In 'I
Made Him Hate Me' the girl describes how, to keep her boy,
she joined in with a group of girls who stole from shops. She
then presented him with an expensive birthday present which he
realised was stolen. Disgusted by her actions he went off with
another girl at his party! Another 14-year-old girl describes how
she was tempted into a pub and was seduced by the glamour of
drinking bacardi and coke, to be rudely awakened by the arrival
of the police.

In 'She's Just Another Runaway' a girl tells how she left
home after an argument, hitched to London, got a flat, job and
boyfriend. Things went wrong, however, when her boyfriend
arrived drunk one night at her flat demanding entry. Frightened
and unhappy she returned home. Fears based on insecurity and
lack of confidence also crop up time and time again. In 'She
Stole My Boy', a writer who claims to be 'quite plain apart from
my hair' has her boy stolen – yet again by her best-friend – and,
by contrast, in another feature a pretty girl tries to grapple with
her lack of success with the boys:

'I played every trick I knew in an effort to be the sort of girl
boys would rave about.'

In the 'Cathy and Claire Specials' the readers have spelt out for
them even more clearly, how they should act. In 'Are You Ready
for Love' infatuations and crushes are dealt with and girls are
encouraged to make a break with dream relationships and look
around for more satisfying real romances. Finally, in a feature
titled 'Does He Feel the Same?' a boy gives advice to girls about
how they should act:

'Don't plan what you're going to say beforehand . . . just make some casual remark.'

'I don't like girls who are always wanting you to give a big demonstration of how you feel about them, especially when their friends are around.'

To sum up, the same themes appear and reappear with monotonous regularity so that the narrowness of the *Jackie* world and its focus on the *individual* girl and *her own* problems comes to signify the narrowness of the woman's role in general and to pre-figure her later isolation in the home.

The fashion and beauty code: from the mirror to the wardrobe

There are two other codes which also contribute to this ideology of adolescent femininity in *Jackie*. These are first the code of fashion and beauty, and second the code of pop music. Again they rarely appear in their 'pure' form; the whole fashion and beauty enterprise for example, is predicated upon the romantic possibilities it precipitates. Greer quotes from a romantic weekly:

'She had a black velvet ribbon round her small waist . . . 'She's going to her first ball,' her mother said to me, 'She's wildly excited'.[38]

and adds that:

'All romantic novels have a preoccupation with clothes. Every sexual advance is made with clothing as an attractive barrier.'[39]

Likewise, for teenage girls, pop music centres on the pop idol who is the prime embodiment of the 'romantic' hero. But despite this general overlap, each of these codes does occupy its own specific place in *Jackie*, but first I want to look at fashion and beauty.

The central concerns of fashion and beauty are the care, protection, improvement and embellishment of the body with the use of clothing and cosmetics. As signifying systems they each

have a powerful existence outside the world of *Jackie* and a few words should be said on these more general cultural meanings.

Fashion and beauty are not merely concerned with the material fact of clothing and 'servicing' the body. As commodities they are cultural signs and one of the qualities of these signs lies in their ability to look fixed and natural. This is clearly illustrated in the culture of beauty. The beauty industry is predicated upon women's uncertainty about measuring up to beauty standards. Cosmetics are designed to compensate for 'natural' deficiencies and to emphasise personal attributes. As such they carry particular, social meanings. Together with clothing they create particular and recognisable images of women:

> In fact, in cultural systems, there is no 'natural' meaning as such . . . the bowler hat, pin-stripe shirt and rolled umbrella doe not, in themselves, mean 'sobriety', 'respectability', 'bourgeois-man-at-work'.[40]

The woman wearing her hair in rollers secured to her head with a chiffon scarf embodies different social meanings from the woman wearing a 'Gucci' silk scarf carefully tied under her chin; and the 14-year-old pop fan dressed in 'Bay City Roller' outfit similarly connotes different meanings from the public schoolgirl, resplendent in uniform. But to decode these meanings the reader must have prior social knowledge, 'routinised knowledged of the social formation'. Fashion has its own specific language, what Barthes calls the language of the 'garment system'. The fashion industry requires that new clothes are constantly being bought, regardless of need. This is guaranteed at least partly by seasonal innovations and style. Fashion depends on its consumers wanting to be up-to-date; so, for example, the sweater is advertised for autumnal walks; but the language of fashion indicates that it is not for *all* autumnal walks but for *this* season's rambles in the country. Likewise the same sweater is not designed for *all* Sundays but for *these present* Sundays.

Fashion then, is predicated upon change and modernity and the job of the fashion writer is continually to create a new language to circumscribe what is new in his or her field. This language necessarily negates, and renders redundant what has gone before it, consigning last year's 'look' to oblivion.

Returning to *Jackie*, we can see that it occupies an anomalous position here. It is not principally a fashion magazine and its fashion pages indicate no uncompromising commitment to the latest fashion. Instead the emphasis is on 'budget buys', good value, economy, and ideas. Similarly its beauty features tend to deal with down-market 'classic' images rather than high-fashion beauty styles. Beauty is announced as a fun feature. The page is set out in highly colourful combinations of photographs, drawings, headlines, captions and texts. Its entertainment value is compounded by the use of puns, proverbs or witticisms which characterise the headlines:

How Yule Look Tonight;
Moody Hues;
Back to the Drawing Board;
Hair Goes.

Typically a photograph is at the centre of the page flanked on three sides by text and commanding the immediate attention of the reader. Although the expressions on the models' faces do vary, a distinct pattern can be detected. First there is the 'just-woken-up' look where the model is at her most natural. This is achieved by the use of an out-of-focus lens and a shot angled so as to be looking down on her face, thus given the impression of tranquility, serenity and 'dewiness' (like TV shampoo adverts).

The complex structuring of this kind of image stems from the fact that it holds together a set of contradictions. It provokes the envy and admiration of the reader and offers her the possibility of achieving such beauty by following the instructions. But this involves making-up and the model's beauty here is predicated upon her 'naturalness'. At the same time the reader recognises that this is in itself a lie. It is rather the result of applying make-up in a certain *subtle* way. Make-up, then, is a necessary evil even first thing in the morning. It is as necessary to the woman as her handbag, designed both to make her more desirable and to hide her natural flaws bags under her eyes, etc.

The second recurring image on the beauty page is the *glow*, which emanates from the model's face. Dressed, made-up and ready to go out, she glances nervously at the camera as though it were a mirror. Gratified by what she sees she radiates a glow

of happiness, satisfaction and pleasure. The glow, technically achieved through the use of warm, smudgy colours (reds/pinks/rusts and browns) signifies a kind of calm anticipation. The expression is almost coy, timid, yet happy and excited. The girl is shining with a confidence which allows her to sit back, passively, awaiting praise and admiration. The message stemming from these images are clear. First, if you look good, you feel good and are guaranteed to have a good time. Second, looking as good as this you can expect to be treated as something special, even precious. And third, beauty like this is the girls' passport to happiness and success.

There are of course variations – not all beauty pages are organised around a central, dominant image. Sometimes the page includes several smaller photographs of different parts of the body, and when the subject is 'weight', the location is frequently out-of-doors and the atmosphere is sporty.

In general, however, the emphasis is on two things, the end-product (the 'look') and the means of achieving it. The fact that this depends on the consumption of special commodities, is kept well in the background, so that the concept of *beauty* soars high above the mundanity of *consumption*.

The theme on which these features are focused are as predictable as they are repetitious, including the care and improvement of each part of the body. Often social customs, rituals and events are drawn upon to provide the framework within which the beauty feature of the week operates. Thus we have New Year *beauty* resolutions, or be*witch*ing looks for Halloween. Again there is an emphasis on seasonality – a handy euphemism both for change and for the necessity of continually restocking the toilet bag. (Warm colours in the winter, lighter shades in the summer.) The reader is told, exactly, what to do and what not to do, and much time and effort is spent spelling out what is unattractive and unfeminine. Often a step-by-step procedure, like a do-it-yourself manual, is adopted. Thus one feature on nail-care starts off by showing how to remove stains and old varnish and how to protect the nails. Next it moves on to nail-health and discourages the girl from biting her nails. Finally she is shown how to polish them. Only at this point are the latest shades and fashions in nail varnish introduced. The tone adopted by the writer is chatty, friendly yet didactic and imperative. But

the assumption upon which all this work is based is that these routines and rituals are absolutely necessary. Not only romance, but even getting a good job, depends on them. It is openly acknowledged that such practices are dishonest, and that they are secret rituals carried out in the privacy of the bedroom. Underpinning this is a sense of shame and humiliation that women and girls have to resort to artificial aids. But in the beauty page this is handled by adopting a tone of resilience – after all, 'all-of-us-girls-are-in-the-same-boat' or else by transforming this labour into a pleasurable act. The shame and guilt of such an enterprise, which stems from an open acknowledgement that the subject does not 'naturally' measure up to these beauty standards, is overturned by the fun elements of the beauty routine. Yet even here there is a note of hesitancy and apologetics 'Unless you're blessed with . . . ? 'If you're lucky enough to have large, bright eyes . . .' The existence and use of make-up is at once a form of female entertainment and pleasure (staying in at night to experiment with hair-dye) and something of which to be ashamed. This latter hinges on a recognition that men find the whole idea of make-up distasteful.

The language of the beauty page, of course, does not question *why* women feel ashamed or embarrassed by this failing, instead it offers practical solutions:

'Let's face it, no one's going to wink at you if your nose is red with cold and your cheeks are white and pinched'. 'Don't rely on nature – cheat a little with a foundation'.

and indicates how girls can get the best of both worlds by deceiving men into believing they are naturally lovely, whilst subtly hiding their own weak points.

The authors adopt a tone of sisterly resignation evoking comfort and reassurance from the fact that these are shared problems. 'Most of us have some things we don't like about ourselves.' The next step is *action*, doing something about it 'no one, but no one should ever feel they are ugly', and finally transforming this action into 'fun', a 'hobby'. 'Take care of yourself and pamper yourself'.

The girl is caught in a web of conflicting directives. First she does not and cannot measure up to the ideal standard expected

of her. Recognising this, she must set about doing something about it as best she can through the use of cosmetics available to her as commodities on the open market. She must embark on a course of self-improvement. Nevertheless she must at all costs, avoid making this obvious.

While other magazines – especially those for older, working girls – handle this dilemma by elevating make-up into the realm of 'style' and bestowing on it an importance equal to that of fashion, *Jackie* comes down unequivocally on the side of the compromise and moderation, constantly using phrases like 'a hint of'; 'the merest touch of'; 'a trace of', and expressing its own position on make-up clearly:

> Most boyfriends (there are a few exceptions) hate loads of make-up, they think it goes with a loud, brassy personality and are usually frightened off by a painted face. Ask the majority and they'll say they prefer natural looks and subtle make-up – so that's the way it has to be.

Beauty routines in *Jackie* then, are of the greatest importance. Being inextricably linked to the general care and maintenance of the body, and thus with good health (no smoking and plenty of sleep) the girls are encouraged to consider beauty as a full-time job demanding skill, patience and learning. Consequently the 'Beauty Box' feature is a manual and handbook together comprising a feminine education. The girls learn how to apply mascara correctly, pluck their eyebrows and shave their legs. Each of these tasks involve *labour* but become fun and leisure when carried out in the company of friends. Besides which, when the subject is the self, and when 'self-beautification' is the object, narcissism transforms work into leisure. None the less, this labour, carried out in the confines of the home (bedroom or bathroom) does contribute, both *directly* and *indirectly* to domestic production, itself the lynchpin upon which the maintenance and reproduction of the family depends.

By doing her own washing and mending, by washing her own hair and keeping herself clean, tidy and well-groomed the girl is, in effect, shifting some of the burden of housework from her mother onto herself. By taking responsibility at one level for her own 'reproduction' she lessens the amount of domestic labour

the mother would otherwise have to carry out. It could of course be argued that the girl plucking her eyebrows and manicuring her nails, is not performing necessary labour. But such labour is not absolutely separate or different from the mother knitting or sewing whilst watching TV. Neatness, smartness and good grooming are absolutely necessary when the girl tries to get a job, and this does not simply mean tidy hair, clean face and laundered clothes. It means being well made-up, having manicured nails, wearing smart clothes and so on.

The girl's invisible work in the home, quite apart from the housework she shares directly with her mother, displays the same ambiguities as her mother's work in this sphere. In each case the sharp distinction between work and leisure is blurred. And, to return to *Jackie*, the insistence on the importance of such labours is relentless. The girl must *always* have glossy hair, shining skin, clean tights, pressed skirts, laundered shirts and so on. Like housework, it is never 'done', but consists of a set of endless chores, to be repeated daily, weekly or monthly. *Jackie* makes it palatable by describing the romantic prospects it promises and by announcing beauty routines in the language of action and fun:

(a) If you do have a problem with yours, find out what it is and *do* something about it right away.

(b) When you're all alone you can have a great time making yourself up . . . try out different hair-styles and see what suits you best.

Far from advocating passivity here, *Jackie* encourages the girl to spend her free time working on herself, immersed in self-improvement! Moreover, the same information is given out year in, year out, so that, like the advice on 'Cathy and Claire' page, it becomes part of the general currency of female knowledge. Every girl knows how to cope with greasy hair, dandruff and rough elbows. Beauty 'know-how' seeps into the larger body of domestic knowledge to be amassed alongside tips on childcare, cookery and love.

Beautification and self-improvement, then, forms the ideal hobby for girls. Simon Frith has already pointed to the amount of time girls spend engaged in these activities. The important point is that beauty-work assumes that its subjects are house-

bound and hence foreshadows yet again the future isolated image of the housewife. And the nature of the work, caring for others, directly prefigures the *kind* of work the girl will later be expected to do for others in the home; from changing her baby's nappies to washing her husband's socks. And so, every moment of the girls' time, not taken up with romance, is devoted to the maintenance and re-upholstery of the self, at least that is how *Jackie* sees it. This work is necessary because on it depends the girls' future success.

The *Jackie* fashion page has little text, its linguistic message merely sets the tone and indicates prices and stockists. Otherwise the whole page, or double page, is covered by the visual images which erupt across it in a mass of colour. The clothes on display are drawn rather than photographed (from this sample only eight issues used photographic models) and as Barthes points out this does have important implications:

> It is therefore necessary to oppose the photograph, a message without a code, to the drawing, which, even when it is denoted, is a coded message. The coded nature of the drawing appears on three levels; firstly to reproduce an object or a scene by means of a drawing necessarily implies a set of rule-governed transpositions; secondly – the denotation of the drawing is less pure than photographic denotation, for there cannot be drawing without style. Finally, like all codes the drawing demands learning.[41]

Each of these points holds true for *Jackie* fashion. In keeping with the rest of the magazine, there is a strong 1960s flavour to the drawings. Their style is firmly rooted in the commercial art of the mid–1960s and resembles the kinds of art-work which covered the walls of boutiques, discos and coffee shops during this period.

The emphasis is on design rather than on realism and consequently the models can look as bizarre and as exotic as *Vogue* models for a fraction of the cost. This means that cheap, badly-cut and shoddy clothing can be transformed into *haute couture* through art-work. In real-life there is nothing very exciting about Tesco clothes, but *Jackie* manages to make them look like high fashion. The models are without exception long-legged, boyishly

flat-chested and huge-eyed; exactly like the Twiggy look of the 1960s. They are then, 'safely' asexual, displaying a kind of child-like innocence. Their poses are highly narcissistic, the models are aware of themselves being watched and admired, and are exploiting this position of power. This behaviour, as feminist writers have pointed out, is the essence of femininity:

> A woman is never so happy as when she is being wooed. Then the mistress of all she surveys, the cynosure of all eyes, until that day of days when she sails down the aisle.[42]

> She has to develop her threatened narcissism in order to make herself loved and adored. Vanity, thy name is woman.[43]

What the clothes and general style of *Jackie* tells us about the code of fashion for young girls is quite straightforward. First, fashion changes with the seasons; second, it changes also with different social events, with the time of day and with its wearer's moods. Third, the girl's wardrobe must be continually be replenished, she must make a real attempt to have the latest style; fourth, fashion also means neatness, matching colours, ideas and, occasionally, experiment. It is never way-out or outlandish, instead the desired effect is a kind of stylish conservatism where much emphasis is placed on having matching accessories, well-cut hair, carefully applied make-up and freshly laundered tights, shirts, etc. Quite clearly such an expensive wardrobe is well beyond the girls' reach at this moment in their careers. None the less they are here being introduced to and educated into, the sphere of feminine consumption. The message is clear. Appearance is of paramount importance to the girl, it should be designed to please both boyfriend and boss alike and threaten the authority of neither.

Pop music in *Jackie*: stars and fans

Finally I want to turn briefly to the fourth code, that of pop music. This is possibly the most difficult to deal with, not least because its very existence in *Jackie* is problematic. This is because the musical side of pop is pushed into the background

and is replaced instead with the persona of the pop idol. First it is worth making some general points about 'pop' and teen magazines. Writing in 1964 Hall and Whannel pointed out:

> It would be difficult to guess, for example, whether an aspiring singer like Jess Conrad pays *Mirabelle* to interview him, or *Mirabelle* pays Jess Conrad, or they both thrive on mutual admiration and goodwill.[44]

Since then various people have commented on the importance of these magazines in selling an act:

> 'Papers like *Jackie* have got an awfully big coverage', says Leslie. 'Imagine how many fans actually see the magazine. We are going for kids and that's what the kids buy.'[45]

Jackie's policy here is quite straightforward. It allocates one single and one double page to pop pin-ups each week. Constantly flooded with publicity material, photographs and personal profiles, the *Jackie* team chooses from these. With its huge weekly sales figures, it is obviously highly sought-after by record promoters and hence is able to choose from a vast range of stars. This is evident in the spectrum of stars who appear each week. In this sample they include such diverse figures as 'Queen', 'Sparks' and 'Brotherhood of Man', all of whom are given an opportunity to develop their image or gimmick in these pop features.

The shift here – away from music to the star – is a crucial one. It happens basically because it is well-known stars who guarantee high record sales rather than a large range of hopefuls. That is, it is always much easier to 'sell' established acts than to promote newcomers. And, as in the case with *Jackie*, aspiring teenybopper stars are primarily interested in selling their images. Music itself is credited with little or no importance in the pages of *Jackie*. This is an important point because it marks the one area in which readers *could* be drawn into a real hobby. Instead of being encouraged to develop an interest in this area, or to create their own music, the readers are presented, yet again, with another opportunity to indulge their emotions, but this time on the pop-star figure rather than the boyfriend. The magazine

offers its readers little information on pop apart from occasional mentions of new releases or forthcoming films. Critical attention is shown neither to the music itself nor to its techniques and production. The girls, by implication, are merely listeners. Moreover with pop, the girls' passivity, as far as *Jackie* is concerned, takes on even larger dimensions. Pop stars are dreamy, successful and to be adored in the quiet of the bedroom. The meaning of the pin-ups hinges then on the *unequal* relationship between the adoring fan and the star looking down on her.

Several points can be made about the pin-up of the pop star unaccompanied by band or group. First it is accompanied by a minimum linguistic message, i.e. simply his name. This starkness points to the overriding importance of the visual element. The star is how he looks. The only additional information needed by the reader is his name. Second, this visual image contains a whole repertoire of signs, one of which can be dealt with under the code of *expression*. These 'depend on our competence to resolve a set of gestural, non-linguistic features (signifiers) into a specific expressive configuration (signified).'[46]

The purpose of the facial expression here is to effect a 'personalising transformation'; a necessary element in the construction of the star who is more than a mere performer of songs. This is done by introducing glimpses of, or hints as to the nature of, the star's personality through his expression, so that this personality corresponds to what have already been set up as familiar male-character stereotypes in the picture stories. Thus we have the pert cheekiness of David Essex, the sweet babyish qualities of David Cassidy and the pretty poutiness of Marc Bolan. Not surprisingly, there is a marked absence of aggressive, sexual, 'mean and nasty' rock stars in those pages. The star's face, the sole male presence in the magazine, looks out of the page, directly into the eyes of the reader, a symbol of male mystery if not outright supremacy. No other character occupies such space in the magazine, even the 'cover girl' has to compete with title, caption, headline and summary of contents, for the reader's attention.

Third, the social meaning of the background and context within which the pop star is often posed is clearly important. David Essex, relaxed and crouching in a garden and with a dog, connotes more meanings than simply his handsomeness and star-

like qualities. There is something comforting and reassuring about such an image. It says that rock or pop stars, out of the limelight, are much the same as anybody else. Their life-styles are not all 'sex'n'drugs' – at least, certainly not those who appear in *Jackie* pin-ups. Essex's relaxed pose also suggests that this is *his* garden, *his* dog, otherwise, constantly being in the public eye, he would find it difficult to be at such ease. He is thus informing the reader that he is rich, as well as being happy, handsome, famous and so on.

But familiar settings and objects are not the only contexts which crystallise the star's image. They can be even more firmly marked through the use of another set of non-verbal signs, i.e. the gimmick. The tartan armbands and scarves of the Bay City Rollers connote 'Scottishness', a reassuring recognisable image shot through with such noble feelings as patriotism, love of one's country, etc. This tartanry combined with their distinct style of working-class Scottish boys, compounds their comfortable homely image by reminding their fans that they too are ordinary working-class lads. Both Essex and the Rollers are saying in their own ways, 'Look at me: I am like you.'[47] Gimmicks eliminate the need for more extended linguistic messages. Through them, the girl is introduced to the star, they are his hallmarks, the signs through which he is remembered. When he is fully established as a superstar, these gimmicks become symbols of allegiance to him, something to be taken up by the fans and worn as a sign of their admiration. Thus we have the typical scene at Rollers concerts where the entire audience is decked out in tartan.

These carefully constructed 'images' find fuller expression in the other pop features which appear each week in *Jackie*. These are:

1. 'Pop Gossip', consisting of tit-bits of pop information, each item being accompanied by a small photograph of the star or group in question.
2. '*Jackie* Pop Specials', usually interviews with the members of a group about forthcoming tours, or films.
3. '*Jackie* Pop Exclusives' – typically 'in-depth' and personal interviews usually with a 'teenybopper' superstar – 'Donny', David Cassidy or Garry Glitter, for example.

The kind of information with which the reader is furnished here can be categorised under three headings – (i) consumption, (ii) family life, and (iii) personal biography.

Consumption

Dyer has pointed to the ways in which stars are presented to the world and 'rooted' in terms of the objects which their fame allows them to accumulate:

> The Rolls Royce is of course almost of itself suggestive of a different world of being – luxuriant, smoothness, wealth. Anyone who is at home in a Rolls Royce seems almost a different order of person.[48]

The commodity is the most visible sign of the star's success and consequently figures highly in his general presentation.

In one edition of *Jackie* we, the readers, are invited on a trip round Rod Stewart's mansion. We see him alternately lounging in its luxuriant surroundings and posing formally as lord of the manor by his mantelpiece in what is clearly the main drawing-room. Simultaneously, however, the seriousness of this image is fragmented by Rod's own personal appearance. Bizarre and exotic, to the point of being clownish, Rod combines extravagent flowing clothes with a working-class, ex-mod hairstyle and tough facial expression. Several connotations flow from this set of images. First, there is the idea of the 'working-class boy made good'; second, there is the element of exposition. *Jackie* is momentarily revealing to its readers how the pop stars lives. The feature is voyeuristic allowing the readers a special privilege, a glimpse into the private life of Rod. Third, in Rod's own self-presentation, there is clearly an element of self-parody, and self-mocking. Despite the splendour of his surroundings Rod is, it seems, unchanged and his loyalties remain with his class origins (expressed in other contexts through his accent, appearance and devotion to football).

Other shorter features produce similar kinds of connotations, 'Pop Gossip' in particular pays special attention to the consumer power of pop stars.

THE
NORTHERN COLLEGE
LIBRARY

BARNSLEY

'One of the Bay City Rollers has just bought his own cottage.'

'Jim Lea of Slade has recently bought a flat in London.'

'Les McKeown of the Bay City Rollers say he's mad about cars . . . "The car I'd like to have is an RO.80 . . . its cruising speed is 140 m.p.h." '

Family life

Since the images of so many stars depends on their being unmarried, such references are usually made to their parents. Several idols talk about the pleasure of family occasions, and those who no longer need to depend on a 'single and available' image talk animatedly about their wives and children (included here are Paul McCartney, Jim Lea of Slade and Alvin Stardust). In each case the family serves to normalise the image of the star. It is presented as a protective and comforting environment, the place to which the star loves to return after exhausting tours.

The effect of these pieces is, again, to assert a sense of sameness, normality, of sharing certain unshakeable beliefs and ideas about life. Human nature, 'natural' interests, and commitments to certain values mean that less important differences are transcended. We are *all* the same in our love of children, comfort, the family, nation, and so on. More than this we *all* enjoy the simple things of life – going to a football match on a Saturday afternoon, eating steak and chips, going on holiday, etc.

The star's personal biography

Often this consists of anecdotes or witty stories about life on the road with the band. Again the intention here is to reassure the reader that the star is not *so* alienated from his roots. He does not feel completely at ease amongst the 'jet set'. One singer, Don Powell of Slade, tells how nobody could understand his accent in America, and Paul McCartney, discussing the early days of the Beatles, describes how horrified he was to find that German people ate fish for Christmas dinner!

In other words, the star is, at heart, an ordinary lad unused

to 'foreign ways'. Frequent references are made to the class origins of certain idols particularly to David Essex's career as a barrow-boy in East London. On the one hand it is simply a reiteration of the rags-to-riches story, on the other it represents an attempt to show the ties between stars and fan even closer evoking a sense of shared experiences and of normality. The pop fan/idol relationship is predicated upon distance through hero-worship and adulation, but is cemented by what they still have in common.

Conclusion

Jackie sets up, defines and focuses exclusively on 'the personal', locating it as the sphere of prime importance to the teenage girl. This world of the personal and of the emotions is an all-embracing totality, and by implication all else is of secondary interest. Romance, problems, fashion, beauty and pop all mark out the limits of the girl's feminine sphere. *Jackie* presents 'romantic individualism' as the ethos *par excellence* of the teenage girl. The *Jackie* girl is alone in her quest for love; she refers back to her female peers for advice, comfort and reassurance only when she needs to do so or when she has nothing better to do. Female solidarity, or even just female friendship, has no real existence in the magazine. To achieve self-respect, the girl has to escape the 'bitchy', 'catty', atmosphere of female company and find a boyfriend as quickly as possible. But in doing this she cannot slide into complacency. Her ruthlessly individualistic outlook must be retained in case she has to fight to keep him. This is, therefore, a double-edged kind of individualism since, in relation to her boyfriend, she is expected to leave individuality behind on the doorstep. In the context of the romantic relationship, she has to be willing to give in to his demands, including his plans for the evening, and by implication, his plans for the rest of their lives.

This discourse, as it takes shape through the pages of *Jackie* is immensely powerful, especially if we consider it being absorbed, in its codified form, each week for several years at a time. But this does not mean that its readers swallow its axioms without question. Until we have a much clearer idea of how

girls read *Jackie* and encounter its ideological force, our analysis remains one-sided. None the less, as a vehicle for meanings that remain with us, perhaps even for life, *Jackie*'s influence should not be under-estimated. If we consider all the other objects and experiences which we recognise as influencing us and shaping our vision of the world, we should not be too quick to dismiss *Jackie* as 'silly, harmless nonsense'. Its success is marked out by its remembered status in the landscape of teenage femininity.

Notes and references

1. Figures taken from C. L. White, *Women's Magazines 1963–1968*, London Michael Joseph, 1970; Appendix IV, and from *British Rate and Data* (June 1977).
2. G. Rosei, 'The Private Life of Lord Snooty', in the *Sunday Times Magazine*, 29 July, 1973, pp. 8–16.
3. Ibid, see also *Willing's Press Guide* 1977 and McCarthy Information Ltd (June 1977) where it is noted that 'Among the enviably high profit-margin firms are Shopfitters (Lancs); Birmingham satchett maker Ralph Martindale, and 'Dandy' and 'Beano' published by D. C. Thomson – all with profit margins of 20% or more.' See also Extel Card March 1977 for D. C. Thomson.

Year	Turnover	Profit after tax
1974	£18 556 000	£2 651 000
1975	£23 024 000	£2 089 000
1976	£28 172 000	£2 092 000

4. L. Althusser, 'Ideology and the State', in *Lenin and Philosophy and Other Essays*, London, New Left Books, 1971, p. 163.
5. A. Dorfman and A. Mattelart, *How to Read Donald Duck* 1971, p. 30.
6. Paul Johnson in the *New Statesman*, 28th February 1964.
7. C. Alderson, *The Magazines Teenagers Read*, London, 1968, p. 3.
8. P. Willis, 'Symbolism and Practice: A Theory for the Social Meaning of Pop Music', CCCS, Birmingham University, Stencilled Paper, p. 2.
9. S. Hall, I. Connell, L. Curti, 'The Unity of Current Affairs Television' in *Cultural Studies* no. 9, 1976, p. 51.
10. George Orwell, 'Boys' Weeklies' in his book *Inside the Whale and Other Essays*, Harmondsworth, Penguin, 1969, pp. 187–203, first published in 1939.
11. Willis, 'Symbolism and Practice', p. 1.
12. J. Clarke, S. Hall, T. Jefferson, B. Roberts, 'Subcultures, Cultures

and Classes' in *Resistance Through Rituals* ed S. Hall, London, Hutchinson, 1976, p. 55.

13. Hall, Connell and Curti, 'The Unity of Current Affairs Television' in *Culture and Domination* Cultural Studies no. 9 CCCs. University of Birmingham, 1976, CCCS. (eds) Hutchinson 1978. p. 53.

14. Antonio Gramsci, *Selections from the Prison Notebooks*, quoted in S. Hall, B. Lumley and G. McLennan, 'Politics and Ideology: Gramsci' in 'On Ideology', *Cultural Studies*, no 10, 1977, p. 51.

15. Ibid, p. 51

16. Ibid, p. 67

17. Simon Frith, *Sound Effects,* New York, Pantheon, NY 1981.

18. Ibid.

19. Richard Hoggart, *The Uses of Literacy*, Harmondsworth, Penguin, 1957, p. 51

20. Frith, *Sound Effects*.

21. B. Berelson defines C.A. as 'a research technique for the objective, systematic and quantitative description of the manifest content of communication', in B. Berelson, *Content Analysis in Communication Research*, London, 1952, p. 18.

22. R. Barthes, *Elements of Semiology*, London, Jonathan Cape, 1967, pp. 95, 96.

23. S. Hall, 'The Determination of News Photographs', in *Cultural Studies*, no 3, 1972, p. 69. CCCS University of Brimingham 1972.

24. Ibid, p. 64.

25. Ibid, p. 65.

26. Quoting R. Barthes, *Elements of Semiology*, London, Jonathan Cape, 1967, p. 91.

27. Ibid, p. 66.

28. My analysis based on these codes is by no means exhaustive, nor does it cover every different kind of feature. Absent are advertisements, personality quiz games, on-the-spot interviews and short stories. However, each of these does fit into the coded outlines, some into more than one. Personality games and on-the-spot interviews obviously would be examined under the code of personal domestic life, short stories under romance.

29. G. Greer, *The Female Eunuch*, London, MacGibbon & Kee, 1970, p. 173.

30. R. Barthes, 'The Rhetoric of the Image' in *Cultural Studies* no 1, 1971, p. 43.

31. Ibid, p. 44.

32. The language is remarkably reminiscent of the 'hip' language of commentaries of the 'teenage scene' in the 1950s, e.g. 'Hey, gang – some square's giving Jules trouble, and 'Hey, what you at man? Like, I don't mind sharing my thoughts with all mankind but I draw a line at the furniture, dig?'

33. L. Althusser, 'Ideology and the State', in *Lonin and Philosophy and Other Essays*, London, New Left Books, 1971, p. 163.

34. These take the form of quizzes, articles and features on birth signs,

all of which are designed to help '*you*' know '*yourself*', e.g. the reader is asked to tick, from a selection of possible responses, what she would do, in a number of given situations. Her answers are than tallied up numerically and there is a particular personality profile which allegedly corresponds to her 'total'.

35. Dorfman and Mattelart, *How to Read Donald Duck*, p. 56:

'The second strategy is called recuperation; the utilisation of a potentially dangerous phenomenon of the social body in such a way that it serves to justify the continued need of the social system and its values, and very often justifies the violence and repression which are part of that system.'

36. J. Mitchell, *Psychoanalysis and Feminism*, Harmondsworth, Penguin, 1974, p. 117.
37. R. Barthes, 'The Rhetoric of the Image', in *Cultural Studies* no 1, 1971, p. 46.
38. Taken from *Woman's Weekly*, 2.7.69 and quoted in Greer, *The Female Eunuch*, p. 171.
39. Greer, *The Female Eunuch*, p. 179.
40. Hall, Clarke, Jefferson and Roberts, 'Subcultures, Cultures and Classes', p. 55.
41. R. Barthes, 'The Rhetoric of the Image' in *Cultural Studies* no 1, 1971, p. 43.
42. Greer, *The Female Eunuch*, pp. 185–6.
43. Mitchell, *Psychoanalysis and Feminism*, p. 116.
44. S. Hall and P. Whannel, *The Popular Arts*, London, Hutchinson, 1964, p. 295.
45. P. Erskin in *New Musical Express*, 2 November 1974, p. 17.
46. S. Hall, 'The Determination of the News Photograph', p. 67.
47. R. Barthes, *Mythologies*, London, Jonathan Cape, 1972, p. 91.
48. R. Dyer, 'The Meaning of Tom Jones', in *Cultural Studies*, no 3, 1972, p. 57.

6

Jackie and *Just Seventeen*: Girls' Comics and Magazines in the 1980s

The logic of consumerism

Since '*Jackie*: An Ideology of Adolescent Femininity' was first published in the late 1970s,[1] feminist scholarship in the field of media studies has grown enormously. Both women's magazines and romantic fiction, have been the subject of sustained critical attention. They have been recognised as key cultural forms reflective of distinctively feminine pleasures. Romance exists, of course, well beyond the pages of the magazines. It carries readers, viewers and audiences through a multiplicity of other forms. These include romantic novels, romantic films, and romantic records. Romance has also been credited with supplying the framework for female fantasy. Studying popular romances has been seen therefore, by feminist critics like Cora Kaplan, as offering a possible point of entry for understanding important aspects of the feminine psyche.[2]

Romance is also a key theme in my study of *Jackie* magazine. Its suffocating embrace was pinpointed as a major element in the oppressive world of adolescent femininity. It was seen as stopping girls from thinking about or doing anything else. According to *Jackie* their lives were to be devoted to the pursuit of romance. And when it did eventually come their way they were to invest all their energies in making sure it did not slip away . . .

Ten years later there have been real and remarkable shifts in the world of girls' magazines. Most notable is the decline of romance. It no longer occupies anything like the prominent pos-

ition it once did. To understand why this is the case it is necessary to widen the net and look at a whole range of publications. Magazines for older girls like *Just Seventeen* and *Mizz* have had a trickle-down effect on *Jackie*. *Smash Hits* has had the greatest effect of all. All three of these have certainly influenced and reshaped the dominant concerns and interests in younger girls' comics. In girls' magazines in the 1980s romance no longer occupies the place it once did. Why this is the case will be explored in more detail in this chapter.

The ascendancy of pop and fashion and the gradual eclipsing of romance can be attributed to a wide number of factors, not least of which is the general awareness in the past ten years, of sexual inequality. There has been a recognition that in the photo-love stories, around which many of the girls' magazines marketed themselves, female passivity and traditional sex-role stereotyping took on a particularly heightened form. The fading in popularity of these love narratives in the 1980s might be attributed to an increasing self-confidence on the part of readers who not only feel these stories to be insulting and silly, but who also let these opinions be known to the editors. Certainly a new relationship between editors and readers has been set up. Editors admit that for too long teenage and pre-teenage readers were treated with amusement if not outright ridicule. Magazine staff now insist that they 'do not talk down to their readers'. *Just Seventeen* and *Mizz* have set a seemingly irreversible trend by describing their readers as intelligent and discerning.

These magazines go to great lengths to ensure that they are in touch with their readers. *Mizz*, for example, carried out extensive market research before launching the magazine. It retains a group of 500 regular readers who test out and comment on it from month to month. Readers' letters are taken seriously and regular 'roadshow events' are arranged so that the magazine staff can meet some of the readers from different parts of the country. These innovations have had a trickle-down effect. *Girl*, a magazine for much younger girls, had a re-launch in June 1988. In the new *Girl* there is only one colour-photo story (from an average of four each week) and the emphasis is on pop, fashion and gossip. (In a telephone interview carried out with the editors at *Girl* it was revealed that a huge readership survey had been carried out before these changes were introduced.)

These moves in girls' magazines, away from the old terrain of traditional femininity, have been paralleled in Media Studies with the development of what might be described as a more reader-centred approach. Thus, as the magazine editors adopt a mode of address which is apparently more in tune with the 'new girl', academic feminists also shift their attention away from the texts and their meanings, to the readers and their different and complex readings. It is useful to summarise the changing emphasis in this body of academic work over the past few years because it simultaneously highlights the real weaknesses in the earlier study of *Jackie*, and points the way forward to developing a greater understanding of girls' magazines in the light of the changes described above.

If readers have been more actively drawn into the magazines produced by publishers like International Publishing Corporation (IPC) and East Midlands Allied Publishers (EMAP) it is interesting and perhaps not entirely coincidental that in Media Studies, readers also occupy a new position of prominence. Gradually there has been a marginalisation of narrow text-based analyses in place of a more contextualised approach which recognises the multiplicity of meanings and readings which any one text or image is capable of generating. Charlotte Brunsdon has recently shown how this shift has transformed the field of TV and film studies.[3] She links this with a similar shift in Literary Studies where the processes of reading are also being integrated into the work of textual analysis. Again if we look at Cora Kaplan's work on *The Thorn Birds*, this new focus allows the author to remember her own reading history, during adolescence, as a shaping influence on her fascination, twenty years later, with this transgressive romance between a Catholic priest and a young girl.[4] Lowbrow fiction of the sort exemplified by *The Thorn Birds* – disapproved of in her household – encourages Kaplan (who draws on her recollections of reading *Gone with the Wind*) to chart out a private journey of sexual and psychic education. This in turn contributes to and enriches her readings of *The Thorn Birds* in an entirely different context.

A concern with reading relations, however, is not wholly restricted to introducing autobiographical material and drawing on that as a critical element in the negotiation of meaning. The active role of the reader has also emerged in Media Studies

where the emphasis is on the audience. Dave Morley's recent study marks an engagement with the complex ways in which television operates within the family, and with the way it plays a subtle role in managing the internal relations of the household, solving and exacerbating conflict, watched attentively and left to flicker in the corner.[5] Morley's work with audiences is firmly located within a social science framework, even though he modifies existing audience research methodologies to produce a much more reflexive and interactive model. He is just one of many media analysts who have insisted recently on the importance of bringing the viewer or the reader back into the study of media forms. The fact that writers as diverse as Morley and Kaplan, and in America Janice Radway, have found a common interest in the social and psychic dynamics of the reception of meaning, is indicative of a movement away from the centrality of the text in all its ideological glory, and a recognition of the fact that texts do not simply assert their meanings on 'unsuspecting' readers and viewers.[6]

So far these issues have been located within Media or Television Studies. It may well prove more fruitful to return to the paradigms of Cultural Studies to find a broader framework for understanding the reception, or absorption or negotiation of meaning. At present all three of these terms are often used interchangeably; this in itself is evidence of the uncertainty about how to proceed in the move back towards the social context of media consumption. What can be seen in this shift away from the text is in fact a kind of creeping in, through the back door, of an updated kind of 'culturalism' into what had been the unspoilt terrain of 'structuralism'. As both Richard Johnson and Stuart Hall have pointed out, 'culturalism' developed very much out of the pioneering work of E. P. Thompson and Raymond Williams.[7] In each case the cultural expressions of ordinary people were seen by these writers as vital, creative forces, reflective of a 'whole way of life'. Thompson's work in social history, Williams's studies of cultural institutions as well as Hoggart's reading of working-class culture were all drawn on extensively in much of the work carried out in the Centre for Contemporary Cultural Studies (CCCS) in Birmingham throughout the 1970s.[8] It was the 'culturalism' of the above-mentioned works which, for example, was combined with some of the features of 'naturalistic'

sociology to produce ethnographic work like Paul Willis's *Learning to Labour*.[9] The assumption was that key elements in working-class life, like the adoption of a particular style or the use of a set of consumer items, could only be understood by reference to the social whole, to the totality of historical relations which together created a recognisable entity which was working-class culture.

A culturalist approach would therefore be committed to looking at the way that media meanings are negotiated within a wider social and class context. The television-viewer is not a blank page. Instead he or she brings to the screen a 'lived experience' which is reflective of his or her place in the world. Dave Morley recognises this, taking it as his founding premise for audience research.[10] However in other forms of reader-oriented analysis such a framework has not been so fully articulated. Janice Radway's work, for instance, is by far the most sophisticated to emerge on the question of the way that women read popular romances.[11] Her emphasis is on the way that the act of reading can carry quite separate meanings from the texts themselves. For these housewives reading romance is an act of independence. It takes place in time stolen from the day-to-day schedule of running a household and attending to the needs of husbands and children. Her respondents describe reading as restorative. It replenishes them emotionally and restores them to that good health needed to cope with the endless routines of housework.

Radway's study is important in its emphasis on the way that women participate in the act of reading and how their feminine position creates the very problems which romance reading seems to go some way toward solving. Nonetheless her methodology raises a number of problems which cannot be resolved without recourse to a wider and more interrogative mode which is able to tap into the specifics of the women's class position, their perceptions of sex and marriage, their position in the job market or lack of it, their relationships with husbands and children and their own self-images. It is what the women do *not* want to talk about which seems to reveal more about their subterfuge reading. Radway is unable to solicit from them whether or not they find the romances sexually exciting. They talk at length about what they do not like in the stories they describe as unsuccessful or offensive, but they are unwilling to divulge to the researcher

what role these narratives play in their own sexual lives. Instead the discussions or the interviews settle on the need to identify with the right kind of heroine who is being nurtured as well as loved by a tender man.

The absence of detail about the lived experience of these women on a day-to-day basis and the denser texture of their lives in which romance reading plays some symptomatic role is reflected in the question-and-answer format adopted by Radway and in her strategy of sticking to the topic of reading in the interviews. Radway is over-attentive to the autonomous act of reading and too inattentive to the other crowded activities which surround it. While she points to the housework, the cooking, the picking-up and dropping-off of children, she is nonetheless primarily concerned with the reader-text interface. This restricts her line of vision and makes it difficult for her to theorise more precisely the relationship between gender and leisure-time in the context of household labour. The absence of material on the respondents' sexual identity and sexual activity also lends a one-sidedness to their strenuous activity as romance readers. Where Cora Kaplan can 'admit' to the sexual pleasures of romance reading, the circumstance of the interview situation and a reticence about talking about sexuality within traditional femininity, means that the respondents can only articulate a kind of 'nice' or tasteful disavowal when it comes to being asked about the possible connections between sexual excitement and romantic reading.

Radway does not dwell on the specificities of financial dependence of these women. This means that she is unable to locate their dependence on romance in a wider social (and psychic) context. It might be their rootedness in the home which minimises their opportunities for real romance and which nourishes a need for surrogate passion. Without the flirtations of the workplace these women might well be projecting all their sexual energies into the private act of reading. Radway's methodology is perhaps over-reliant on the statements made to her by the women and insufficiently reflective about the deeper processes which lie behind these utterances. There is a feeling throughout that they are all extremely anxious to please her and at the same time guarded and restrained about the less cheery circumstances of their lives. This is a familiar research dilemma – one which

is only partly overcome when the researcher drops the mantle of research and somehow enters into the 'lived experience' of his or her participants' lives.[12]

In my earlier work on *Jackie* I restricted myself to a purely textual analysis and reserved the question of how the magazine might be read as something to be pursued at a later date. As various critics have pointed, out this was far from satisfactory. It created an image of *Jackie* as a massive ideological block in which readers were implicitly imprisoned. Martin Barker for example, argued, that such an approach also seemed to assume that girls were incapable of countering this onslaught or even of setting it alongside other different meanings they were encountering elsewhere.[13] Barker *et al.* have also suggested that such a unified notion of *Jackie* was blind not only to the readers but also to the internal tensions and contradictions which disrupt the magazine, making it more open to contestation than might otherwise be imagined. By setting their own Cultural Studies students a set of reading exercises these authors show just how varied responses to comics and magazines can be. An ideological model of the type evidenced in my reading of *Jackie* was therefore incapable of understanding the partial readings, the breaks and the contradictions. It seemed to assume that the contents of the magazine were somehow reproduced inside the heads of the girls and that what was excluded from the magazine was being intentionally shut out. *Jackie* was seen as presenting a coercive ideology without examining whether or not it appeared in this way to its readers.

Elisabeth Fraser set out to show, with the help of seven small groups of girls aged between 13 and 17 from a range of different backgrounds that my analysis was indeed too predictive.[14] Using a set of extremely structured questions she sought to untangle the complex ways in which the meanings of the stories were reached. For example, she revealed how in a story like *Pretty in Pink* (serialised for *Jackie*) the girls liked the romance between Blane the sexually undemanding hero and 'Andy' (Andrea) precisely because in real life boys did not conform with that romantic ideal and were much more likely to be sexually demanding. The story was attractive to them for the distance between it and reality. In this and in other similar cases Fraser shows how readers are rarely 'victims' of the text. My own 'naive' reading

is therefore discredited in favour of a more fluid, more active and ultimately more engaged process of reading in which readers typically participate in the creation of textual meaning. Fraser also reminds us that *Jackie* is frequently read lazily. The girls skim-read and look to the ending in stories they find unsatisfactory. They draw on their past knowledge of the genre to judge the stories and even to miss them out completely.

Mary McLoughlin, in an excellent unpublished piece of work, pursued this critical line of inquiry even further.[15] She challenged my initial assumption that by virtue of their age and sex *Jackie* readers were particularly vulnerable to ideological manipulation. Such an assumption she claims was wrongly based on the widespread belief that young people are more affected by media messages than are their parents, and less adept at challenging meanings which they find inadequate or unappealing. McLoughlin reveals an altogether more complex picture in relation to the reading practices of the thirty girls she interviewed and asked to keep diaries. Like Fraser's sample they display a pleasure in seeing the rules of narrative operate the way they are supposed to do. The happy ending provides the girls with an expected pleasure and thus fulfils their expectation of enjoyable reading. At the same time their reading routines vary enormously according to time, place, and other available activities. They flick through *Jackie*, they read it in segments, they read it voraciously to cut off from the family noise around them, and they read the same issue again when they have nothing else to do. *Jackie* makes sense to them as a weekly ritual. It punctuates the end of the week and thus creates a feeling of security. This is reinforced by its repetitions and its continuity. The stories that seem to go on forever and the features which are the same over the years also fulfil this function of reassuring sameness.

The fantasy element in the stories plays an equally meaningful role. The girls do not simply absorb it and believe it, but look to it as a means of providing them with a kind of personal chart for future and present emotional dilemmas. The stories set within a family, where the heroine finds herself a victim of injustice, allow readers to see the family as a power-structure where unfairness and cruelty can indeed flourish. In romantic fiction the repetitious unexpected meetings with boys in parks, on the bus, or in the supermarket, resolve the dilemmas faced by girls of

this age about negotiating the early stages of romance where convention dictates that they wait until he makes the first move. By stressing the context in which these comics are read, and by paying close attention to the responses of the girls she interviews, McLoughlin does indeed offer a more grounded account of their involvement as readers.

> 'When there is something boring on the telly and everyone else wants to watch except me, I put on my headphones and look through *Jackie* till the programme's over.'

McLoughlin indicates just how far removed girls are from the days when reading was a leisure activity in itself, and when there were few other media distractions. This alerts us to the historical changes which, over a period of twenty years, have transformed leisure patterns in such a way that *Jackie* becomes not a leisure activity in its own right, but one which can be relied upon as a fallback when other, more attractive possibilities, are momentarily unavailable. *Jackie* has to be seen therefore in conjunction with other media forms.

This state of fragmented reading, this ability to slot in and out of a range of media modes simultaneously, this familiarity with a range of narrative codes against which stories and fictions can be measured for their success or failure – all these competences and abilities not only shape the act of reading and the way in which meaning is drawn out, they are also features which can best be understood by locating them within a multi-media universe. This is a situation where the media in its various forms invade all our private and our public moments. The term 'postmodernism' is often used to define this new situation. Baudrillard talks about the way in which we are no longer offered the opportunity for privacy, or even for individualised alienation.[16] Instead a whole barrage of media forms is waiting to invade these spaces, pulling us from our private miseries with advice columns, agony aunts, 'how-to' books and so on. Girls' comics and magazines, as we shall see in the following pages, provide an excellent example of this trend. Indeed it will be a central argument of this chapter that problems, and advice about how to solve these problems, plays an increasingly important role in all the magazines, displacing romance altogether.

Baudrillard also focuses on the shift towards an information-based society, where people are given the same information in an increasingly diverse number of forms. This too has a remarkable resonance when we look at magazines and comics in the 1980s. What we find, along with the problem pages and the problem-based stories, is an over-abundance of facts, snippets and informational fragments. Set in a high colour and glossy format, what magazines like *Smash Hits* and *Just Seventeen* offer, and what all the other magazines are desperately trying to catch up with, is an endless flow of information about the stars – about their lives, their future plans, their next record, their next tour, the houses they hope to buy and so on. This kind of material was always there in *Jackie*. But now in the new 'glossies' it takes on a much more immediate, instant quality, as though it has just been 'faxed'-through, direct from the personal office of the star in question. Small boxes with print-out 'fax' and with quotes from the stars cover the pages of these publications. They can be taken in at a glance, they do not even have to be read, and their concern is overwhelmingly with the familiar figures from the world of pop music or from TV. This too is reflective of another trend in the magazines, a preference for material which claims to deal with the real lives of the stars rather than for stories which concentrate on the imagined lives of romantic heroes and heroines. The celebrity system, therefore, combines with the information society, and with the 'culture of narcissism', to supersede and make almost redundant, the old world of girls' comics with their staple and unchanging diet of stories followed up by problems and with pop and fashion trailing behind.

The 'ecstasy of communication' which is promised in the garish multicolour lay-out of these magazines, and in the use of different typefaces, disguises a deeper logic. This is the logic of consumerism. The self which is to be improved now requires even more cosmetics and other products to achieve this end. Girls' magazines, which once were able to survive without the massive advertising revenue from cosmetic and fashion manufacturers which fill the pages of women's magazines, are now in the business of attracting advertising on a much bigger scale. *Just Seventeen* carries, not just more advertising, but advertising in a different and more 'cut-up' – and therefore less apparent-style. Many of its features consist of sets of mini-ads where different products

(eyeliner, hair-mousse, lipstick) are featured in boxes coming under some unifying editorial theme. In this way consumer-culture exerts itself more strenuously than ever. Fashion is featured more prominently and the idea is not just to look at the much more lavish fashion spreads but also to buy, or at least to think about buying, or to want to buy. The celebrity system is also, of course, within the system of consumption. Looking at *Wet, Wet, Wet,* and knowing about where they intend going on their holidays, is not completely divorced from listening to and buying their records. It is not a prerequisite of the magazine that any purchases are made, but it is part of its inner logic that consumption becomes a naturalised feature of the readers' experience.

In the past ten years one part of the music industry has concentrated overwhelmingly on the pop 'teenybopper' market, so the success of magazines like *Smash Hits* or *No 1* have also got to be set alongside the willingness of the record companies to offer a great deal of support at short notice, in terms of interviews, promotion 'shots' and over-the-phone information to the new pop magazines. This in turn creates problems for the other more traditional girls' magazines like *Jackie* and *Girl* which do not have the same fast 'lead-time' and which do not benefit from the same 'special relationship' with the record companies. It is impossible for them, for example, to run 'Top Ten' chart lyrics, even if they wanted to, without spending a great deal of time and money getting copyright clearance. The pop publications however can afford to do this from week to week.

All this contributes to the new prominence and independence of the teenage girl, backed by a recognition that she is not just boy-mad and thinking of nothing other than an engagement ring. These changes, however, are completely compatible with the insertion of the female teenage subject into an even-more-hectic cycle of consumerism, particularly into the cycle of pop-consumerism where weekly pocket-money can make or break a star. In all the magazines mentioned this consumerist emphasis seems to be balanced equally between pop and fashion. And the centrality of the self in fashion and beauty and the widespread recognition that these interests are no longer pursued simply to impress boys, but are about self-image and self-satisfaction, is not at all dissimilar to that 'self' found in the glossy pages of young women's fashion magazines like *Elle*. In *Elle* fashion dominates

all other concerns. There are no problems, no sex stories, no personal revelations, only the infinitely perfectible self and the clothes to go with that self. *The decline of romance in the girls' comics and magazines might therefore be seen in this context, where it is marginalised or even disposed of in favour of simple concentration on the potentially sophisticated and discerning young consumer.*

I have so far drawn attention to the kinds of debates which have emerged in relation to the examination and analysis of popular media forms over the past ten years. In the following pages I will look in more detail at the changes which have taken place on the pages of teen magazines, making sense of these in terms of shifts and changes in the perceived definitions of and understanding of femininity in the 1980s.

The decline of romance

> With the advent of the photo-story we found that the scope became much more limited. We could not longer do the historical stories and the romances seemed to lose that nice emotional quality they had. It all became much more realistic, like the problem page set to pictures.
>
> Assistant Editor, *Jackie*, 7.8.1988

The documentary dimension which the use of photographs in the romantic picture-strips introduces, immediately requires a greater commitment to realism. Much of the fantasy element is eliminated, as are the costume-drama romances, the beaches at sunset and the romantic urban skylines. It's not just a question of cost, though line drawings which 'sketched in' these views, panoramas and other details could be bought a lot more cheaply than their photographic equivalents. It is also a question of the formal constraints of the genre when it is framed by the perspective of photographic realism. Line-drawings like those found in *Jackie* and most of the other girls' comics throughout the 1970s allowed great licence with perspective. Thickened black lines emphasised a moment of danger, or perhaps of passion. Sometimes a central image would spill out of its box trespassing on the space of the other 'clips' as though to emphasise its own centrality. This

technique, borrowed from the classic American comic, allowed the hero or heroine to come lunging out towards the reader. The overall effect was one of dynamic action. Comic characters raced through their narrative dilemmas. The speed with which they could be read was complemented by the speed of the events described. One image seemed to topple over onto the next. This is not the case with the photo-narratives. The rigid requirements of the photographic mode slows the speed down dramatically. The limited number of events and characters which can be fitted into a 2″ × 3″ frame means that there is great reliance on close-ups and on snatches of conversation which move evenly between one character and the next.

While readers are used to the pace of televisual realism which shifts slowly from one character to the next and which relies on close-ups for emotional effect, on the flat page of a magazine photo-romance becomes a stiff awkward form. Narrative development often seems to grind to a halt leaving behind a series of clips showing characters posing with a woodenness which at points verges on parody. This goes some way perhaps in contributing to the dwindling popularity of the photo-narratives. But despite the fact that in sales figures, magazines like *Jackie, Blue Jeans, Patches and Girl* have indeed been superseded by the fashion and pop weeklies and monthlies, the photo-stories are still there. A detailed reading of these stories over a period of three years (1985–8) reveals a number of features which are at once reflective of this narrative crisis in the magazines and at the same time expressive of key issues and tensions in the area of love and sexuality as experienced by working-class girls in the 1980s.

Most of the photo-stories in *Girl, Jackie, Blue Jeans*, and *Patches*, in this period, take place in recognisable working-class locations. These include the council estate, inside the home, on the street outside the home, in the youth club and occasionally in the school playground. These picture-clips show ordinary working-class boys and girls sharing often cramped-looking houses with their parents, brothers and sisters. They spend their leisure time watching TV or else going down to 'the club' or disco. The leisure activities of middle-class girls are completely excluded from this photo-realist world. There are no tennis clubs, no ballet or jazz dancing classes, no horse-riding and no trips to the theatre

or to the local library. This in itself marks a change in *Jackie* which for so long tried to achieve an overwhelming classless effect in its picture-stories. The transition to photographs suddenly plunged Jackie into a world which was bounded by the signs and symbols of class. To be 'up to date' and competitive with its rivals which had already adopted the photo-format it had to abandon its earlier attachment to the idea of girls in flats in anonymous cities falling for the boy upstairs. This was simply not reflective of how most young people in the 1980s lived.

There have been some other noticeable changes in the kind of stories found in these magazines over the past few years. Girl-characters are less passive and less likely to mope about waiting for the telephone to ring. They are less the victims of romance than they once were in the world of *Jackie* in the 1970s. A new realism prevails which means that the stories which deal with love and romance do so in a way which highlights the problems or the difficulties. The stories have become in effect fictionalised and visualised problems. There is less kissing or 'necking' shown in the pictures. And there is almost no heavy petting on the sofa. These changes could be attributed to a number of factors, the increasingly young age of the readers, for whom having a boyfriend is more a question of classroom teasing for example, than a reality, or perhaps the impact of television series like *Grange Hill* which cater for younger, pre-pubescent viewers.

These shifts could also be attributed to a wider climate of greater sexual equality which rejects and resists 'sloppy romance' as outdated and old-fashioned. Once again television is likely to have had the biggest impact. Popular series like *Grange Hill*, *Brookside* and *Neighbours*, go to some lengths to overturn rigid gender-stereotyping. These programmes show girls having the best of both worlds. They are strong-minded, independent and assertive, and at the same time they have dates, fall in and out of love, and think about getting married. Boys are seen to be capable of having feelings while also enjoying masculine activities. As protagonists in relationships, girls are shown to be occupying a more equal position than they did ten years ago. Television is so central to leisure activities and is so much talked about by young viewers that is is difficult to imagine it not having an influential effect on other culture artefacts marketed towards youth like teen magazines, and, as Janice Radway has pointed

out, romance does change.[17] However, in the photo-stories con-
sidered here it will be part of my argument that change is as
much part a product of the 'generic crisis' mentioned above, and
of the fact that the editors and writers no longer know what to
do with the stories, as it is also a product of female discontent
with the kind of stereotypical behaviour which was such a staple
part of the picture-romance. The future of the form, it seems,
is uncertain.

Let us then look more closely at the specific magazines and
the kinds of stories which have appeared on their pages in the
past few years. There are quite clear differences between the
various stories carried by each of the comics (in this case *Jackie,
Girl, Patches* and *Blue Jeans*). Some focus almost entirely on
family relationships while others, like *Jackie*, 'try out' a number
of story-types in a bid to capture the spirit of the 1980s. Only
Patches and *Blue Jeans* retain a commitment to the traditional
romance. And since their sales are both steady and relatively
low it might be concluded that equally low overheads allows
their publishers to hold onto them as less profitable but nonethe-
less stable products. Both these magazines are also unambigu-
ously down-market. They speak directly to working-class girls
and carry little of the material which crosses class boundaries
and which contributes to the success of *Just Seventeen and Smash
Hits*. There is very little fashion in these publications, less empha-
sis on beauty and 'looks' and less space given over to uninterrup-
ted pop coverage. Instead they devote more space to the three
or four stories they still carry each week. The girls in these
stories tend to be more reliant on male approval and more in
need of a boyfriend as a means of achieving some degree of self-
value than is the case in the stories found in other comics.
Frequently very little seems to happen in these photo-stories. A
boyfriend is lost or won, the story ends in an embrace or in
tears. Some moral anecdote is loosely threaded through the nar-
rative which in turn seems to do nothing more than lurch from
one set of conversations to another.

One story titled 'Obsessions' is fairly typical of this genre. It
opens with a couple having a row in a cafe with a waitress
hovering around in the background. The boy returns the next
day alone and looking upset. The waitress makes a move to
capture his attention and ends up with a date. To the experienced

reader of comic-strip romances she seems to be unwisely forward and pushy and indeed she is later shown as taking all the initiatives such as telling him that she has her own flat, inviting him back for coffee after their first date and being sexually over-eager. He is put off and sorts things out with his old girlfriend. The waitress is then pushed to the side and cannot believe that he does not really love her. She then becomes obsessed with him and begins to follow the couple about, staking a claim on the boy and making things difficult for his girlfriend. He denies having any feelings for her and she is left feeling bruised and used. The moral, of course, is that she asked for this treatment by being too easily available in the first place. Like so many other stories 'Obsession' is less of a romance and more of a warning – a kind of readers' true experience set to pictures.

Frequently the stories lack any substantial narrative development. In one *Patches* story a girl expects to be going away for the weekend and therefore will not be able to go to the party to which she and all her friends are invited. At the last moment her plans fall through and she decides to go to the party after all, in disguise. She is dismayed and bewildered when her boyfriend spends the evening chatting 'her' up and leaves in tears, too late to discover that he was talking to her on behalf of his shy friend . . . The lack of fantasy in the photo-stories in *Patches* and *Blue Jeans* and the constraints of realism are occasionally compensated for through the introduction of a magical element. In 'Message in a Bottle', for example, a girl makes up a love-potion and brings it with her to a party where she hopes to be able to slip it into the drink of the boy she fancies. However, a whole group of boys take it by mistake and spend the evening pursuing her so much that the boy on whom she had her eye does not get a look in.

A familiar stock of feminine wisdoms winds its way through these stories. If you cannot get the boy you want do not hang about, make do with the one who is keen on you, you might even end up falling for him. It's better to have somebody than nobody. This lesson comes across loud and clear in 'Fat Chance' where a girl who is slightly overweight is desperately trying to get rid of a few pounds before going on summer camp where she will be spending time with the athletic boy she fancies. But even with her newly trim figure he is still not interested.

Dejected, she exchanges a few words with a boy who is an avid bird-watcher. She discovers that she prefers less active hobbies and that this bird-watcher is just as nice as the athlete. The impossibility of being alone and without a boyfriend in these romantic narratives articulates with the wider context of working-class life to which allusions are continually made in the stories. The action frequently takes place in the supermarkets where the girls have jobs after school, or in the butcher's shops where their boyfriends work.

In contrast with this sense of sameness, *Jackie* stories in the past few years seem to jump from one type to another as though indicative of its loss of direction in a world where it once occupied a position of absolute dominance. From 1986 the stories in *Jackie* dropped to just two. These tend to move from the more traditional 'He's two-timing me so I'll two-time him' type of narrative, to the more daring stories which translate real dilemmas into a photo-form. These are overladen with the signs of working-class life as though to give them authenticity and thereby secure them all the more precisely in the context of 'real life'. Boys suddenly become 'lads' and friends become 'mates'. Boys frequently steal, sometimes in front of their girlfriends whom they expect not to 'shop' them. Indeed they sometimes even expect them to hold onto their 'stolen goods'. Romance is also replaced by the more problematic demands of sex and girls are shown as having to work out whether it really is love or whether he is just after 'the one thing'. In one story a first-form girl is the envy of her class because she is going out with a good-looking fourth-former. The problems arise when he begins to expect more of her than she is willing to give. Even though she manages to hold onto him for some time she senses that the crunch is going to come as indeed it does one evening after a night out when she agrees to go back to his house. She ends up running out in tears saying that she is 'not ready for anything like that yet'.

In this more realist mode peer-group pressure is shown as influencing the behaviour of young people, especially boys. In 'All Talk' the 'lads' tease Pete about how much he is 'getting from' Jane. To save face he implies that they are sleeping together and when this gets round the school the girls gossip about Jane's now-tarnished reputation. When she finds out she

is shocked and upset. Pete eventually admits that he made it up to impress the boys and pleads with her to have him back. Another story continues in this more controversial mode by addressing the question of mixed-race dating as seen from the viewpoint of a white girl. Her parents say things like 'You shouldn't be going out with somebody like that' and the boy also finds that he has to put up with the pressure on them to split up. Somehow, however, they manage to keep going.

Despite these innovations (one story even took up the question of sexual harassment at work) and despite a kind of *Grange Hill* equivalent titled 'The Grat Pack' a multi-threaded serial set in a school called 'Gratton Comprehensive', the stories still seem barely to stumble along, desperately looking for any narrative twist which comes their way. In 'The Grat Pack' very little happens at all except that there is some evidence of friendships between boys and girls which are not automatically transformed into the language of love and sex. Since *Jackie*'s reputation has depended both on the number of stories it runs and on their variety, it is not surprising that the decline of the stories is reflective of the decline of the magazine as a whole.

In June 1988 *Girl* dropped its weekly average of four stories to just one. It did this as a result of an extensive reader-survey which indicated that pop and fashion were more popular than romance with 1980s teenagers. *Girl* stories in fact focused much more on the family anyway. The romantic interest was always fairly low-key and pre-pubertal. Romance was synonymous with the tricky problem of getting to know boys, or exchanging glances with them. It was also about the girls themselves recognising and attempting to come to grips with the psychological changes brought about by the onset of adolescence. Otherwise the stories were about facing up to the reality of family conflict and even breakdown. In one series which ran over a period of several months, titled 'Annie's Place', two sisters had to learn to live with their parents' separation and with their new partners. And in 'Patty's World' the heroine who had just got used to her new step-father also had to acclimatise herself to the idea of a lodger who, as it turned out, was an unpleasant and suspicious character. In 'The Prize' a girl and her brother entered a competition hoping to win a holiday for their exhausted, hard-up and

quarrelling parents. They were lucky, won the holiday, and their parents came back in much better spirits.

Stealing and petty theft also enters into the world of *Girl*. But this time it is the temptation to steal from within the family in order to keep up with other girls. One girl steals from her gran's secret 'tin' to buy tapes to go with her ghettoblaster. When Gran discovers the theft Sally has to sell the ghettoblaster to replace the money. Apart from this she is also ashamed of herself and bitterly regrets stealing from a member of the family. Theft appears in a variety of forms but it is not as serious as that described in the other photo-stories and it is rarely premeditated. Frequently it is the *idea* of stealing which is dealt with rather than its reality. *Girl* stories steer well clear of the kind of controversial topics found in recent issues of *Jackie*. The problem element in the photo-stories is almost entirely restricted to family problems and this is balanced by stories which also stress the fun dimensions of family life. These include narratives hinging on an eccentric 'gran' or an interfering but funny aunt . . . and so on. Social realism finds a small place alongside these pre-teen interests. Mum cannot make ends meet and will have to take on an extra job; Dad is made redundant and the whole family might have to move to a different town where he has been offered a job. An elder sister's boyfriend is having trouble finding a job ('Any luck at the Job Centre, Pete?') . . . and so on.

In this social world where the girl-characters are just feeling their way into adolescence, romance is lightweight and relatively troublefree. In 'Dream On', for example, a girl who works on Saturdays in a florist's shop dreams that one day a boy will come in and buy a bunch of flowers for her. Her dream eventually comes true and she cannot believe it when it happens. In 'Stand By Me' another girl reflects on why her boyfriend has given her up so quickly. She does her best to win him back but when this fails she switches off and turns her attention to another boy she has seen in the playground at lunch-time.

The single remaining *Girl* story has stuck with this kind of whimsical formula. There is very little action, few characters and a more dream-like quality. The story is to be looked at rather than read. The black-and-white realism has given way to full-colour photo-strips, all the detail is pared down and the narrative itself is abbreviated. For example, in one of these stories a girl

bumps into a good-looking boy in the photo-shop where she is getting her holiday pictures developed. She is given the wrong photographs and hopes that they might be his so that she will have the opportunity of changing them with him. As she looks through them however she sees that they belong to somebody quite different. Disappointed she realises she is unlikely ever to see him again.

This kind of story is closer to the whole atmosphere of the new *Girl*. It is not just that pop music dominates the re-launched magazine, but that fantasy about pop boys saturates it. Romantic *fiction* about the boy-next-door have given way therefore to more direct *fantasies* about pop stars. *The need for narrative has mysteriously disappeared and has been replaced by an excess of information about an endless flow of young men whose records are either in the charts or about to be in the charts.* Instead of stories there are more giant pin-ups, and endless numbers of pop 'snippets'. Pop stars are joined by the stars of soap (currently almost all the characters in *Neighbours*) and by TV presenters like Philip Schofield, to create a panorama of visuality focusing on male good looks . . . *Girl* magazine is not just in line with current trends by minimising its story content, by increasing its pop coverage, by giving over more space to 'stories' about the stars and by ensuring that its remaining photo-narrative is evocative of these pop fantasies, it is exactly within that terrain which in the late 1980s brings together pop consumerism with the pleasure of fantasy. The relationship between the magazines and the record industry becomes one of increasing mutual dependency expressed in, and symbolised through, the emphasis on looking.

Questions and answers

One evening, I heard noises coming from my parents' bedroom. I started crying and my mum came into my room. When I asked her what was happening she said she and my dad were having sex. I never realised they did this. I just can't imagine it. I've tried to talk to my mum but she just said I was being stupid. Later this year I found dirty magazines in their drawer. Please tell me what to do. I'm desperate and want to run away.

It's a pity your mother is unable to talk to you about this, but my guess is that she may find it embarrassing . . . I'm very sorry that this upset you and made you feel so uncomfortable. If you feel it would help to talk things over with a sympathetic counsellor, send a s.a.e. to . . .

Despite the long-standing place of the problem page in girls' and women's magazines, very little sustained critical attention has been focused on this intimate mode which relies for its success on a careful navigation of the boundaries which mark out the private from the public. The problem page is a public form which invites readers to seek help by promising confidentiality and advice. The problem page works on the assumption that many people experience the same kinds of problems and will therefore benefit from realising they are not alone. In girls' magazines there is a recognition that adolescence brings into being an acute set of conflicts and contradictions and that frequently there is nobody from whom to ask advice.

The advice column or problem page has a long history. As Janice Winship has pointed out the strongly moralistic tone of the earliest advice columns has given way in the past twenty years to a more supportive approach.[18] Nonetheless the cosy intimacy of the problem page and its seeming entrapment in the world of feminine 'troubles' has led to it being the butt of jokes and to its journalists or 'agony aunts' being ridiculed by their more 'serious' colleagues. The only way they can overcome this low status in the field of journalism is to become experts rather than intimates and professionals rather than 'aunts'. A few like Claire Rayner and Marjorie Proops become celebrities writing their own books and appearing on television. However, with the notable exception of Melanie McFadyean, the advice-columnists working on girls' magazines like those dealt with here tend to remain more or less anonymous. Their only defining characteristic is that they are apparently still young enough to understand the misery and distress brought about by seemingly trivial and insignificant adolescent fears and anxieties. McFadyean, *Just Seventeen*'s 'agony aunt' for five years, suggests that the low status of the advice-column journalists is the result of snobbery and disdain within the world of serious 'quality' journalism.[19] Writing

for a problem page is seen as an unimportant task in the same way that girls' comics are seen as essentially silly or lightweight forms. McFadyean argues that problem pages serve a crucial function for millions of readers who do not have access to the world of counsellors or sex-educationists, and who possibly do not have the kind of enlightened middle-class parents who are able to talk openly to their daughters about the changes taking place in their bodies or about the world of adolescent sexual encounters.

The advice column is therefore an open forum for a section of the population for whom there is not a huge array of therapeutic facilities available or even sympathetic liberal-minded teachers. During any one year at *Just Seventeen* McFadyean received on average 12 000 letters, i.e. 250 each week. From this only twelve or fourteen would be chosen for publication. It was precisely the number of letters which poured in that forced her to confront the degree of pain and misery which so many girls were experiencing.

> Letters describing this kind of hell [a sex-abuse case] arrive with every postbag and the agony aunt is often the first person the girl has told.

From this perspective it might be argued that this 'silly' form is in fact playing an extremely important role. It is listening and responding to, a discourse which so far has found no other space in which it is able to 'speak itself'. McFadyean lists the kinds of problems which arrived on her desk. These include boyfriends, love and sex, followed by careers, health, looks and self-image, fears of pregnancy, family problems, school, fears of homosexuality and disclosures of sexual abuse or incest.

This is an accurate account of the range of problems dealt with in most of the weekly magazines throughout the 1980s. There are variations, however, in the questions which gain the greatest prominence and in the style of response to these questions. Each magazine attempts to develop its own particular angle on the problem page and this is usually reflected in the person (or persons) who answers them. In *Jackie* for example, Cathy and Claire give the problem page a friendly confidentiality, as though the readers are asking advice from their elder married sisters. In *Blue Jeans* and *My Guy* the problem page is more

anonymous, the questions more starkly stated and the issues raised frequently of a more serious nature. *Just Seventeen* not only publishes questions which would not appear in the other magazines, like the one quoted at the start of this section; it also answers these questions in greater length, and with a liberal open-mindedness not found elsewhere. The best example of this is the issue of lesbianism or homosexuality. In all the other magazines this is occasionally raised in terms of 'a girl at school who is staring at me and my friends and acting strangely'. The standard response is that this is nothing to bother about and that the girl is probably going through some sort of phase. *Just Seventeen*, in contrast, will strongly assert that there is nothing wrong with lesbianism, that it is perfectly normal but that in our homophobic society young people who think they might be gay or lesbian experience great difficulty in coming to terms with their sexuality because of the prejudice and discrimination they are likely to suffer.

This frankness has resulted in McFadyean receiving letters from angry parents who see her column as providing young people with ideas and knowledge which is either wrong, dangerous or misleading. Complaints of this type point to those features which are at the heart of the genre; the boundaries which demarcate and define that knowledge which is appropriate or inappropriate, acceptable or unacceptable. It is not surprising that problem pages trade in sexual knowledge since it is this which is so uneasily avoided in our culture and so heavily coded in the normative language of love, romance and marriage. Advice columns exist because of so much that cannot be said, or cannot be discussed elsewhere. They occupy a particularly important place in teen magazines because it is in adolescence that this knowledge takes on an urgency. Even with the advantage of liberal parents, unembarrassed sex-education teachers and supportive friends, there is a whole area of grey uncertainty which cannot be mentioned. It is in writing that such knowledge can be requested and it is in the printed form that it is dispensed. The problem page depends therefore also on the boundaries which navigate the space between 'spoken sex' and 'written sex'.

For these reasons problem pages possess their own special qualities. They promise to articulate that which cannot easily be put into words, they promise to address those issues which lurk

in the background as sources of fear, distress or disturbance. An ability to unsettle as well as to reassure makes the problem page something which is laughed at or even ridiculed. It taps those regions which are tainted with uncertainty. It recognises the conflicts and torments which are part of the human condition. It is, of course, a primarily feminine form since it is not only women's lot to suffer personal unhappiness in a particularly acute form; it is also their duty to try to alleviate the unhappiness of other people. Caring and nurturing and attending to the 'affects' are still women's work. While men dominate the medical and other professions women far outweigh men in the 'caring professions'. As a result women are more likely than men to 'seek help' and to acknowledge problems in their personal life. This is apparent not only in the popularity of the problem pages in girls' magazines and in their almost exclusively female focus, but also in the gender exclusivity of the magazine form. There are no male equivalents to *Girl, My Guy, Patches* or even to the more pop-focused *Just Seventeen*. Boys have to read both the magazines and their problem pages surreptitiously, when their sisters have finished with them. In recognition of this a few magazines have introduced a boys' advice column. This serves a double function of allowing boys to describe their insecurities and simultaneously reassuring girls that boys also suffer.

Let us look at the range and type of problems appearing each week on the pages of *Blue Jeans, Patches, My Guy, Jackie* and *Just Seventeen*. There are a number of questions common to all these magazines which solicit a similarly 'sensible' response. These range from the nasty girl at school who is too eager in her pursuit of boys, to the friends who want to play truant, the Mum who still wants to choose all her daughter's clothes, and the girl who cannot stop borrowing money. Also common across all these publications are the anxieties about weight, spots, BO, ugliness and 'flat-chestedness'. The most significant question which has found its way onto all the problem pages in the past five years relates to sexual abuse. Physical abuse within the family also appears, ranging from cases of drunken fathers hitting out, to regular beatings by both parents, to being continually and unrelentingly picked upon. Partly as a result of the recent attention given to abuse in the media and partly also because of the appearance of AIDS, there is greater explicitness about sex

in the problems published and in their answers. Much of the coyness has gone and the replies are both firm and frank. Girls should not feel obliged to have sex with boys just because they are being persuaded, if on the other hand they want to be sexually active, they must find out about, and make use of, effective contraception.

The nature of the answers reflects not just a changed sexual climate. It also suggests that a wide range of feminist ideas has entered the realms of popular common sense. Assertiveness is encouraged in personal relationships. If a girl is being hit or mistreated by her boyfriend, she is advised to give him up immediately. If her boyfriend is over-possessive, short-tempered, or taking her for granted, she is advised to assert herself more strongly and if this fails, to think about breaking off the relationship. To the girls who write in worried about a possible pregnancy ('I haven't had a period for four months and I didn't use any contraception . . .') the answers are uncompromisingly frank, urgent and to the point. (In answer to one *Patches* reader who received no sex education at home or in the school, Jane Cousins's well-known and controversial feminist book *Make It Happy, Make It Safe* is recommended.)

Of all the magazines, *Jackie* has held back most of this increasingly open attitude to sex. This is most likely the result of D. C. Thomson's well-known commitment to old-fashioned puritanical values. There are fewer questions about sex, pregnancy and contraception in *Jackie*, and instead there is an emphasis on all the old boyfriend problems ('two-timing', 'he's cheating on me,' etc.). The only noticeable change is that the coy and frequently unrealistic pieces of advice which used to be given ('Why not just go up to him at the bus-stop and spin him a sob-story about just having lost your dog?') have given way to a more relaxed approach. It is now possible to survive without a partner and it is even possible to opt for friendship rather than romance. If nothing else, *Jackie* readers are encouraged to develop a stronger sense of self-esteem than was the case ten years ago.

The voyeuristic element becomes less prominent when the problems published are issue-based rather than narrative-based. This occurs when the problematic features are highlighted and the story-elements played down. The experiential dimension fades and is replaced by a slightly more impersonal mode. Once

again *Just Seventeen* has taken the lead here. McFadyean's edi-
torial as well as advisory style, transformed the problem page
into an open forum rather than a private space. McFadyean
berated her readers when she felt necessary, and answered their
queries with neither coyness nor embarrassment. Occasionally
she let her exasperation slip through, especially when she felt a
reader was allowing herself to be exploited. McFadyean also
realised that it is often the fine pernickety details about sex which
remain the most confusing and puzzling.

To a girl whose partner's condom has split during intercourse
McFadyean recommends the 'morning-after' pill and supplies her
with the details about how she can get hold of it. To the girl
who has been sexually abused since she was 2-years old, she
gives several column inches to explaining exactly what she should
do and where she can seek help. Other subjects tackled by
McFadyean during her time at *Just Seventeen* included exploit-
ative, low-paid work, political issues such as apartheid,
depression, lack of self-confidence and unhappiness at home. By
taking on this broad range of issues McFadyean managed to shift
the balance away from the troubled world of femininity and the
kind of resignation which so many problem pages evoked, and
insisted that these were social problems and that they were not
the result of individual failure, weakness or stupidity. Where
Cathy and Claire initiated girls into a closed world of suffering
McFadyean sought to dispel a whole set of myths and mytholog-
ies about femininity. Where Cathy and Claire still whispered
their replies, like chemists wrapping a box of tampons discreetly
in a brown paper bag, McFadyean shouted them out loudly in
the hope that they would be heard.

It was suggested earlier that in the more down-market comics
like *My Guy* and *Patches* the problems were starker, often of a
more serious nature than those found in *Jackie* and *Just Seven-
teen*, and somehow more poignant. To illustrate this point it is
worth drawing attention to the kinds of problems found in one
issue of *My Guy*. Chosen at random from a three-year run of the
magazine there was, on the double-page spread, one pregnant 14-
year-old who had run away from home and was too scared to
phone her parents, another girl whose parents continually called
her a 'cow, a bitch or a slut', one girl who wanted to be a model
and had allowed a 'photographer to take pictures of her posing

with no knickers', and another girl who could no longer bear her home and her drunken father. In an issue of *Patches* there was a girl who thought she was about six months pregnant, a girl who had been 'used and then dropped', another girl worried about her mum who seemed to be letting herself go and no longer cared about her appearance, a girl who wanted to know if it was possible to get pregnant without having sex and somebody whose best friend was having severe psychological problems.

The extent to which sexuality plays a dominant role in this range of unhappy and distressing experiences forces a more direct engagement with the way in which the problem page defines, navigates and regulates the sexual expectations of teenage girls. This in turn necessitates a final look at the genre as a whole. In that small body of work which exists on the subject, three positions can be detected. Many of the foregoing comments are responding to an article by Melanie McFadyean where she describes her role as agony aunt at *Just Seventeen*. McFadyean's position could be described as *realist* in that she takes for granted the transparency of the question-and-answer form in the production of its meaning. The problems are authentic expressions which are directly reflective of the experiences they describe.

The problem with this is that it fails to take into account all the intermediary processes in which McFadyean herself as editor and advisor participates and which play a crucial role in determining the meaning of the problems and the problem page. It ignores the selective devices which shape the role the page plays in the magazine as a whole and it ascribes to the readers who write in, a unity of feeling and sensibility which is a direct reflection of their suffering.

McFadyean has done much to dislodge the old, shameful and conspiratorial tone of the problem pages. But her assumption that all the problems are mechanically and automatically reflective of pain and distress blinds her to the other functions of the page. She makes no mention of the pleasure associated with the problem page and with its popularity across a wide range of publications. Her failure to engage with the multiplicity of readings which these pages can produce (cynical, disbelieving, humorous, etc.) make her a 'naive' reader of her own page. This is further emphasised by her neglect of all those interventive pro-

cesses in which she herself participates when she is choosing which problems to publish, and which features of the problems to highlight and engage in the reply. This is accompanied by an unwillingness perhaps to accept the fact that problem pages are not always read in private and not always for the 'truth'. Most agony aunts know, as McFadyean must know herself, that at least some letters are written collectively during the school lunch-hour. This does not detract from the importance of the question being asked; indeed if Freud is right the joke element in writing as a group emphasises its significance, not for one person but for the group as a whole.

The fun-dimension of the problem page is more openly acknowledged by Janice Winship, whose position might be described as more conventionally *feminist*.[20] The pleasure element depends partly on the *schadenfreude* effect – the relief that other people's problems are worse than one's own. It is also closely tied up with the voyeurism which accrues from seeing those other miseries described in print. This, she claims, is what makes the problem pages so deeply anti-feminist. There is little chance for sisterliness or solidarity among women when such individualism and self-complacency are built into the heart of the genre. Winship concentrates therefore on the internal relations which characterise the form rather than on the external circumstances in which it is read, giggled over and passed along the back row of the classroom. Her argument is that having to write in to a magazine in this way is in itself a sign of isolation and loneliness. Without the advantage of a supportive female network it is no wonder that the problems themselves are seen and experienced as reflective of a personal failing rather than as the product of an unequal society. Magazines encourage such individualism and therefore implicitly store up the damage already done elsewhere. Attention is rarely drawn on the problem pages to the wider context in which such problems are created as a result of the structural subordination of girls and women. Winship also argues that the replies do little in the way of offering scope for real change. They discourage women from connecting with each other and from devising ways of confronting their discontent collectively. They prefer to keep things quiet and confidential. They prefer to deal in hushed tones than in noisy clamours.

This is close to the kind of position taken by myself in my earlier work on *Jackie* (see Chapter 5 of this volume). As various writers have since pointed out this too is guilty of a kind of naivety. Problems may be socially produced but this does not mean we experience them as such. Nor does it mean we do not look round for some kind of relief or resolution. It is unlikely that an advice column which continually pointed to the social origins of feminine discontent would attract enough letters each week to keep going. Feminist critiques of the individualism which is inscribed within the formal dynamics of the problem page fail to confront precisely the constraining elements which dictate what can and what cannot be said within that form.

Instead of seeing the problem page as a kind of last outpost for communication when there is no other means available, it is possible to turn this model on its head, and redefine it as a very public form depending for its effect on a kind of masquerade. That is a public form which feigns a private intimacy thus permitting not so much a trickle of strangled cries from the heart, but rather a flood of sexual voices. This final position might be described as *Foucauldian*. Following the important work of Michel Foucault and more recently by Stephen Heath on sexuality, such a position would recognise the problem page not so much as a sign of sexual repression but rather as a reflection of the profusion of sexual discourses which fill the air-waves, cover the pages of the magazines and invade the inner reaches of the domestic sphere.[21] The proliferation of discourses which came into being in the late nineteenth century have the effect of eroding the division between the public and the private. All that can be investigated or inquired after sexually is subject to the scrutinising gaze of the discursive machinery which surrounds us all. This means that even the kindly tones of the agony aunt could also be seen as part of a regulative system. The encouragement to write in, the compulsion to 'tell all' reveals a powerfully normative mechanism at work. Instead of being repressed or swept under the carpet, sexuality is something which now must be spoken about. It has become the mark of our true individuality and the expression of our inner selves. Within this framework the problem page defines the contours of the sexual discourses which are appropriate to adolescence. It requires teenage girls to describe their anxieties, fears and sexual insecurities so

that they too can participate in the discursive apparatus which are all the more easily controlled by being out in the open. A problem shared . . .

> Witness, confession, testimony . . . We should all narrate, recount, tell ourselves, fill the testimony columns of *Penthouse* or *Mayfair* . . . *Playboy* or *Playgirl*.

Stephen Heath sees this process, 'the constant narration of the social relations of individuals', as part of a much wider work of 'social representation'.[22] That is, the individual learns his or her individuality precisely through this ceaseless telling and re-telling of personal failings and anxieties and dilemmas cast in the form of a series of never-ending stories. The person who seeks a way out of his or her problem has already learnt how to express it in such a way as to conform to the requirements of the genre. The reader learns through seeing the story in print what to expect, how to feel and what sense to make of his or her own similar dilemmas.

Relations of power are diffused through a whole set of 'capillary actions' which come into being, in this case, around the conventions and framing devices characteristic of the form. The power lies then in the hands of the media whose role it is to define the appropriate language, to provide readers and viewers (whichever is appropriate) the correct terminology and to make out for these social subjects how they are meant to feel, how they are meant to act.

In this context teenage readers, as Melanie McFadyean points out, are not powerful individuals. The problem pages depend for the existence on the willingness of readers to write in, and they must therefore be presented with a friendly open-minded image. The power to select what gets published and to highlight which kind of issues appear and most of all to dispense information and advice is entirely in the hands of the editors. The regulative, controlling mechanisms operate precisely along the terrain of the provision of knowledge and the way in which it is dispensed. Foucault alerts us to the way that an apparently liberal and even progressive discourse can in fact also be playing a policing role, particularly in the field of sexuality where society invests such a great deal in attempting to separate the normal from the abnor-

mal, the acceptable from the unacceptable. From this viewpoint the problem page would represent a privileged site in the creation of a number of discourses designed so that they may be used by teenage girls to make sense of their complex and frequently contradictory feelings in relation to their own sexuality. It might even be described as a focal point for the construction of female sexuality which exists alongside other discourses, sometimes in harmony with them and on other occasions and in other contexts at odds with them. The problem pages, therefore, add to the clamour of already-existing organising discourses, such as those found in the school, the home and elsewhere in the mass media.

These discursive forms and apparatus are also open to change and contestation. The problem pages have seen remarkable changes over the past ten years. To understand these changes it is necessary to draw from all three of the positions outlined above (realist, feminist, Foucauldian). The possibility of a counter-discourse has come from the impact of feminism and feminist ideas which have found their way into the public sphere over this period.[23] Janice Winship's feminist critique of the problem pages is ironically challenged by that feminism-from-within which has surfaced in so many of the women's magazines over the past ten years. This is partly a result of the people now working on the magazines who themselves have been influenced by feminism. And the young women readers who have benefited from achievements of 1970s feminism and who as a result are more aware of sexual inequality, at a kind of common-sense level, are more likely to want from their magazines something other than the kind of advice Cathy and Claire used to dole out about not being too clever because it puts boys off! This change of climate has also made it more possible for other areas of discussion to be opened up. The reality of sexual abuse or incest as described to Melanie McFadyean needed the political space made available by feminism in order to break through into public discourse where it still occupies an uneasy place today.

In conclusion, it is in the problem page that we find, in the 1980s, the strongest definitions of teenage femininity. It is here, rather than in the realm of romance that female identity is given shape.

Just looking

Of all the features which regularly appear in girls' comics and magazines, pop coverage has the closest and most direct links with the world of commodities and with the 'hard sell'. The advertisements dispersed throughout the pages of the magazines are of course wholly given over to promoting their various products. But the other contents retain a slightly more distanced relationship with consumerism. Apart from pop, which is encoded for this audience into the language of the stars in what Stuart Hall has described as a 'personalising transformation',[24] the other features are more directly about the self and the self in its social context. Some of this material has a consumerist focus. The fashion and beauty pages, for example, introduce girls to the huge ranges of cosmetics and beauty products targeted at this end of the market. But this is balanced by the way in which the reader is encouraged to exercise personal choice over her image and to play an active role in developing a personal style. The fashion and beauty pages encourage an active negotiation on the part of the girl. There is less of a hard sell for the simple reason that an interest in these subjects is taken as a natural, taken-for-granted feature of femininity. It would be extremely unusual not to be interested in hairstyles, 'cleansing' and all the other intimate rituals which are an intrinsic part of being a woman in contemporary consumer culture . . . The relationship between women and music – and in this case pop music – is however much more problematic.

The music industry is still dominated overwhelmingly by men, as are its products. Men control the technology, the record companies, and the publicity departments. Women (or girls) are concentrated in clerical and secretarial work and in the press offices. At every level men play a more active role in pop, rock, soul, funk, rap and all the other musics which have emerged in, or which continue into, the late 1980s. Women buy fewer records, go to fewer gigs and know less about music than their male peers – except, that is, for the millions of teenage and pre-teenage girls for whom music means stars, and in particular a set of stars who direct their energies and their image towards this audience. 'Teenybop' stars have been around for a long time now. Everybody, including the stars themselves, points back to

the Bay City Rollers of the 1970s as emblematic of this special relationship between pre-teen girls and late-teen boys whose musical talents are irrelevant and whose hits are written, produced and often performed for them by other people.

There are a number of features which mark out the 1980s as different in this respect. As the music business faces what is becoming a long-term crisis of profitability there are more of these sorts of stars.[25] Although there is a good deal more money to be made from older and established bands like Dire Straits, record companies must also look to the less reliable world of fast-turnover pop. These stars are young, easily manipulated and hungry for fame and publicity. With the expansion of the magazine industry and the greater coverage given to pop on television, groups like Bros take up a great deal more space in the magazines and in the other mass media forms, than was conceivable ten or fifteen years ago. This greater prominence given to pop has also coincided with a critical shift away from 'indie' music or serious pop back towards pure pop. Pop as a genre, in its most contrived, artificial and quintessential forms, has taken on a new respectability and has therefore attracted the interest of a wider range of musicians who otherwise might have gone for a more upmarket audience. Since the early 1980s the pure pop mainstream has also been pinpointed by Paul Morley writing in the *New Musical Express* as well as by musicians like Scritti Politti, ABC and many others as a kind of point of intervention, a place where it might be possible to be subversively popular instead of being critical or radical from miles out on the fringes of the independent scene. There was a moment, at the tail end of punk, when these musical energies were re-directed back towards that sector of the music industry which was most despised by serious musicians. This was a market which consisted of a female rather than male audience. The new attitude on the part of those bands and musicians whose interests were turning in this direction, combined a finely tuned recognition of the profits to be made from the pocket money of 13-year-olds, as a result of soft soulful pop tunes and heart-throb good looks ('Wham' were the best example) with a new commitment to the pop mainstream. There was a kind of camp splendour about having thousands of girls screaming and crying and setting up

fan clubs up and down the country. (Boy George was also a key figure in this post punk-to-pop crossover.)

The sweet sad strains of the Pet Shop Boys could be seen as taking this trend as far as it could possibly go. The Pet Shop Boys represent the high quality end of the pure pop spectrum. At the other end are the streams of one-off performers, marketed on their looks and increasingly on their reputations from the world of soap opera or advertising. This includes Nick Kamen of Levi 501 fame and more recently Jason Donovan of Neighbours. These 'celebrities' try their luck as pop stars in the hope that their popularity established in one sphere will magnify and catapult them, with the help of a good songwriter, into the mega-star stakes of the pop-music industry. In between these two extremes are the staple stuff of the pop charts and the kind of performers continually profiled in *Smash Hits, No 1, Girl, Jackie* and all the other magazines. In the past few years this list has included Wet Wet Wet; Aha; Curiousity Killed the Cat; Rick Astley, Brother Beyond and of course Bros.

The re-emergence of 'pure pop' in the 1980s has coincided with that change in direction in girls' comics and magazines already described at length earlier in this chapter. In the 1970s pop appeared in the pages of *Jackie* in one of two guises. There were standard pin-up shots in the back and middle pages, and there was a page of pop gossip slotted in elsewhere in the magazine. It was this latter which was to prove so elastic a form in the 1980s. Partly as a result of the upsurge of interest in the lives of the stars and celebrities as seen on the pages of the tabloids over the past ten years and partly also as a result of the pressures inside the record industry to break and make a more steady stream of stars, pop gossip has come to be one of the most prominent forms given space each week in the magazines. Indeed so all-encompassing is the influence of pop in *Jackie, Girl* and *Just Seventeen* that it is virtually impossible to separate the pop content from the other material in the magazines. *It is pop rather than romance which now operates as a kind of conceptual umbrella giving a sense of identity to these publications.* The presence of pop can be detected throughout the magazines. Pop stars, male and female, act as fashion models whose image is dissected for readers to copy. For example in a recent issue of *Just Seventeen* (September 1988) a series of pop look-alikes were

featured as fashion models on the front page. These included a girl wearing clothes and make-up like Wendy James from Transvision Vamp, a black girl done up in Bros clothes and another girl who modelled herself on Yaz. These images were then followed up in a five-page spread containing information and ideas on how to copy these various looks. More space is also given to interviews and profiles where the stars are subjected to questions like 'Which part of your body do you least like?' . . . *Just Seventeen* runs a feature titled 'Wish You Were Here', where girls can write in with their pop dream and, in Jim'll-Fix-It style, the magazine makes it come true. The resulting double-page spread contains on average no fewer than nine colour pictures, showing the girl enjoying a day with the group or star of her choice. The visual emphasis in this feature is not unusual.

Indeed it is a mark of the new pop focus in these magazines that the visual takes dominance over the written text. Pop is about images and about looking. Girl stars like Kylie Minogue, Tiffany, Madonna, Debbie Gibson and others appear regularly in girls' magazines and in *Smash Hits* in much the same way as their male peers. They are interviewed, quizzed about their private lives and their childhood memories, and photographed in a multitude of poses. However in the girls' magazines they take second place. The emphasis is very much on the boys who have more or less replaced the fictional boys found in the romantic stories. Any discussion of the music performed by these boys is almost wholly missing from the coverage given to them. There are no reviews, no comments on the kind of music they play, not even a description of their musical styles. Instead there is an overwhelming interest in personal information. The magazines increasingly play the role of publicist for the various bands who fall into the teenybopper camp. In return their pages are filled with glossy pictures and they can claim to have a direct line to the stars. This makes for cheap and easy copy. Three pages can be covered in a flash with the help of a transatlantic telephone call, a tape-recorder and a selection of publicity shots often provided by the record company.

In another recent issue of *Just Seventeen* a huge amount of space was devoted to Bros. They appeared on the front page in an inset, in the three first pop gossip pages (titled 'Frontline') and then they were featured over four pages in an exclusive

interview where they told readers how much they had enjoyed Japan, what kind of girls they liked to date, what their favourite food was . . . and so on. The language accompanying this kind of feature is joky in tone, light-hearted with a tinge of pastiche in its exaggerated use of 'teenage' slang. For example, the copy which introduced the Bros feature ran as follows: 'THEY'RE BACK . . . well sort of. Because its virtually impossible to pin Bros down on old man Blighty for more than a few billi-seconds these days, such are their global gallopings.'

Elsewhere in the magazines there are competitions to win Tim (of Bomb the Bass) Simenon's shoe, a feature where an invited star is asked to describe his/her best points in five minutes over the phone, double-page pin-up spreads, Donny Osmond's week in a feature called 'Donny's Diary' on the inside back page of *Just Seventeen*, an endless stream of gossip-pics showing stars caught by a cameraman in unexpected and funny (i.e. unflattering poses), and three-sentence information snippets about the everyday lives of as many stars as can be found in the charts.

This saturation coverage is partly responsible for the decline of *Jackie* whose sales have plummeted from their mid- to late 1970s peak. With a tiny staff most of whom are based in Dundee it is impossible for *Jackie* to be as up-to-date with 'pop info' as its rivals in London. Where it was able to fill its pages for years with the cheaply produced picture stories, problems and 'readers' true experiences', the demands brought about by this new pop culture make it difficult for *Jackie* to compete. It is still produced on the kind of colourful but matt-finished paper which in the 1970s seemed almost glossy in comparison with *Bunty* and *Judy*, but which in the late 1980s lacks the sophisticated lay-out and high-colour effect achieved by *Just Seventeen, Mizz, Smash Hits* and even *Girl*. *Jackie* does not have the kind of journalists who, following in the wake of *Smash Hits* are always on the 'blower' with Simon Le Bon of Duran Duran or Morten Hacker of Aha. Its relationship with the pop world is more tenuous, its emphasis more old-fashioned, paternalistic and less commercial. In the consumerist stakes of the 1980s *Jackie* lags behind. It still carries relatively fewer advertisements than the other magazines and it displays those commodities which are not being advertised but are instead being profiled, less prominently. *Jackie* still wants to be a traditional girls' magazine. Economically it is not in the

business of sending journalists to Japan to cover the Bros tour, and ideologically it retains a commitment to the old, traditional values. It would prefer to be in the business of moral education than in the world of transatlantic pop gossip.

The second key feature which emerges from this shift in balance away from romance towards the world of pop, is the emphasis on 'information' and the role this plays in female culture. For example over a period of one month every single issue of *Jackie, Girl, Smash Hits, No 1, Just Seventeen* and *Mizz* carried the same pop news stories. These emanated directly from the press release material made available by the record companies and were only re-written slightly with a different emphasis or angle in each of the different magazines. These included information about how Debbie Gibson had written one of her hits for a boy she saw on the beach, but never got to meet and about how she wrote her first song titled 'Know Your Classroom' when she was five. A similar catalogue of facts about Tiffany was published during the same period (who had fallen out with her mother and step-father and had gone to live with her grandmother), Kylie Minogue (who would never live alone as she would miss her parents too much), Rick Astley, Kim Wilde, Five Star, and many others. This profusion of 'facts' is accompanied with a profusion of visuals to the extent that the two seem to be integrally connected. The reader looks and knows and thereby acquires the necessary accoutrements of contemporary pop femininity.

These magazines also offer one of the few cultural spaces in which girls can stare unhindered and unembarrassed at pictures of boys. The endless supply of pictures including the pin-ups and the snapshots serve a sexual function based on looking. Many of these images draw attention not just to the head and shoulders but also to the chest and crotch, emphasising the male body as sexual and not just a matter of 'dreamy' good looks. However, looking is not just about entering into some kind of semi-sexual trance. It is also about knowing who is being looked at, what image he projects and what his records sound like. If this were not a crucial function of the pin-ups then they would remain precisely pin-ups, anonymous bodies and heads and shoulders like those found in soft pornography or in Page Three of the *Sun*. Looking at the pictures is thus connected to a whole chain of events and activities. It points the reader to the record and

therefore to the radio, the television set where she can see the latest video, the record shop and the concert hall. A wide range of media products have some stake in the careful placing of visual material other than (and alongside) the straightforward advertising copy. As Bros 'make it big', magazine sales rise according to their coverage of Bros. In turn Bros use the magazines to thank the fans for their loyalty and to reassure them that no matter what they read, it is the fans about whom the band care most. Since Bros rely on the readers and fans to buy their records and thus in turn 'make them famous' an integrated circuit is set up which is reflective of the interlocking dependencies which exist at a wider level between all those different component parts of the 'leisure industries'.

In the same way that pop cannot be entirely separated from all the other contents and features in the magazines, so pop is also the connective link between the record industry, the television companies, the advertising agencies, the motion-picture industry and all the hi-fi-equipment companies with interests in video, CD, 'walkmen', portable TVs and other low-level gadgetry which is none the less within the possible purchasing power of teenage girls. If the new magazines derive additional profits from the increased sales which their pop coverage brings, that same pop coverage makes a bid for the spending power which in the 1970s was beyond the imaginative grasp of an industry which assumed that girls bought the occasional single but not a great deal more. These days are now over, and being the focus of the concerted attention of the record industry is one of the costs young girls have to pay for their 'sexual equality'.

The hard sell is on at this point in their 'life cycles' for the simple reason that female pop consumerism on the Bros scale, cannot be relied upon in the longer term. Girls soon cease to be 'fans'. Being a 'Brosette', like being a Bay City Roller fan in the 1970s, or a Beatlemaniac in the 1960s, is not really compatible with entering into the real world of love and romance. It is an interim state, a transition point between being a girl and being a young woman. As far as the music industry is concerned girls buy records and pester their parents to buy them their own sound system and so on, and young women buy fewer records and tend not to replace their hi-fi. The question therefore is how to draw sufficient numbers of newcomers into the teenybop

market so that the losses are not so badly felt when their elder sisters move on to other things. The colour, the buzz, the high-quality photographs, the direct line to New York, the press passes and the new respect for the magazines which were once seen as silly, are all manifestations of the anxiety on the part of the industry to maximise their returns from this sector of the market.

The speed with which the boys can slip from the limelight is almost proportional to the speed with which the girls can move on to something else. It is the fear on the part of the industry that they give up altogether which accounts for the new accessibility of the stars. It is this which makes the stars at once heroic and ordinary and not beyond the grasp of the girl next door, or the average reader of *Smash Hits* or *Just Seventeen*. While it is unlikely that now in the 1980s, in a world dominated by leisure technologies, female fans will indeed retire into some quiet backwater beyond the reaches of *Top of the Pops* or Radio One, they remain nonetheless an unknown quantity in terms of predicting their long-term involvement as consumers in the global music industry. As older teenagers and as 'girlfriends' of male fans they nonetheless no longer signify as fans.

The particular problem for the music industry is in effecting the shift away from the visual emphasis which is the selling-point in the teen and pre-teen magazines, towards the musical emphasis which is needed if they are to become adult consumers (rather than fans). This difficulty is reflected in the massive absence of pop in the women's fashion and glossy magazines. By the time female magazine readers get to *Elle* or *19* or *Cosmopolitan*, pop-fandom has receded to the realms of pubescent memory, and the music industry can no longer rely on the kind of sales figures it enjoyed when these readers were buying *Jackie, Girl* or *Just Seventeen. The high pop profile found in these pre-teen magazines is therefore as much a sign of the instability of patterns of pop consumption, as it is an index of the increasingly fragile success of the pop-music industry.*

Fashion and beauty, the body and the pursuit of personal style

Fashion and beauty features take up a great deal more space and are also more dispersed throughout girls' comics and magazines than they were in the 1970s. They now occupy a place of prominence along with pop music while romance and the problem pages have been pushed into the background. In *Just Seventeen* beauty issues include body maintenance, hair-care and make-up. Attention is divided evenly between advocating good health and emphasising good looks. In the former this is achieved through a balanced diet, exercise, preventive medicine, 'regular check-ups', and so on. In the latter the health 'regime' is supplemented with the use of make-up and with the help of cleansers, tonics, shampoos, and all the other products which are marketed as vital feminine accessories. *Just Seventeen*'s position is anomalous in that its contents and advertisements are ostensibly focused on older readers (i.e. over 15 years old) who have more pocket-money than their younger sisters. It is these younger girls however who make up a major part of the readership. They are being presented with a much wider range of commodities than is found in those magazines more accurately targeted at their own age group, raising the question of what effect this has on their present and future consumption and what strains it puts on the parental purse.

Just Seventeen's success seems partly to lie in its appeal to both the 15-year-olds and to these younger readers. Beauty features are frequently directed towards the new ranges of products available in outlets like Body Shop which also cater for an extremely large age range. The relatively cheap, 'natural' and inexpensively packaged goods produced by Body Shop and also by Boots, makes these stores an obvious attraction for teen and pre-teen girls. The magazines benefit from the success of Body Shop and the other health and beauty retailers by the opportunity which they provide for promotion features. This has been one of the most noticeable changes in the magazines in recent years. The opening pages of most girls' comics and magazines contain 'bitty' features where new products are promoted often with an accompanying picture and sometimes with a form which can be sent off for a free gift. These are neither advertisements nor standard feature-type articles. They remain formally separate

from the double-page advertisements for ranges of cosmetics, shampoo advertisements and the smaller box-type advertisements for products like Anne French cleansing milk and other items which represent the staple of 'beauty' advertising copy for these comics and magazines, and, like the pop features, add to the informational focus of the magazine.

The tone of these beauty features is however markedly different from the traditional *Jackie* material on the subject. The emphasis now is on personal choice and the creation of a 'beautiful' individual identity. Readers are still encouraged to spend time on themselves but not to do so slavishly. There is a greater 'fun' element, a pleasure in experimentation and a suggestion that this should not be taken too seriously. The same pastiche-like language evident in the pop coverage can be found accompanying the beauty features. There is of course an undeniable element of regulation. The visual images show models who are extremely thin and conventionally beautiful. While some of the pressure may be off to dedicate huge chunks of time to 'being beautiful' there is still the implicit assumption that beauty routines are a normal and inevitable part of being female. Individual choice may not go so far as to refuse the compulsion to participate in these technologies of the self, although it is possible to opt for a 'natural' look, which is less labour-intensive.

To resist these rituals is to jeopardise the security of a firm gender-positioning. Cleansing, rinsing and all the other beauty routines help teenage girls to work their way towards a clearer notion of their own sexuality without necessarily introducing a more active or boy-oriented dimension. They are at the heart of what it means to be a girl rather than a child, and for this reason hold such an attraction as 'differentiating' rituals.[26] At the same time these are normative gender-specific processes as feminists for many years have pointed out. They pave the way for a woman's status and identity to become synonymous with her physical attractiveness. Boys are spared the time-consuming processes and though for them too the body become the repository and the visible sign of male sexuality, they can use that time, which girls *must* give over to the requirements of being beautiful, in a variety of different ways. It is convenient then that more female leisure time is spent in the home, and that girls are still expected to pay much more attention to their appearance than

boys are. When boys do become interested in style and personal appearance, this interest is much less tightly tied up with the home and the processes of continuous consumption.

If femininity is always more uncertain and less secure than masculinity, as a result of the rejection of femininity which is part of the psychic development of boys and girls, then it is the function of the images and texts of advertising and all the other beauty and fashion features to strengthen this fragile feminine identity, and in doing so to introduce girls to the seduction of buying.[27] Even though masculinity has recently been softened through similar commercial processes, even though men can now buy cosmetics at Next and beauty products in Harrods and at Body Shop, even though boys are more vain, more interested in fashion and more concerned about their personal appearance, the immersion in the body, the attention given to hair, and eyes and lips and legs and to every conceivable part of the anatomy, is still the privileged sphere of intimate femininity. Its rituals initiate girls into a world where they learn to be more certain and happy about themselves and the prescribed expectations of their gender. But both the certainty and the happiness are, as we know, fragile states. The market for beauty products does the job of helping to anchor femininity while at the same time unsettling and undermining it. If there is always another better look to be achieved or improvement to be made then there is no better way of doing this than by introducing an element of uncertainty and dissatisfaction. *Jackie* magazine thrived on this undermining principle by concentrating so much on what Bettelheim has called 'narcissistic disappointments'. The fear in *Jackie* was always that of failure. In *Just Seventeen* it is rather that of getting behind or of getting lost in the style stakes which embrace not just clothing but the whole field of personal appearance.

Beauty features therefore include double-page 'beauty problems' including puffy eyes, cracking nails, spots, dry hair and other similar complaints, double-page hair features (to perm or not to perm, to colour or not to colour?); a 'skin' special feature called 'Do sweets give you spots?', and another one called 'Spot Check'. In each of these features the rituals and the treatments are presented to readers either as fun or self-indulgence (immerse yourself in a herbal bath) and usually both. This means that a

necessity is transformed into a pleasure, an imperative into an act of self-love, or of self-gratification ('You deserve a treat'). This is a language and a rhetoric used extensively in advertising and in women's magazines. In girl's magazines it plays an introductory role suggesting the potential for bodily pleasures which resides in a range of products and which take the grind out of endlessly preparing the feminine self for the outside world. (Later, these rituals come to be associated – particularly in advertising – with anticipating sexual pleasure, the reward for having the good sense to choose this product or that shampoo.)

Beauty products articulate a symbolic space in the transition from childhood dependence to teenage independence. The tiresome rituals of washing, presided over by the mother, are transformed into the private rituals of 'cleansing' carried out by the self. The soaps and lotions and tonics and the freedom of choice exercised by the girl in purchasing these items play some role in effecting this transition. These kinds of processes, invisible to the sociologist whose concern is with the more public expressions of teenage or pre-teenage culture, are part of what Erica Carter has labelled the 'interiority of femininity'.[28] They fit in with both the sociological imperatives to be a girl and the psychic ordering which the girl 'needs' in order to feel that she is a girl.

Fashion and style in girls' comics and magazines in the 1980s show evidence of two changes. The first of these is the role of pop in influencing style and the second – to borrow once again a term from Stuart Hall – is the personalising transformation.[29] In this case this refers to the process through which a unique individual look is forged often through 'creative rummaging' in second-hand clothes markets. These two style directives complement each other. The pop stars provide a range of images which are then copied by thousands of girls. *Just Seventeen* orchestrates this contradiction by defining pop style as a cue for personal style and by marking it out as separate from high-street fashion. The way readers can be stylish lies in looking to the stars for ideas and then translating these looks into something to which they can add their own special itemised 'trademark'. Almost all the fashion features in *Just Seventeen* throughout 1988 have followed this pattern. Where the other magazines are less pronounced in their preference for style over fashion, they do show some signs of abandoning the commitment to conventional

dress which was a hallmark of the fashion features in all the magazines in the late 1970s. They do this perhaps more out of having to compete with *Just Seventeen* and with the pop influence of *Smash Hits* (which carries no fashion features but which does feature numerous photographs of pop stars in 'style' outfits) than out of any commitment to style for the sake of it and to imaginative dress of the sort favoured by *Just Seventeen*.

Punk has a great deal to do with the move away from safe, cheap dressing (from British Home Stores or Littlewood's) towards an emphasis on creating the self through the construction of a bizarre or outlandish personal style. The way in which this shift is reflected in the magazine is expressed in the idea that it is not sufficient to be pretty. Personality and 'fun' have also got to shine through. In *Just Seventeen* fun can be extended to embracing eccentricity or even 'madness' in dress. Pop music is seen as allowing all kinds of excess in the creation of a particular look. This means going to great lengths to ensure that nobody else will look quite like you. The key term in the fashion vocabulary of the late 1980s in *Just Seventeen* therefore is 'customized', i.e, taking a standard item of dress already endowed with all the necessary style credentials (501s for example), and then going on to improvise around this item. Thus in a feature titled 'Funky Beat' the accompanying copy reads as follows: 'Reveal almost all in a down-town mix of happening little numbers. They're naughty but nice.'

The outfits shown include jeans with a silver belt and off-the-shoulder top, cut-up jeans trimmed with lace, fringing and fake fur, and black levis worn with a cheap gaudy-looking real chiffon top. 'If you cannot get hold of anything on these pages, then just nip into your local haberdashery department and rip off a few designer ideas. They're so simple to copy.' A few pages later this theme is pursued further in a feature called 'Custom-made'. 'Personalise your denim for streetwise style. Copy our wicked designs and let your imagination run wild.' The pictures which follow show a hippy revival style titled 'Flower Power' ('Buy a remnant of floral material and cut out the flowers. Then sew them all over your jeans'). 'Haltered Images' shows a denim jacket cut into a halter-neck top worn with a lurid pink blouse underneath, and 'Yaz it up' features one of Yaz's favourite jackets, denim and covered with metal-can ring-pulls. Finally, in 'the

pom-pom club' another denim jacket is this time cropped to belly level and ringed with red pom-poms and the accompanying jeans are cut up and made into a mini-skirt hemmed with gold thread and red pom-poms.

In all these style ideas the influence of punk (the standard item is the pair of ripped Levi 501s) and of Madonna, is most startlingly clear. This is a messy, unkempt, and exaggerated look. The ideal model is a kind of urban ragamuffin. Sexy, skinny, but not simply there to be looked at. (This is expressed in the continuing popularity in fashion shots of Doc Marten shoes.) Unlike most fashion photography *Just Seventeen* positions its models boldly within youth culture, which in the 1980s does not mean in any one youth culture but rather part of that spectacular parade of retro, revivalist subcultures which coexist side by side. Fun elements and a strong emphasis on pastiche can be seen. Gestures are made to designer fashion but these too are treated with subcultural scepticism. They can be copied and run up more cheaply at home. *Just Seventeen* fashion therefore pokes fun at the high-minded tones of most fashion journalism. The essence of style is not to take it too seriously and not to pay much money for it. Style has to be home-made, do-it-yourself for it to have any real value. *Just Seventeen*'s fashion pages show a down-to-earth realism about what their readers can afford. There are continual references to being hard-up and to having to stretch pocket-money and occasional earnings as far as they can go.

In the 1970s *Jackie*'s response to reader's lack of money was to advise them to buy wisely and to go for a subdued and safe, pretty look by shopping in the cheap department stores or in chains like Chelsea Girl. *Just Seventeen* reverses this entirely and using the pop world for models it encourages readers to be as outrageous as they like. The shops it features still tend to be cheap and fashionable (Hennes, Top Shop and Chelsea Girl) but the emphasis is on creative buying, second-hand buying and jumble-sale buying. Madonna emphasises punk tacky glamour with a kind of 'fun' throw-away attitude. More recently Wendy James of Transvision Vamp has continued in this tradition of slutty sexiness. As Judith Williamson and others have pointed out, Madonna projected a femininity which took most pleasure in itself. Madonna was always like a schoolgirl having fun dressing up and 'being sexy'. Even at the peak of her fame she was

not quite 'nice' enough to be straightforwardly sexy like Kylie Minogue. Her mix-and-match, lace-and-denim style, her crucifixes, beads and lace gloves all located her too firmly in the punk subculture. It is only when she is compared with Kylie Minogue, Tiffany, Debbie Gibson and all the others vying for her place in the charts that her subcultural status becomes apparent. Unlike them she was never desperately trying to please. This is also true of the other female pop figures favoured by the *Just Seventeen* fashion editors. Salt'n'Pepa and the Wee Papa Girl Rappers who also go in for 'bad' style (cycling shorts, black leather and zips, slashed jeans, etc. and more recently Yaz, are frequently shown in their own customised clothes.

Mizz has followed the fashion lead set by *Just Seventeen* but has also blunted the edges of *Just Seventeen*'s trendsetting styles by introducing a number of softening devices. It usually carries two fashion features, one of which shows clothes more suitable for work, like a recent piece on raincoats titled 'Wet Wet Wet?' Most of the coats displayed were more classy than anything found in *Just Seventeen* and were stocked in Chelsea Girl, Hennes and Miss Selfridge. In the same issue *Mizz* also carried a denim feature but instead of taking denim as a kind of raw material and then encouraging a kind of imaginative reconstruction around it, the *Mizz* team followed an opposite track and narrowed down the reader's wardrobe to ten essential items, not to look classic as is most often the case in features like this, but to look stylish. Thus the reader cannot go wrong with 'a blazer, a denim jacket, loafers, a pair of jeans, a pair of trousers, a little black dress, a black skirt, a white shirt, a patterned shirt and a twin-set'. Even here we find the second-hand stall mentioned in the accompanying fashion advice 'When it comes to a blazer, it might be worth spending a bit more money because a blazer is classic rather than high fashion and will last for ever. But if your budget's tight (and even if it isn't) it's always worth rooting around in second-hand and charity shops for a bargain or two.'

Jackie and *Girl* both carry fashion double-page spreads which are more conventional both in terms of the lay-out of the page and the clothes which are shown. Unlike the other style magazines there is relatively little evidence of the influence of the visual style of the punk-magazine iD. Instead the spread usually carries between three and six shots of the same girl in a number

of different but related outfits. These are whole-body shots in which the girl is often posing in an active or energetic way. These younger girls are not trying to be sexy in the way *Just Seventeen* models are. They do not pout and they tend not to be wearing a lot of make-up. However, they are more individualistic and stylish than their counterparts of ten years ago. Secondhand clothes are only occasionally mentioned and the fashion editors of these magazines tend to be more reliant on the mainstream high-fashion stockists like Jeffrey Rogers and Top Shop. There is more emphasis on these pages on matching clothes rather than on playing around with fabrics, colours and styles which clash. A more sensible attitude prevails and the impact of pop is less felt.

Tiffany comes closest to being the role-model inspiring these pages and she of course is mocked in *Smash Hits* and *Just Seventeen* for being the most unstylish person in pop. Tiffany's preferences are for long sloppy jumpers, favourites with pre-pubescent girls for their high modesty factor. They cover up all curves and bumps and the developing body can hide beneath them. Where *Just Seventeen* speaks to an age-range which suddenly wants to flaunt it (like Madonna) *Girl* still addresses in its fashion pages a kind of pre-teen shyness manifested in baggy shapes, sloppy jumpers and outsize tracksuit tops.

This difference reflects exactly the kind of transition which moves the reader from pre-teen to teenage femininity and from *Girl* to *Just Seventeen*. What the clothes and the cosmetics articulate is an almost imperceptible move from a mostly private identity and a style geared towards hanging about at home, going for walks in the park or for shopping trips 'with Mum', to a more public identity made manifest through the display of a personal or personalised style. The hallmarks of this lie in its particular combination of individual and peer-group attributes. *Just Seventeen* clothes need not necessarily be for club nightlife. Their 13- and 14-year-old readers are unlikely to be spending Saturday evenings out on the town. They will be spending time with each other on Saturday afternoons, hanging about the shopping centres, going to the local cinema, or in the early evening meeting up with friends for a pizza. In this state of semi-independence fashion no longer means Marks & Spencer, instead it means carving out a very particular image which carries connotations

which are recognised and which make sense in the school as a sign of attachment to some stylish subcultural groups and against others (the ripped jeans look, for example, against the sombre all-black 'goth' look). *Just Seventeen* style addresses schoolgirls who are interested in both pop culture and academic achievement. The emphasis on customised style is a useful introduction to 'making do' on a small budget for girls who will be at home or on a grant at college or university for some considerable time to come, and who want to be stylish. In the environment of the school, and more so in college, at art school, or at university, individuality is at a premium. Designer fashion is well beyond the budget of would-be students and so *Just Seventeen* fashion offers a wealth of ideas for dressing through the years of higher education. *This emphasis on individuality and implicitly on achievement is in sharp contrast to Jackie style of the late 1970s. The language of fun and femininity still prevails but it now takes on a new more confident edge. It is brimming with expectation. Its optimism is about opportunity, not romantic dependence.*

Conclusion

This chapter has attempted to map the field of girls' comics and magazines in the 1980s. It is necessarily incomplete in that the issues focused upon are in a sense a reply to, and update of, those raised in an earlier piece of work (see Chapter 5). It has not been possible to include the question of race and how it appears or fails to appear in the magazines. Although a substantial number of pop stars who are featured in all the publications mentioned here are black, the prevailing emphasis is implicitly towards white readers. For example, black stars are rarely described in the kind of 'cor, he's gorgeous' manner jokily used to describe white pop stars. When blackness is raised, it is precisely 'raised' as an issue, and is rarely normalised except in the context of it being taken for granted that black music forms the background for most of the contemporary club styles. And while black girls are increasingly used as fashion models, the stories, problems and editorial features still seem to assume that the average reader is white.

Race is missing and so also is the 'political economy' of these

particular publications. Patterns of ownership and control and the place of these magazines in the rapidly changing world of the mass media have also been beyond the scope of this volume, as have the related questions of magazine technology, the labour process involved in magazine production and the professional ideologies of journalists working in this field. Along with the more sociological questions of readership referred to in the first section, all these are areas which might well be explored in more detail at some later date.

Instead the focus has been on the changing internal world of the values and ideas found in the pages of the most popular comics and magazines in the 1980s. It has been argued that a new climate prevails where dependency on boys and on romance has given way to a new, more confident, focus on the self. The practices and rituals of femininity which were once carried out in order to attract boys and to secure a future based on being a wife and mother are now done on behalf of the self. The old competitive relationships between girls which were such a standard feature in *Jackie* and which often involved battling it out over a boy, have also disappeared to be replaced by the less sexually specific idea of having fun with 'friends'. Even the old idea of the (frequently untrustworthy) 'best friend', seems to have been replaced by the importance of having friends of both sexes.

Sex is a good deal more obvious especially in *Mizz* and *Just Seventeen* where it is assumed that many under–16-year-olds will indeed have sexual relationships. Partly as a response to the crisis around AIDS, information is much more frankly and clearly given out. The 'responsible' self is, perhaps, the other side of the consuming self. Teenage girls are credited with greater intelligence than they were in the 1970s. They are also recognised as future workers, and most of the magazines devote more space to jobs and careers than they did in the past. However, given that the great majority of their readers are still at school, and that it is the tradition in these magazines to define themselves and their interests outside, or even against, the world of school and work, it is to the world of pop culture, friendships, relationships, fashion and beauty that they are most dedicated.

What can also be seen in the world of contemporary girls' comics and magazines, is an almost perfect microcosm of post-

modern values including the dominance of the visual text over the written text, retro dress, joky tones, a love of the swift and slick fast-turnover images of pop consumerism, pastiche, and an overwhelming emphasis on 'informationalism'. Amidst these cut-up, fragmented images and texts there is a curious, unresolved blend of conflicting meanings. Picture love-stories have more or less disappeared, reflecting the end of a requirement for narrative. These stories have been replaced by the visual dominance of pop pin-ups, and by the increasing space taken by information about the stars. The shift has been away from the kind of love-stories in which romance was entirely predicted on female passivity, to a different kind of (equally fantasised) 'encounter', which can be understood by looking rather than reading, or else through reading informational snippets rather than reading whole fictions. The obvious question is to what extent does this create new, less-oppressive sexual meanings or whether it merely reflects a change of fantasy material (from photo-boys to pop-boys) nurtured and reinforced by the growth, expansion and dominance of the music industry and its focus on the pre-teen market?

It has been my argument that fantasy material based on either stories about boys or images of boys with accompanying information about them is a psychic pre-requisite for the transition from a pre-pubertal femininity to a more overtly adolescent femininity. Some feminists would describe the provision of such material as part of the process of 'compulsory heterosexuality'. While it is certainly true that the fantasy images are mostly male and the fantasised relationships implicitly heterosexual, it is also the case that there are more female pin-ups in these magazines, and it could be argued that they play an interesting and complex role in this same process in moving away from a childhood sexuality towards something which is both different and exciting. The point should not be to denounce the existence of pop pin-ups but to understand the place they occupy as autonomous forms which allow 'looking' and which encourage and act as triggers for various forms of sexual imagining.

In this context it is not surprising that pop stars 'work better' as fantasy figures than fictional boys, in that they are part of a real, shared leisure culture (based on music, concerts, dancing, staying at home, listening to records, watching TV, etc.) in which

all girls can participate. Pop fantasies are superior because they are simultaneously private and public. The picture love-story was read, remembered perhaps, but then cast aside. The pop pin-up and the interview with Bros feed into leisure culture in the classroom, on the street and in the concert hall.

Ironically it was the realism of the fictional boys which was their downfall. In the end they had too many faults. They were too much the boy-next-door. Pop boys in contrast are not presented to female fans and readers in narrative form. It is up to the girl to weave her own story around the facts with which she is so generously provided. The 'status of informationalism' is therefore that it replaces full stories with hints of stories or 'trailers' for stories. It is exemplary fantasy material in that it leaves gaps and spaces wide open for individual interjection.[30]

For example, a standard 'informational' feature might hinge on asking Rick Astley what his favourite bars and restaurants are. With this material the reader is invited to construct for herself a story in which she manages to get a job 'working as a waitress in that cocktail bar' when he drops in. Pop rhetoric colonises the world of fantasy pushing the ordinary boys-next-door into the margins and flooding that whole private space with overwhelmingly public images, which resonate across leisure culture and which have therefore a currency and appeal far beyond the world of the magazines.

The stories have all but disappeared (swallowed up perhaps by the great success of television 'soap' narratives) and instead there are any number of pop fantasies available, based on this never-ending supply of 'facts'. These coexist alongside all the other more positive (in the sociological sense) qualities of the new girls' magazines; the emphasis on careers, the frankness on questions of sex, the confidence, the assertiveness and so on. What we also find at the heart of the new girls' magazines is, of course, a well-informed, intelligent and socially concerned young consumer. Is it the case then that the 'cost' of equality in the new girls' magazines is that readers become more strenuously addressed as young consumers? If this is what has happened then it is neither altogether surprising nor does it mean that the readers do as they are required and become 'consuming selves'. Pop culture would not exist in the form it does if it were not for the huge profits and the fast fortunes to be made by making

music or producing magazines or fashions or cosmetics for this teenage and pre-teenage market. But this relentless logic of capital should not blind us to the changing messages found inside the magazines. Perhaps the single most interesting change in the publications has been the result of the outlook and editorial values of those working inside them and the attention they pay to the girls who make up their readership.

To pursue this further it would be necessary to examine the ideas and values of those working on the magazines. Such an ethnography of production values is unfortunately beyond the scope of this study. It is possible however to draw attention to those journalists like Ian Birch and Kimberley Weston as well as Melanie McFadyean (all of whom have worked on *Just Seventeen*) and who on several occasions have asserted their commitment to gender-equality and to creating a more confident femininity on the pages of the magazine. This represents a new and perhaps unexpected development. It is certainly a good example of working within the mainstream institutions of the mass media to transform many of its dominant messages without eliminating its popular appeal.[31]

For teachers of Media Studies, the conclusion might be that magazines are not just consumed and read, but also produced. Greater attention should be paid to this dimension, not just because it sheds further light on how definitions of femininity are constantly open to change but also because by paying attention to those who work inside magazines, students might well recognise the space these magazines offer for contestation and challenge. This might also make magazine journalism more tangibly within the career horizons of the magazine's keenest readers . . .[32]

Notes and references

1. A. McRobbie, Chapter 5 in this volume.
2. C. Kaplan, 'The Thorn Birds: Fiction, Fantasy, Femininity' in V. Burgin (ed.) *Formations of Fantasy*, London, Methuen, 1986.
3. C. Brunsdon Chapter 4 E. Seiter (ed.) *Rethinking the Audience*, Chapel Hill, University of North Carolina Press, 1989.
4. C. Kaplan, 'The Thorn Birds'.
5. D. Morley, *Family Television: Cultural Power and Domestic Leisure*, Comedia, 1987, London.

6. J. Radway, *Reading the Romance: Women Patriarchy and Popular Literature*, London, Verso, 1987.
7. See, for example, R. Johnson 'The Story So Far: and the Future Transformed' in Introduction to D. Punter (ed.) *Contemporary Cultural Studies*, Longman, 1986; and S. Hall, 'Cultural Studies: Two Paradigms' in T. Bennet (ed.) *Culture, Ideology and Social Process*, London, Batsford Academic, 1981.
8. See, for example, E. P. Thompson, *The Making of the English Working Class*, Harmondsworth, Penguin, 1974; Raymond Williams, *Culture and Society*, London, Chatto & Windus, 1958; and R. Hoggart, *The Uses of Literacy*, Harmondsworth, Penguin, 1957.
9. P. Willis, *Learning to Labour*, Aldershot, Saxon House, 1977.
10. D. Morley, *Family Television*.
11. J. Radway, *Reading the Romance*.
12. I. Eng, 'Feminist Desire and Female Pleasure: On Janice Radway's *Reading the Romance: Women, Patriarchy and Popular Literature*, in *Camera Obscura*, 17/18 (Spring/Summer 1988).
13. M. Barker *et al.*, 'Methods for Cultural Studies Students', in Introduction to D. Punter (ed.) *Contemporary Cultural Studies*, London, Longman, 1986.
14. E. Fraser 'Teenage Girls Reading *Jackie*' in *Media Culture and Society Sage*, vol. 19, 1987.
15. M. McLoughlin, 'The Pleasures of Reading', unpublished BA dissertation, North East London Polytechnic, 1987.
16. J. Baudrillard, 'The Ecstasy of Communication' in H. Foster (ed.) *Post-modern Culture*, London, Pluto Press, 1985.
17. J. Radway, *Reading the Romance*.
18. J. Winship, *Inside Women's Magazines*, London, Pandora, 1987.
19. M. MacFadyean, *'Agony Aunts and Advice Columns'* in *The New Statesman and Society*, 19 August 1988.
20. J. Winship, *Inside Women's Magazines*.
21. M. Foucault, *A History of Sexuality*, vol. I, Harmondsworth: Penguin 1982; and S. Heath, *The Sexual Fix*, London, Macmillan, 1982.
22. S. Heath, *The Sexual Fix*.
23. C. Weedon, *Feminist Practice and Post-Structuralist Theory*, Oxford, Blackwell, 1987.
24. S. Hall in 'Working Papers' in 'Cultural Studies'.
25. S. Frith, *Music For Pleasure*, London, Polity Press, 1988.
26. B. Bettelheim, *The Uses of Enchantment*, London and New York, Thames and Hudson, 1967.
27. A. McRobbie, 'Interviewing Juliet Mitchell' in *New Left Review*, no 170, August 1988.
28. E. Carter 'Alice in Consumer Wonderland' in A. McRobbie and M. Nava (eds) *Gender and Generation*, London, Macmillan, 1984; and 'Intimate Outscapes: Problem Page Letters and the Remaking of the 1950s German Family' in L. Roman (ed.) *Becoming Feminine*, Brighton, Falmer Press, 1988.

29. S. Hall, in 'Working Papers in 'Cultural Studies.
30. M. Ryan, 'The Politics of Post-modernism in Postmodernism: Theory, Culture and Society, vol 5, nos 2–3, June 1988.
31. Ibid.
32. The conclusion to a version of '*Jackie*: An Ideology of Adolescent Feminity' which appeared in A. McRobbie and T. McCabe (eds) *Feminism For Girls* looked to the possibility of an alternative to *Jackie* which countered its ideas and values with a sharp-edged feminist approach. The economics of the early 1980s however put paid to numerous alternative publishing ventures, and *Shocking Pink*, a magazine which attempted to put this idea into practice, seemed to disappear as suddenly as it appeared in the first place. From then on the debate in Left and feminist circles moved – imperceptibly perhaps – towards the idea of working within the mainstream and trying to bring to the large media institutions new and critical ideas. This arguement also took into account the widespread idea that publications like *Jackie* were bought because of their appealing format. There was something about them that thousands of young readers liked. It was impossible to duplicate this out in the wilderness of the alternatives, better therefore to move back towards the big institutions and work to transform them.

7

Dance Narratives and Fantasies of Achievement

Dance and culture

> At first the child sat numbed, tense. Then chills began going up and down her spine. Her hands clenched. She could feel the nails piercing the flesh of her palms, but it didn't matter. Nothing mattered, only this – only loveliness mattered . . . Yes, she would dance – and nothing would stop her, nothing, nothing in the world.
>
> Gladys Malvern, *Dancing Star*, London, Collins, 1965

> So what will be a girl's reactions? . . . She dances, thereby constructing for herself a vital subjective space . . . The dance is also a way of creating for herself her own territory in relation to the mother.
>
> Luce Irigaray, 'The Gesture in Psychoanalysis', in *Between Feminism and Psychoanalysis*, ed T. Brennan, London, Routledge, 1989

It is surprising how negligent sociology and cultural studies have been of dance. As a leisure practice, a performance art and as a textual and representational form, dance continues to evade analysis on anything like the scale on which other expressive forms have been considered. And while dance theory and dance criticism are well-developed fields in their own right they do not offer the kind of broader social and cultural analysis which is still so much needed. Dance history tends to be either empirical (and anecdotal) or else collapsed into the biographical details of

great dancers. Some of this work is, of course, a useful resource for the sociologist of dance. It is here that we come across the many accounts of the impact of Isadora Duncan's techniques, and the descriptions of the network of artists, painters and dancers, mostly Russian exiles who came to live in Paris in the early years of the century. The immensely interesting biography of Nijinsky, written by his widow in 1933 (with a postscript in the 1958 edition) provides a fascinating glimpse of dance culture and its links with the other high arts in the early years of the century.[1]

Most of the other easily available dance-history volumes are published as lavishly illustrated coffee-table books or else as exhibition catalogues. The only piece of cultural studies analysis which intrudes into this area marked out by the dominance of taste and connoisseurship is Peter Wollen's recent essay.[2] Wollen argues that while the theorists of modernism are loath to admit it since ballet has always been regarded as a less important art, the Russian Ballet directed by Diaghilev, choreographed by Fokine and with stage sets by Leon Bakst, was enormously influential in the uneasy lurch which was made in the early years of the century towards a modernist aesthetic. By documenting the central importance of Diaghilev, and the way in which his most popular ballet, Scheherazade, looked to the orient as a way of unsettling sexual and cultural mores, Wollen reinstates ballet as a crucial vehicle for the expression of radical ideas. The Russian Ballet was poised between the old and the new order, and its decadence and excess accounted for what was an unfair marginalisation in the writing of modernist history.[3]

Wollen's essay shows not just the importance of ballet in the broader sphere of the arts, but also the extent to which the boundaries which are used to demarcate aesthetic forms are frequently artificial. Diaghilev's Scheherazade, with Nijinsky as the athletic, effeminate and androgynous centre part, with music by Rimsky Korsakov and with lavishly coloured and oriental sets by Bakst, was on the cusp of the shift into modernism. This ballet and those that followed posited the dancer's body as unconfined, as more natural and 'modernist' in its movements than had been the case before.

Most interesting, perhaps, is Wollen's comparison between the

balletic body of that moment in history and the ambiguously extravagant body which was part of punk style of the early 1980s:

> We can perhaps see a link between the Russian ballet and punk, the radical excess of the last years of the ancien regime and that of postmodern street culture, complete with its own scenography of bondage, aggressive display and decorative redistribution of bodily exposure.

This analogy is important because it locates ballet outside the narrow terms of high culture, and posits it as something which has connections with the aesthetics of everyday life. The Russian ballet was as prefigurative as punk was, when it reverberated across British society in the late 1970s and early 1980s.

In a sociology of dance it would also be important to consider the role of dance journalism and the way in which it shapes our perceptions of ballet in a number of ways. Ballet is simultaneously a 'low' high art, a spectacle for virtuoso performance, a part of the 'national heritage', a showcase for other national identities and an opportunity for promoting international relations. Since the review is the most widespread and accessible form of writing which accompanies a text or performance, what journalists do with dance and how they make sense of it would form an important point of inquiry. It is unfortunately the case, however, that the dance columns which fill the pages of the Sunday newspapers rarely move beyond either a descriptive account of a performance focusing on the star, an assessment of an adaptation, or a retrospective account of a dancer's life. The pity of this generally uncritical and unreflexive writing is that it remains largely unread by those who do not count themselves within the small enclave of committed dance fans. It rarely opens up dance to a new audience because it does not consider dance in a wider context. It seems not to be interested in the complex pleasures of watching dance and it never sets out to explain to the uninitiated how dance is staged, cast, produced and performed. Most importantly it fails to prise open the momentum of the particular relationships set up between the dance company and its audiences, and the socio-cultural basis of such a relationship.

Dance theorists and critics do not relish the idea of dance

being appropriated by sociology and cultural studies. In much the same way as musicologists complain about how sociologists rarely talk about the music outside all the other social relations within which it is 'packaged', dance critics dislike the thought of others trespassing on their terrain. But dance comes to us packaged in the messy social contexts of consumer capitalism, class culture and gender and race relations. Ballet is a form which occupies a specific position in the high arts and popular culture spectrum. It is the poor relative of opera, but like opera is increasingly marketed not for an élite but for a mass market. On these grounds alone dance should be of great interest to the sociologist, and not just as a cultural product and a form of mass entertainment (one which moves from ballet to the chorus line, from *Swan Lake* to *The Top Hat*) but also as a form which invites a participative response, speaking to and with the body.

Dance would have to be considered therefore in all its diversity. Its history in folk and urban culture as well as its status in contemporary culture would necessarily entail an investigation of key cultural overlaps including, for example, dance in the cinema, the popularity of the musical and the place of dance in the history of rock'n'roll. Running alongside this would be the place of dance in black Afro-American culture and the relationship between black and white culture in the post-war period. Finally it would also be important to consider dance in terms of its place within the state-funded arts.

For the purposes of the following analysis the crucial point about dance is that as an art, a representational form, a performance and a spectacle, it has an extremely strong, almost symbiotic relationship with its audience. For girls and young women, particularly for those not brought up in a cultural background which sees it as part of its duty to introduce young people to the fine arts – to painting, literature, classical music, great drama and so on – dance exists as a largely feminine and thus accessible practice. It also comes to life as a set of almost magical childhood narratives in the form of girls' ballet stories. In each of these forms dance carries within it some mysterious transformative power. Its art lies in its ability to create a fantasy of change, escape, and of achievement for girls and young women who are otherwise surrounded by much more mundane and limiting leisure opportunities. Dance is also different from the other arts in

that it is readily available to young girls as a legitimate passion, something that, unlike painting or classical music or even writing, they might be expected to want to do. It has a more 'interactive effect' than the other high arts. The Royal Ballet speaks to the thousands of pre-teen and teenage girls who learn ballet each week in the same way as the film and TV series, *Fame* and *Flashdance*, speak to those children and teenagers who dream of going to stage school, or who learn disco-dancing at school or on a Saturday morning. Images of dance have the effect of making people want to do it. Which images or which performances they watch is of course dependent on a wide range of social and cultural factors.

Ballet lessons cost money and they are not usually provided during school-time. This limits the range of those who can learn ballet. Disco-dancing and modern dance lessons are often provided free by local authorities. Pop and jazz dancing are therefore more widely available forms. Ballet requires leotards, shoes, tights of the right thickness, 'block shoes', and so on. Pop dancing requires only tights and a T-shirt. (These differences crop up repeatedly in ballet fiction when a girl who dreams of being a ballerina is forced to make do with disco-dancing lessons because she cannot afford all the extras which go with ballet.) Ballet is therefore an activity favoured within the middle and lower middle classes while disco-dancing is more likely to be linked with working-class girls. Ballet, however, occupies an uncertain place in middle-class culture. It does not carry the same value as classical music. Proficiency in music and knowledge of the great composers carries greater cultural weight than knowledge of dance and a proficiency on points. The 'cultural capital' of music holds the pupil in much better stead than that acquired in dance.[4] Pupils are encouraged to join the school orchestra while those who want to dance will rarely find a school which takes dance (as a gender-specific subject) as seriously as it does music.

A sociology of dance would have to consider this cultural ambivalence. The middle-class preference for music reflects the connotations which dance carries as a pleasure of the body rather than of the mind. And because dance is also a popular leisure activity where the female body has been allowed to break free of the constraints of modesty, dance has aroused anxiety about sexual display. It was for this reason, for example, that the early

middle-class pioneers of the youth club movement discouraged dancing as a legitimate club activity. And since dance halls were associated with working-class leisure, the middle classes, anxious to define themselves as different in all aspects of taste from their working-class counterparts, preferred to have their daughters taught piano (though a degree of gracefulness on the ballroom floor was a necessary accomplishment for the middle-class girl in search of a husband). This parental preference for music was also a reaction against the 'dangerous' popularity of dance fiction among girls of all social classes which romanticised the stage and which invariably focused on some dramatic escape on the part of a girl who wanted to dance but was thwarted by her strict and narrow-minded parents.

It was mentioned earlier how it was strange that dance had proved of so little interest to sociology and cultural studies. Strange because despite the absence of a sociological language which would embrace the formal dimensions of dance there is nonetheless a diversity of wider social questions and issues which are immediately raised by even the most superficial consideration of dance. Some of the most richly coded class practices in contemporary society can be observed in leisure and in dance. The various contexts of social dancing tell us a great deal about the everyday lives and expectations of their participants. Dance marks out important moments in the life-cycle and it punctuates the more banal weekly cycles of labour, leisure, and what Ian Chambers has labelled the 'freedom of Saturday night'.[5] It is perhaps not insignificant in this context that the last night of the annual Tory party conference is usually highlighted on television with Mrs Thatcher taking to the floor with a partner who is neither her husband nor a member of her Cabinet. This might well be a gender-specific leisure choice. Mr Kinnock uses this same slot and television time to sing with a male voice choir.

Dance and club culture

Dancing, where the explicit and implicit zones of socialised pleasures and individualised desires entwine in the momentary rediscovery of the 'reason of the body' . . . is undoubtedly one of the main avenues along which pop's sense travels.[6]

A sociology of dance would have to step outside the field of performance and examine dance as a social activity, a participative form enjoyed by people in leisure, a sexual ritual, a form of self-expression, a kind of exercise and a way of speaking through the body. Historians of working-class culture have acknowledged the place occupied by dance in leisure and the opportunities it has afforded for courtship, relaxation and even riotous behaviour. Unfortunately, in most cases, the nature and form of the dance remains in the background, something more enjoyed by women than by men and therefore marginal to the real business of working-class life. This imbalance is slowly being redressed by American social historians like Elizabeth Ewen who has attempted to chart the various histories of immigrant and working-women's leisure in the early years of the century.[7] However in this country it remains an uncharted ground coming through only in fleeting references in oral history or in collections like Sheila Rowbotham and Jean McCrindle's *Dutiful Daughters*.[8] Even here memories of dancing are always associated with pleasure and with loss as though the rest of the woman's life can be measured against such moments. Social history generally has tended to be more concerned with the problem of order and with the policing of the working class in its leisure time. Robert Roberts makes a few telling comments about the social anxieties which came into play around the dance halls in the years following the end of the First World War.[9] These fears and anxieties hinged around the possible promiscuity of the working-class girls who flooded into the dance halls as many nights a week as they could and who also dressed up and wore make-up for the occasion in a way which was seen as shocking and indicative of some immoral intent.

This strand continues right into the post-war years. Dance halls remain a key feature in working-class leisure and a focal point for the expression of concern about working-class youth. Outside the evangelical thrust of youth clubs and other forms of State-provided or religiously controlled leisure, the dance hall or disco, run for profit by 'uncaring' businessmen, exists as a site for the kind of moral panics which have marked the field of 'youth' for many years. However, the target for the moral panic evolves not so much round dancing (though rock'n'roll dancing and jiving were linked with sexual license) but rather round the other activi-

ties accompanying dance: drinking, drug-taking, or violence. Dancing is the least of the worries of the moral guardians. If the boys did more of it there would be less to worry about. The girls are less likely to fight, less likely to drink themselves into a stupor (partly because of the risks of not getting home safely) and less likely to consume drugs on the same scale as their male peers, because of the double standard which still holds that a girl out of control is less socially acceptable than her male equivalent. Because of these social constraints and sexist sanctions girls are less of a problem and therefore remain largely in the shadows, dressed up, dancing, and immersed in the 'reason of the body'.

Geoff Mungham is the only sociologist who has turned his attention to the more mundane aspects of social dancing.[10] In *Youth in Pursuit of Itself* he locates the importance of dancing in the life-cycle of working-class girls for whom getting a husband at a relatively young age is a social and an economic imperative, and for whom also the dance hall provides the main opportunity for finding a possible partner. Like Richard Hoggart he sees the enthusiasm of young girls for dancing and having a good time as a 'brief flowering' before they settle down to the hard work of being a wife and mother.[11] For older working-class women memories of these good times sometimes burst through the surface as they take to the dance-floor on the odd night off, or at the 'girls' night' at the local pub. Ann Whitehead graphically describes this kind of married women's leisure in her classic study of rural life in Herefordshire.[12] But beyond these fleeting comments and fleeting images, and since Mungham's essay on dance hall culture, there is and has been very little else. Dance, like fashion, seems to find expression more at the level of 'popular memory'. Film footage of hundreds of couples crowding the dance-floor after the end of the Second World War is immediately evocative of a whole social moment, in the same way as footage of 1950s couples jiving or of early Mods moving to the black 'sounds of the city', conjure up in a flash what the early 1960s were all about.

The link between dance and youth culture is reflective of how a crucial element in subcultural activity was played down, if not altogether ignored. Despite Phil Cohen's early listing of subcultural components – argot, ritual and style – dance has hardly merited any attention whatsoever.[13] With the notable exception

of Dick Hebdige's description of the short sharp movements of the 'pogo' dance and its articulation with the other elements of punk style,[14] and Ian Chambers's extensive documentation of the clubs and dance halls which have provided the backdrop for urban youth culture and music in the post-war period,[15] there has been little or nothing said about the various dances and movements which have been a constant feature of urban youth cultures.

A trivialised or feminised form? A ritual without resistance? A sequence of steps some steps removed from the active, creative core of youth cultural activity? Chambers mentions a range of dance styles by name: the shake, the jerk, the Northern soul style of athletic, acrobatic dance, as well as the break-dancing and 'body-popping' associated with black youth. He also makes connections between white youth culture dancing and the black music and dance from which it has continually borrowed. But he is faced with the same difficulties which seem to have beset other sociologists when it comes to locating the movements in the context of the culture. He evades the issue by referring to the 'rich tension of dance' and then going on to engage more critically with the music.

Chambers's work is important because it recognises the centrality of dance in leisure and it makes connections between dance and Afro-American music, suggesting that it is this and in particular, soul, which has provided the corporeal language for white youth culture dancing over the past forty years. Chambers is certainly not blind to gender-dimensions in dance. Indeed he articulates a sharply differentiated means of experiencing dance according to gender. Dance for girls represents a public extension of the private culture of femininity which takes place outside the worried gaze of the moral guardians and indoors in the protected space of the home. Male youth stylists however take to the floor within the direct ambiance of the subculture, hence the dominance of boys in the Northern soul scene, or in black jazz-dancing, breakdancing and so on. Chambers also seems to suggest that because boys in youth subcultures have been closer to the music in a technical sense so too have they been closer to the dance. The problem with this is that it posits a static and sexually divided model which is not in fact reflective of the active involvement of both girls and boys in dancing and in the various

club cultures (in particular the recent 'Acid House' phenomenon). Chambers' analysis is the outcome of an approach to dance conducted through the medium of music and musical taste where boys have undeniably been at the controls and where girls have been in the background. Such an emphasis lets the author off the hook in relation to dance itself. 'But dancing is itself an obscure reality, the not-so-innocent refuge of many a social secret.'

It is the clubs and dance halls which have provided a whole series of subcultures with their own private spaces. It is here that the distinctive styles have found a place for their first public appearances. It is from the clubs that the first reports and snapshots filter through to the public and to the readers of the colour supplements. The already privileged place occupied by youth cultures in the style glossies and in the fashion pages means that the incubation period of subcultural style is speeded up to the point that this is only a momentarily privatised space. Within a flash the details have been itemised, and the customised ripped jeans, the cotton headscarf knotted behind and the 'granny specs' have been installed in yet another ever-extending subcultural history related by the style experts. The function of the club in this context is simultaneously to construct the distinctiveness of the new style as different from what went before (cool is out, *un*cool 'jollity' is in; one style of dance is out, another is in; and so on) and to spread the word before moving on to something else, to new musical sounds and new dance steps. The essence of these processes in the age of the post-modern mass media with their thirst for new copy, and their space for life-style items, is the rapidity with which an emergent style is killed off through instant over-kill.

What remains are the same old cultural cocktails of dress, music, drugs and dance and the way in which they create an atmosphere of surrender, abandon, euphoria and energy, a trance-like state and a relinquishing of control. As Dick Hebdige has suggested, these cannot be understood without reference to the 'phantom history' of youth subcultures – that is, to the black experience and the impact of Afro-American culture on white youth culture.[16] In the same way as rock'n'roll music bears the traces of its origin in Afro-American culture, so too does jazz dancing, pop dancing, and the kind of funky sexy movements

demonstrated by generations of black performers (Little Richard, James Brown, Tina Turner, Michael Jackson and Prince) which were copied step by step by white singers and dancers and drawn into the mainstream entertainment business as a result.

It is this latter process which feeds into and shapes the whole popular dance experience of the post-war period and particularly that pursued within the youth subcultures. No historian of dance should be able to ignore the way in which a range of cultural forms, mainstream and subcultural have drawn on black dance. The steps in Hollywood musicals are as derivative of black culture as those carefully copied in the clubs and dance halls by generations of young white people from the 1950s right up to the present day. Even the most cursory glance at footage of black dancers reveals the debt owed to them by Fred Astaire, Gene Kelly, Ginger Rogers and many others. Likewise in social dancing. There is a slow process where black American dance styles are taken over, adopted and extended by white dancers and performers. Jagger acknowledges his debt to James Brown and Tina Turner, while soul fans remember the impact of the Philadelphia TV show, *Soultrain*, for the new dance ideas it provided. If, as Paul Gilroy has argued, black dance addresses the body in a different register from that of formal ballroom dancing or folk dance, if this urban soul-dancing traverses the entire body surface shifting the centre of erotic gravity away from the narrowly genital and allowing instead a slow spread, then the meaning of this hyper-eroticism must be seen in the broader context of racial discrimination and prejudice.[17]

Lurking behind the fears of the moral guardians has also been the spectre of racial difference and otherness, the hysterical anxieties about the black rejection of work and labour discipline, the assumptions of sexual license and drug abuse and the contaminating effect these might have on white youth. At the other end of the spectrum is the equally racist assumption about black 'ability' in the sphere of entertainment – an ability which, of course, has its own material history, its own dynamics of necessity. Within this rhetoric of racial inferiority is also the debased positioning of black song and dance, and black influenced forms, as lower arts or even native art.

This has certain consequences for the remaining sections of this chapter, especially those dealing with two popular and con-

temporary dance narratives, *Fame* and *Flashdance*. In each case a narrative tension is set up around this divide (ballet/jazz, classical/pop) and in each case it is 'satisfactorily' resolved within the framework of the story. In the film, *Fame*, the resolution hinges on the multicultural performances and the range of 'abilities' demonstrated by the kids (black, white and hispanic) and highlighted in the graduation show which also marks the end of the film where the performance moves seamlessly from classical to 'progressive' pop and then to gospel. In *Flashdance*, Alex who is poor, orphaned and part-hispanic, is able to give up her sleazy disco-dancing job when she wins a place at the prestigious ballet school.[18] Even in the novel, *Ballet Shoes*, which I shall also be considering in this chapter, there is evidence of the classical/pop divide though here it is characterised by two of the three sisters making choices in opposite directions, Polly towards Hollywood where she will sing, dance and act, and Posy to a European ballet school.

Dance fictions

The experience of learning to dance as a child or as a young girl, and then later, in adolescence, the almost addictive pleasure of social dancing to an endless beat in the darkened space of the disco or nightclub, are relatively unchanging forms in the landscape of female leisure culture. They also provide a multiplicity of narrative possibilities in popular entertainment, in film, on television and in fiction. These narratives will be the focus of attention in this section. It will be part of my argument that dance occupies a special place in feminine culture because for many women and girls whose upbringing or education do not involve any direct relation to the world of art or culture, ideas about dance made available through texts and stories serve as an introduction to these spheres. The meaning of art in this context is sufficiently wide (and conventional) to allow it to signify a 'realm of the senses', an arena for self-expression and a form which is capable of transporting the reader or viewer away from the difficulties of everyday life. In this heightened state the reader or viewer is also invited in fantasy at least to identify and become part of the spectacle. In the language of

the narratives, dance exists as a passion. As such it awakens a strongly emotional response on the part of the girl. The attraction of dance narratives, therefore, lie in the fantasies of achievement they afford their subjects.

The three chosen narratives for analysis are the girls' novel, *Ballet Shoes*, the film and TV series, *Fame*, and *Flashdance*, the 1983 film which attempted to build on and extend *Fame*'s earlier and enormous success. Along with a focus on achievement, passion, dedication and self-discipline, each of the chosen works also engages with the terrain of what in psychoanalysis is called 'the family romance'. These two poles act as the framework for the development of the narratives. As the stories unfold they move backwards and forwards between the desire to achieve and the constraints and expectations of the family. Work becomes an alternative romance, a dream to be pursued even if it is against the odds. Dance operates as a metaphor for an external reality which is unconstrained by the limits and expectations of gender identity and which successfully and relatively painlessly transports its subjects from a passive to a more active psychic position. What is charted repeatedly in these stories is this transition from childhood dependency to adolescent independence which in turn is gained through achievement in dance or in the performing arts and therefore in the outside world.

All three texts are conventionally feminine texts, though *Flashdance* also attempts to extend its audience to men and boys. The readers and viewers, however, are largely female and all three products are marketed accordingly. These are unique cultural objects for the reason that they define an artistic mode as a kind of Utopia and as a symbolic escape route from the more normative expectations of girls and young women found in most other forms of popular culture. It will be my contention that these narratives have proved so popular precisely *because* they depart strongly from the kind of narrative submissiveness associated both with girls' magazine stories of the type outlined by Valerie Walkerdine in her short study of girls' comics, and with teenage romantic fiction.[19] The romance of work and achievement simultaneously resolves the difficulties posed by the family romance (in psychoanalytic terms) and postpones the difficulties envisaged in the transition towards adult feminine sexuality. It does this either by disregarding sexuality altogether (*Ballet*

Shoes) or by reducing romance to a minor episode, a fleeting embrace (*Fame*) or else in the more adult world of *Flashdance*, by treating it as something which can be an additional, unexpected pleasure, but subordinate to the real business of work.

In both *Fame* and *Flashdance* pop or disco dancing play a major role in the narrative development and both are associated either with being poor or else with being black (or both). In *Fame* jazz-dancing of the type associated with Afro-American culture is given equal status with ballet and this is taken as a symbol of the schools commitment to multiculturalism and racial equality. In *Flashdance*, however, hispanic-born Alex is pleased to be able to leave her disco-dancing days behind her when she eventually wins a place in the Pittsburgh Ballet School. This is partly because throughout the film her go-go dancing is portrayed as overtly sexual and therefore sleazy. Unlike the 'funky' dancing of Leroy in *Fame*, Alex's dancing in Mowby's bar is choreographed to arouse sexually and this is accentuated in the film by the effect she has on the men sitting around watching her perform. However, for her audition to ballet school she returns to a more acrobatic disco style and despite the initial frosty looks from the panel she eventually manages to get them tapping their feet in enjoyment. In this penultimate moment in the film we see a small act of validation of pop dancing and by implication of pop culture, even though it remains a sign of Alex's untutored ability.

I have chosen these three narratives for a number of reasons. They address specific ages of readers and viewers (teenage and pre-teenage girls) and have been immensely popular with them and with a wider constituency of even younger children as well as adults. As well as reflecting different historical moments (*Ballet Shoes* first appeared in 1936) the texts also range from the classical to the popular in terms of taste and cultural preference. *Ballet Shoes* is a classic of girls' fiction, a specifically English and middle-class portrait of fantasised childhood in inter-war Britain. *Fame* was first a film, directed by Alan Parker in 1980, and then it became a TV series achieving almost cult status two years later. Although describing the lives at the New York School of Performing Arts of a group of teenagers, the *Fame* narratives were focused on a much younger viewer. *Fame* (the film) was also reflective of a number of media strands emerging in the

early 1980s. It functioned not just as a narrativised showcase for pop music and dance performances, where the sound-track was strongly publicised and then released as an album, it also worked visually as a high-fashion text. The early 1980s saw the mass popularity of dance-exercise style. *Fame* helped to trigger the leggings, sweat-band and leotard look and helped also launch the success of thousands of dance classes and exercise centres, of which in Britain the Pineapple Centre in London is still the best known. *Fame* is also interesting because of its strongly multi-cultural emphasis. This is more strongly highlighted in the film than in the TV series. Indeed the film might well be credited as one of the most racially mixed pop-musicals to have been prod-uced in recent years.

Flashdance is different in a number of respects. It is more overtly trashy than *Fame*, its visual overlaps with other media forms are more obvious and more derivative (critics described it as a prolonged pop-video or a movie-length advertisement) and its narrative was recognised as extremely unlikely (critics also suggested that the story had been created with the help of a computer which was able to bring together a combination of highly marketable features). Even here, however, we find a number of themes pertinent to the concerns of this chapter. Ridiculous as its narrative might be, the film still holds a peculiar attraction. It is regularly shown on TV and has a healthy shelf-life in video-shops across the country (though this might be partly attributable to the film's erotic appeal). But what marks it out as different from *Fame* is not so much the sex or the romance but rather that Alex is presented as more sexually knowing than her counterparts in *Fame*. *Flashdance* was marketed for a slightly older teenage audience and for a less exclusively female viewer. While the narrative disavows the vulgarity of the dancing which Alex is forced to perform in her early days as a dancer, the visuals contradict this message and at key points throughout the film allow the audience to dwell at length on the purely sexy gyrations of the dancers.

Let us look then in more detail at the individual texts. *Ballet Shoes* was written in 1936 by Noel Streatfield and has been reprinted almost every year since then. It is read by pre-pubescent girls of all social and ethnic backgrounds and the narrative is heavily overladen by the kind of themes which make

it more than open to a psychoanalytic interpretation. Three foundlings are brought back to England over a period of time by the man whom the children come to refer to as Gum (great-uncle Matthew). They are left under the care of Nurse and Sylvia with very little money as absent-minded Gum disappears abroad to continue with his work as an explorer. The three children are called Pauline, Petrova and Posy and they give themselves the surname of Fossil as befits their strange and unknown parentage. Orphaned and without any secure financial future the Fossils, with the encouragement of Nurse and Sylvia, set about finding ways of earning their own keep. One of the boarders living with them in genteel poverty in Kensington teaches in the Children's Academy of Dance and Stage Training in Bloomsbury and she manages to get them lessons in return for payment at a later stage when they begin to work.

> The Fossils became some of the busiest children in London. They got up at half-past-seven and had breakfast at eight. After breakfast they did exercises with Thea for half an hour. At nine they began lessons. Posy did two hours reading writing and kindergarten work with Sylvia and Pauline and Petrova did three hours with Dr Jakes and Dr Smith . . . At twelve o'clock they went for a walk with Narnie and Sylvia . . . Narnie thought nicely brought-up children ought to be out of the house between twelve and one even on a wet day.

As pupils at the Academy the girls receive an education in the arts by reading and performing *Richard III, Midsummer Night's Dream* and Maeterlink's *Blue Bird*. Pauline shows an increasing talent as an actress; Petrova, the tomboy, manages to get a few parts while preferring the unfeminine world of cars and aeroplanes, and Posy develops the temperament of the talented ballet dancer destined for great things. The narrative spans a predictable number of auditions and disappointments and successes. It also dwells on financial difficulties and on ways and means of overcoming them such as pawning necklaces and making dresses from old hand-me-downs and so on.

Through successions of wet summers, rainy winters and endless bouts of 'flu, the Fossils eventually realise both the prospect of fame and the likelihood of fortune. Pauline is offered a part in

a Hollywood movie and will be escorted by Nurse. Posy is to be the most famous of the three and wins a place in a leading ballet school in Europe and Petrova is rescued by the sudden return of Gum whose masculine interests coincide with her own.

What makes an old-fashioned story like this so popular with pre-teen readers? What accounts for its continuous success in a world now marked out by much more sophisticated interests? And what are the links between *Ballet Shoes* and the other chosen narratives of this chapter? *Ballet Shoes* is not just a middle-class story about scrimping and saving, and then succeeding, as many critics would have it. (*Ballet Shoes* is the kind of unfashionable book which is disapproved of by librarians for precisely these reasons.) Nor is its popularity expressive of a nostalgia for a particular kind of English household management and child-rearing as exemplified by Nurse's preference for brisk walks and self-reliance. *Ballet Shoes* works as a text of transition and development. It simultaneously allows its readers to fantasise a family space unencumbered by sibling rivalry and parental dictate (a state of affairs experienced negatively in one way or another by boys and girls of all ages and social backgrounds) and to contemplate a future state of being which promises reward, recognition and happiness. The narrative also works through, in fictional form, the kind of psychic material which in itself is a product of the difficulty girls face in moving towards achieving a feminine identity.

The Kensington household inhabited by people among whom there are no blood relatives, plays a role similar to that of the boarding school in school stories (*Malory Towers, Trebizon, The Chalet School*, etc.) or indeed in ballet-school stories (the best-known of which are the stories of Sadlers Wells by Lorna Hill). These non-familial spaces provide readers with a kind of fantasy playground where they can contemplate what it would be like without the symbolic constraints of the mother, father and siblings, and where they can explore over and over again what it would be like to be an orphan, or to be without close contact with parents or relatives, to be simultaneously relieved and relinquished. More than this, readers can also take up and experiment with non-gender-specific activities. In the ballet school or boarding school there are echoes and replays of the child's original

bisexual disposition played out here as a kind of *grande finale* before the real world once again intrudes.

Bettelheim has suggested that the role of children's fiction is to 'manage life in an age-appropriate manner'.[20] To the sociologist this sounds excessively normative, prescriptive and unalert to the material circumstances which have a much more dramatic effect than any work of fiction on a child's ability to manage its own life appropriately. It is easy to imagine sociologists also arguing that Bettelheim's is a conservative and adaptive model of childhood socialisation where the text propels the child into his or her allotted role, becoming in effect a vehicle for social control.

However, as teachers and researchers testify, the popularity of this story transcends the divisions of social class and race. Gill Frith's study shows that this kind of novel is read repetitively and addictively by schoolgirls aged between 10 and 12. *Ballet Shoes* sits comfortably alongside the Sadler's Wells stories already mentioned and Enid Blyton's popular *Malory Towers* series.[21] Many of Frith's respondents were Asian girls living in the poorest parts of Coventry and for whom the reality of boarding-school life was far removed. They knew it was a fantasy structure they were reading over and over again, but they enjoyed both the exciting plots and the predictable endings. The highly ordered routinised world of the boarding-school was at once reassuring and thrilling.

Frith's argument could be extended by drawing attention to the absence of parents in the narratives she describes. Bettelheim has marked upon the absence or death of parents in classic fairy tales. The real parent is replaced by a wicket stepmother or sometimes by a cruel stepfather. This repeats a theme described by Freud where the child frequently imagines that she is not the child of his/her parents but rather a child of some 'exalted personages' from whom for some reason she has been parted.[22] In fiction this fantasy is frequently developed into a full-blown narrative. In *Ballet Shoes* it represents the trigger which sets the whole narrative in motion. The anxiety about origins is revealed in the children's choice of a surname. The '*Fossils*' which Gum collects are also symbolic expressions of what the childish unconscious ponders over, the mystery of its origins, the question of its identity. A sign of some unfathomable time. Fictional

articulations of the drama of parentage play an important part in allowing the child to explore this dilemma and also to speculate on what in reality might be too terrible to contemplate – the child's anger or even fury against the parent and most often the mother, and the cruelty of which he or she perceives the parent being capable. Hence the desire for another parent. The 'orphan' narrative signifies the parental fall from grace, the disappointment felt keenly by the child as the parent is revealed as less than perfect. It also charts the shifting ground of dependency as the child approaches adolescence.

In *Ballet Shoes* the absence of both real and adoptive parents and their replacement by the more anonymous 'Nurse' and Sylvia is transformed into an opportunity to achieve, unencumbered by the rivalries and other difficulties which, in real life, act to contain or restrict the child's desires. The reward for Pauline, Posy and Petrova's achievement, however, is the sudden and unexpected return of Gum. Removed from the Oedipal scene for as long as is psychically reasonable, Gum is then able to take up the mantle of paternal authority. He allows Pauline to go to Hollywood and Posy to go to a ballet school in Europe.

In psychoanalytic terms, the Fossil household, with its rooms full of respectable lodgers, like the boarding-schools with their dormitories of girls, legitimates the reader's desire to imagine a hypothetical space where the dilemmas and difficulties of everyday life are magically resolved through the working-out in fantasy of precisely that which cannot be consciously admitted – that is, their ambivalent and changing relations with their parents, their rivalries and resentments against their brothers and sisters, their desire to move towards the outside world which because it is too threatening is itself contained in the narrative in the form of a school or house full of boarders.

Central to *Ballet Shoes* is the question of feminine identity and it shares this concern not only with other classic girls' novels, like *Little Women* and *What Katy Did*, but also with the magazine stories consumed each week by teenage and pre-teenage girls. The narrative equivalent of *Ballet Shoes* would be the line-drawing stories found in *Bunty, Mandy* and *Tracey*, comics addressed to the 8–10-year-olds and containing between six and seven stories each week. There is no boys' equivalent to these forms. There are classic boys' stories which also use the setting of the

boarding school but these tend to be individual texts; they do not connect with the kind of genre of writing described here. And there is certainly no boys' equivalent to *Bunty* or the other girls' comics. Boys' comics of the sort described by George Orwell in his well-known essay written in the 1930s, are no longer in existence.[23] It might be surmised that the leisure activities of similarly aged boys are quite differently constructed.

The repetitious reading described by Gill Frith, the continuing popularity of a form which might otherwise have been super-seded by the modern mass media, and the continual working and re-working within the texts of the question of what it is to be a girl, points to the kind of ambivalence and uncertainty which psychoanalysts from Bruno Bettelheim to Juliet Mitchell have seen as part of the intractable difficulties in the fixing of feminine identity and indeed in the impossibility of achieving a satisfactory resolution to this problem.[24] What Bettelheim has referred to more cryptically ('most women do not painlessly slip into their roles as women') Juliet Mitchell has examined and re-examined in a variety of different contexts.[25]

In *Ballet Shoes* feminine identity is split in three and rep-resented in the different personalities of the three girls. Pauline is good, hard-working and responsible; Posy is gifted but spoilt, indulged and therefore extremely selfish, and Petrova is the 'boy', the narrative reminder of the child's bisexual disposition. This splitting allows the reader to see her own internal but coexisting divisions made manifest but also handled – and there-fore resolved – through the distinct personalities of the girls. Each of these separate characteristics is validated in the end. It is not just that each girl gets what she wants, but that each of their individual quirks are recognised as necessary for them to achieve their goals. No one is punished, not even Petrova whose unfeminine interests are allowed to be pursued. In *Ballet Shoes* an active if internally divided femininity is projected into the text and is seen as enabling. It is this which makes the book so appealing to its generations of readers. It certainly stands out in sharp contrast to the stories described by Valerie Walkerdine mentioned earlier.

Many of these picture stories in young girls' comics like *Bunty* and *Mandy* paint an altogether different portrait. They too are preoccupied with aspects of the family romance but the narrative

emphasis and the outcomes are different. Walkerdine's argument is that in most of these stories the girl is encouraged to put up with the enormous suffering imposed upon her by a cruel step-mother or father or by jealous siblings. In suffering passively, however, the girl can be sure that eventually she will be rewarded, and that it is therefore worth being a 'good girl'. Stories like these located within a pre-teenage scenario anticipate a future when the good girl who has successfully learnt all the codes of femininity will find her 'prince'. *Ballet Shoes* and all the other school stories mentioned create an entirely different scenario first by effecting an escape from the site of potential trauma or cruelty (i.e. the home) into a more neutral sphere such as the school, and then by plunging headlong into an activity, ballet or gymnastics or whatever. These are then pursued with all the passion of a great love, a fabulous obsession. The shoes in *Ballet Shoes* are a symbol of effectivity and escape and of pre-pubescent female desire.

Fame, Flashdance and fantasies of achievement

Fame was first released as a feature film in 1980 and its success led to the creation of a TV series of the same name based on several of the characters who appeared in the film. The series focused each week on a number of narrative dilemmas which in the course of the episode would be satisfactorily resolved. These programmes were broadcast on BBC I in the UK during 1982 and 1983 and they were immediately successful with young viewers and particularly young girls. *Fame* soon began to develop a kind of cult status. Its stars became household names in much the same way as the stars of the Australian series, *Neighbours*, have done in the past eighteen months. Interest then moved back to the film which was re-released, and to a variety of commercial spin-offs. The 'Kids From Fame' performed a number of live stage shows in London and in other major cities, the soundtrack reached the *Top Ten*, the single 'Fame, I'm Gonna Live For Ever', reached number one and an additional album of Fame hits was released. The stars appeared on chat shows and the whole Fame phenomena added momentum to the exercise craze of the early 1980s.

There were a few key differences between the film and the TV series. The film version was visually a great deal more adventurous than the TV show with its style verging at points on cinematic naturalism. The camera seemed to 'drop in' on rehearsals or simply record in an understated kind of way, the day-to-day life of the school. The plot was skeletal. It merely followed the paths of a number of young hopefuls through from the first auditions to graduation day three years later. Throughout the course of the film various individuals emerged. Each had some personal dilemma to work through, and most of these related to a parental relationship. In each case the strength of the peer-group friendships helped in this process. Emphasis on the family in the TV series was even more marked, sometimes dominating all the action. In the film version, however, the viewers' attention was directed more towards the performance and those few narrative strands that did emerge were more controversial. One boy was forced to come to grips with his homosexuality; a girl called Coco became involved unwittingly with a porn film-maker, and Leroy's girlfriend became pregnant and had an abortion. Four-letter words were scattered generously across the text as the film tried to achieve a realistic effect.

The film also engaged more directly and in greater depth with the split between high culture and pop. It did this by drawing on a number of assumptions and popular stereotypes. The first of these involved crediting black music and dance with a kind of spark of authenticity, missing in the colder and more austere world of the white classics. These qualities of warmth, humour and style extend, in the film, in two directions simultaneously. They include both personalities and performances. Thus Leroy is a 'wide boy'. He knows how to manipulate the system to his own advantage. His poverty and his time spent on the street lend an even more attractive edge to his personal image. He is both sexy and stylish, admired by all and especially by his dance teacher, Lydia. His talent is also a reflection of many of these attributes. Even without tuition he is a born dancer. His ability amazes his white, ballet-educated peers. He is continually late for class to the annoyance of his teachers but when it comes to it, he shows himself to be as disciplined and committed as any of the others.

Popular culture and high culture occupy the same status in the

school and are seen as equal to each other as long as they are pursued with the same degree of dedication as is needed to achieve in these highly competitive fields. In the world of entertainment what is important is success, not what side you come down on in the high-culture pop-culture divide. Individual dedication and determination negate such unhelpful distinctions. At a personal level these are registered as choices (Bruno upsets his father and his music teacher by preferring to play electronic progressive pop rather than the classics) and as signs of difference, they can add an exotic edge or frisson to interpersonal relationships between the pupils. In one of the favourite scenes in *Fame*, a rich white girl who looks and acts aloof and snobbish, is practising alone in the long mirrored rehearsal room. Wearing a pink leotard and dancing on blocks she performs a beautifully executed solo to a piece of classical music on tape in the background. The viewer can see that Leroy is watching, spellbound by her classical performance and attracted by her beauty. But it is unclear whether she knows that he is watching right up until the last second when the tape finishes and she completes her final pirouette. Her body language and expression convey a sense of distance, until she suddenly winks at Leroy and invites him to join her in the changing room. The asexual image of classical ballet is thus debunked and the distinction between high and pop culture is shown not to be insurmountable.

In performance terms this moment in the film is paralleled by an earlier sequence which also acts as its reverse. Leroy and his black female dancing partner perform their audition piece to gain a place at the school. The dance teachers, all white save for Lydia, are lined up, unsmiling, severe and, it appears, biased wholly in favour of classical dance. Only Lydia, who looks softer and is wearing make-up, would seem to have any time for jazz dancing. To a loud soul track Leroy and partner take to the floor and perform an extremely sexual and gymnastic routine. At one point Leroy passes his hand over his crotch as though in sexual pleasure, in time to the beat. The camera cuts to the panel who look horrified and embarrassed except for Lydia whose expression is one of slightly shocked enjoyment. She begins to move to the music as the short scene comes to an end. In doing so she is indicating that she identifies with this black culture and that it does have a legitimate place in the school.

This strand is further developed and resolved in the final moments of the film. This sequence consists of an end-of-term performance for the graduating students and is performed as a kind of non-stop showcase for each of the characters to display their talents. The audience is made up of parent and teachers and the camera cuts to and fro between the adults and the young performers as they get their chance to appear in the spotlight. Once again this provides an opportunity for celebrating race and cultural equality. In the closing moments of the performance where emotions have already been roused to a peak, the performance moves quite suddenly and entirely unexpectedly from a classical mode into a strong black gospel mode. Black parents and children sing and clap and are joined by their white peers as gospel is also given its place in the school's multicultural repertoire.

The New York School for the Performing Arts is therefore a perfect meritocracy and as such is a metaphor for America as it would like to see itself. Popular culture (particularly music) is a unifying force. When the kids spontaneously break into dance outside the context of the rehearsal room it is always to the backdrop of black urban dance music. Even the ballet dancers 'get down'. Race therefore becomes just another obstacle to be overcome. Black students are prepared for the outside world of discrimination by one of the black teachers who warns them that they are going to have to be able to stand up for themselves by not letting prejudice overwhelm them. But his message is little different from that of all the other teachers, black or white. In this register race is not much different from any other difficulty they are going to have to face in their struggle to make it. In the context of Hollywood entertainment this is an entirely appropriate way of understanding racial inequality. The more there is of it, the more reason to overcome it and get to the top. Race becomes an incentive to work even harder, a self-regulating form of labour discipline.

This is also a useful idea in a society where young black males are increasingly passed over as a result of a combination of racism and structural changes in technology and the labour market. There is indeed a real question of labour discipline for that section of society deemed most 'dangerous'. Leroy in *Fame* is a figure of white fantasy, a kind of black 'head boy', a rough

kid turned good, a symbol of all that young black males in reality are not. The melting-pot mentality of *Fame* is predicated on there being sufficient difference to highlight the way that different races – with all their idiosyncracies – coexist, without those differences arousing racism or conflict. In both the film and TV series racism is avoided by stressing the rich ethnic mix of the pupils where black is only one of many identities and where each of these identities is portrayed through a range of familiar stereotypes. Thus Doris in the TV series might come from a comfortably-off Jewish family, unlike Leroy or Coco, but they still give her a tough time emotionally. Again in the TV series 'ethnic' is interesting where 'white' can be neurotic. Julie – white, beautiful and unconfident – is continually failing to accept her parents' divorce as final and trying unsuccessfully to engineer their reconciliation. When this fails she returns to her cello for consolation, and channels all her anger and emotional disturbance into her classical music.

This raises an additional, related point. In both the film and the TV series art plays an emotionally cathartic and therapeutic role. It helps each of the characters to overcome the difficulties they face particularly in relation to their families and it also provides them with something in which they can lose themselves. When Coco's or Lydia's romances go wrong, when 'he' doesn't turn out to be the right guy, their recognition of this fact is almost always punctuated with a solo dance . . . alone at night in the studio . . . the dance movements are at once an expression of pain and a means of getting over it. A shared commitment to art is also the basis for friendship in *Fame*. Art is always an emotional space. Achievement or disappointment in the 'performing arts' is a cause for great floods of emotion. In *Fame* the characters each have to learn to cope with disappointment. These move with great regularity from family to art and back again. Only occasionally are the romances those of the kids themselves. They are kept at a few steps removed from adult sexuality. Instead their relationships still focused on the family or the peer group.

It is this which makes *Fame* such a satisfactory pre-pubescent text. Like *Ballet Shoes* there is a concern with separation. In the film version a shy timid girl is only able to discover her acting talent once she has summoned up the courage to show anger to

her anxious and over-protective mother. And the gay boy with whom she strikes up such a friendship is haunted by his mother's early separation from him. Indeed it is his monologue: 'We spent two whole days together and it was just like we were sweethearts' which opens the film. As in other pre-teen texts this journey of separation is made safe by the boundaries and limits set by the institution. Teachers act as surrogate parents without any of the messy emotional strings. Friendships which for the most part do not develop into sexual relationships give the kids the confidence to try out new experiences and to work in an environment where there is a shared commitment to the same kind of work. This is the Utopian element. This is what makes *Fame* a modern version of *Sandra at the Ballet School*, or *No Castanets At the Wells* or *Ballet for Drina*. In *Fame*, as in these more traditional novels, work is a grand passion, never just a means of earning a living. The romance of work in these feminine texts is particularly resonant and even poignant, since achievement in work rapidly fades into the background in most girls' teenage fiction.

Flashdance, in contrast, sits unevenly between these two genres. It is a ballet story for teenage viewers and it suffers under the strain of the conflicting expectations of what constitutes a ballet story and what constitutes a successful teen film. Like so many of her counterparts in ballet fiction, Alex is motherless. Her only adult friend is an elderly Russian woman who takes her to the ballet and who encourages her to apply to ballet school even though she has never had any lessons. Alex practises alone at night in her shabby warehouse apartment by copying the steps from ballet videos. Since the narrative deals with that period of time running up to her successful audition, there is no space for peer-group culture or the institutional life of the school. Alex's only institutional support comes from the girls with whom she dances in the sleazy working men's club at night after work. And this environment is cheap, nasty, and somewhere to be escaped from. Psychologically Alex is alone until she strikes up a relationship with the handsome son of the owner of the steelworks where she works as a welder. This introduces the sexual dimension which is a necessary part of the teenage text but which in this case has to be reconciled with Alex's great desire to get into ballet school. The narrative solution to what would otherwise be a generic difficulty lies in the introduction of a feminist

slant. Alex is not typically feminine. She is doing a man's job, while managing to retain her glamorous good looks. She is not scared to live alone and until Michael comes along she is single. This emancipated image is emphasised throughout the film. Alex cycles to and from work and through the city streets at night. She has only a large dog as companion and protector and she is fiercely independent. She is also sexually liberated and actively initiates sex with Michael. She does not mind selling her body in Mawby's bar if it helps her to earn money to pay her way. And, finally, she is proud of the way she lives. She is neither looking for nor wants a man to rescue her, though in a sense that is what she gets.

Alex is pretty but poor. She does pop dancing because that is all she has managed to teach herself. At her audition she performs a gymnastic dance routine where the sexuality is toned down. Her energy impresses the panel of judges who, in a scene strongly reminiscent of that described earlier in relation to *Fame*, reluctantly end up tapping their feet in time to the beat. It is being modern and up-to-date which works in favour of Alex. It is not that her pop culture dancing is vindicated in the way it is in *Fame*, rather that it is taken as a sign of raw talent, rough at the edges but with potential for learning real, i.e. classical, dance.

Unlike *Fame*, *Flashdance* is a narrative of desired social mobility. Alex is disadvantaged by her poor background but her aspirations are to escape. She does not want to do this through a man or a romantic relationship, but she wants to get to where 'high art' is found and that is undeniably on the other side of the tracks, in the 'Grand Met' or its Pittsburgh equivalent, in the austere and beautiful building in the city centre where perfectly outfitted students practise pliées and arabesques with complete disregard for anyone outside their privileged world. Alex's achievement is that she gets there and by implication leaves behind her the steel works and the working men's bar. The visual double bind in the film comes into play around Alex's body – she speaks through her body in dance, it is her only 'commodity', her labour power and her artistic raw material. Cinematically, however, it is also the object of the male gaze. Michael is immediately attracted to her body as she dances in the bar. The camera lingers voyeuristically over every inch of her body as she

performs. It is this which marks out the cinematic style from that of *Fame*. While the dancing is sexy in *Fame* the bodies remain the possession of their owners. The camera at no point takes over and dwells upon them fetishistically. But it is this which makes *Flashdance* a more adult and a more male-oriented film. In narrative terms it is this sexual 'looking' which Alex will escape when she moves into the environment of the ballet school, but in cinematic terms it is the sexual looking which counterpoints the feminine desire to dance which motivates the action. This creates an unevenness and imbalance which cannot be resolved in the course of the film. *Flashdance* remains a film for girls, to be looked at also by boys.

Dance, culture, art

The purpose of this chapter has been to sketch out some possible parameters for the construction of a sociology of dance. It has been argued that where such a sociology would by necessity include a number of areas beyond the scope of this chapter (the dance labour process, for example, the dance institutions, dance and the national heritage) of equal interest and importance would be the kinds of areas frequently bypassed in the world of cultural theory. Dance representations and the presence of dance images in a variety of media forms would form the basis of a study of the place of dance in contemporary consumer culture. Dance fictions and their role in pre-teenage feminine culture as well as dance as a leisure practice enjoyed by thousands of young girls, would be of vital importance in building up a gender-oriented model of dance, as would the practices and conventions surrounding social dancing and its place in contemporary youth culture.

The role of dancing in the development of romantic or sexual relationships has not been considered in depth here, nor has the presence of girls as dancers in the post-war youth subcultures. Instead attention has been focused on a moment which precedes teenage dancing and which has generated its own particular cultural expressions around dance. In dance fiction, and especially in 'ballet books for girls' the reader is presented with an active and energetic femininity. In these books and in *Fame*, a more

contemporary cinematic example, it is assumed that girls will be overwhelmed by a grand passion to dance or to perform. This passion will take them through a number of difficulties which with extreme dedication and hard work will be overcome. The emphasis is not so much on achieving 'fame' but on the processes of getting there. Dance fictions are therefore about work, the sacrifices that have to be made, the relationships which have to be cast aside. In these narratives young female readers are also introduced to the idea of art and the special place it occupies in culture. Despite the conventional and perhaps mystified definition of art which crops up repeatedly in these stories art is, for many readers, an enabling concept. Art is presented as something which can change the course of a life. It can give a young girl a legitimate reason to reject the normative expectations otherwise made of her and can provide her with a means of escape. This is the kind of language in which dance is presented to pre-teen readers, as something worth giving up a lot for, something which will pay off later in terms of great personal fulfilment. While some might argue that this is a damaging, pernicious and misleading myth more likely to end in 'the back row of the chorus line' than on stage at Covent Garden, the point is that it acts as a participative myth, a fantasy of achievement and a way of taking one's destiny into one's own hands.

The romance of dance and the importance of work combine in these popular narratives. There are few other places in popular culture where girls will find such active role models and such incentives to achieve. In almost all the examples discussed here success requires the absence or the marginalisation of the family and familial relationships. Because the girl is more tightly ensconced within the family than her male peers, it is all the more important for her to free herself of these ties if she is to achieve her potential. Indeed it would be possible to attribute the success and popularity of these fictions with pre-teen girls to these factors – that they continually and repetitively explore the dynamics of moving into a more independent space which carries with it the promise of achievement while simultaneously holding at bay the more adolescent dynamics of sexual success where a whole other set of competencies come into play. In these fictions the physical body seems to be speaking in a register of its own choice.

Notes

1. R. Nijinsky, *Nijinsky*, Harmondsworth, Penguin, 1960.
2. P. Wollen, 'Fashion/Orientalism/The Body' in *New Formations*, no 1, Spring, 1987.
3. See also Eric Cahm 'Revolt, Conservatism, and Reaction in Paris, 1905–1925', in M. Bradbury and J. Macfarlane (eds) *Modernism*, Harmondsworth, Penguin, 1976, for an interesting discussion following the same lines as Wollen and concentrating on the dramatic effect which Diaghilev's *Rite of Spring* with music by Stravinsky had on Paris audiences, 'Fighting broke out and the hubbub practically drowned the music; the refined innovations of Debussy were one thing, but these private rites of Russian tribalism another.'
4. P. Bourdieu, *Distinction*, London, Routledge & Kegan Paul, 1984.
5. I. Chambers, *Urban Rhythms: Pop Music and Popular Culture*, London, Macmillan, 1985.
6. Ibid.
7. E. Ewen, *Immigrant Women in the Land of Dollars*, New York, Methuen, 1986.
8. J. McCrindle and S. Rowbotham, *Dutiful Daughters*, Harmondsworth, Penguin, 1977.
9. R. Roberts, *The Classic Slum*, Harmondsworth, Penguin, 1971.
10. G. Mungham, 'Youth in Pursuit of Itself' in G. Mungham and G. Pearson (eds) *Working Class Youth Culture*, London, Routledge & Kegan Paul, 1976.
11. R. Hoggart, *Uses of Literacy*, Harmondsworth, Penguin, 1956.
12. A. Whitehead, 'Sexual Antagonism in Herefordshire', in D. Barker and S. Allen *Dependence and Exploitation in Marriage*, London, Longman, 1976.
13. P. Cohen, 'Subcultural Conflict and Working Class Community' in S. Hall (ed.) *Culture, Media, Language*, London, Hutchinson, 1980.
14. D. Hebdige, *Subculture: The Meaning of Style*, London, Methuen, 1979.
15. I. Chambers, Urban Rhythms.
16. D. Hebdige, *Subculture*.
17. P. Gilroy, 'There Ain't No Black in The Union Jack', *The Cultural Politics of Race and Nation*, London, Hutchinson, 1987.
18. *Flashdance* was marketed as a teen dance film. The publicity still and the TV advertisements for the film drew attention to the erotic dimension, focusing particularly on one moment in the film when Alex appears to be dancing under a shower. It might be suggested that the narrative was designed to attract a female interest and the visual subtext to appeal to men.
19. V. Walkerdine, 'Some Day My Prince Will Come', in A. McRobbie and M. Nava (eds) *Gender and Generation*, London, Macmillan, 1984.

20. B. Bettelheim, *The Uses of Enchantment*, London and New York, Thames & Hudson, 1976.
21. G. Frith, ' "The Time of Your Life": The Meaning of theSchool Story', in G. Weiner and M. Arnot (eds) *Gender Under Scrutiny*, London, Hutchinson, 1987.
22. Freud quoted by B. Bettelheim in *Uses of Enchantment*.
23. G. Orwell, 'Boys Weeklies' in *Inside The Whale and Other Essays*, Harmondsworth, Penguin, 1969.
24. See, for example, A. McRobbie 'Interview with Juliet Mitchell' in *New Left Review*, no 170, August 1988.
25. J. Mitchell, *Women: The Longest Revolution*, London, Virago, 1985.

Reference

Streatfield, Noel, *Ballet Shoes*, Harmondsworth, Puffin, 1984.

Films

Fame, directed by Alan Parker, MGM, 1980.
Flashdance, directed by Adriane Lynn, MGM, 1983.

8

Teenage Mothers: A New Social State?

Since the early 1980s there has been a subdued moral panic simmering under the surface about young unemployed girls becoming pregnant, remaining single, and as a result extricating themselves from the whole business of looking for a job. Single parenthood means that financial dependency (the young mother is not able to work while she is looking after her baby) shifts from the male partner to the state, and it is this which has caused stories to appear in the tabloids about teenage pregnancy being used as a means of receiving extra benefits, getting a council house, or at least of getting on to the council waiting list. In 1985 Rhodes Boyson, in response to one of these outcries, claimed that 'the state should not encourage bastardy'. Some months later following the Tottenham riots there were various mutterings including some from the Prime Minister herself about the problem of young single mothers (of whom there were apparently many on the Broadwater Farm). Mrs Thatcher's argument was that mothers must be more willing to take responsibility for their children's behaviour. The statements in the popular press which followed this implicit blaming of 'anti-social' behaviour on black single mothers, added a thinly veiled racist dimension to the question, contributing directly to what has been called 'the pathologisation of the black family'.[1]

There have been a few feminist and anti-racist responses on this subject and a handful of research studies on which I shall comment presently. These have not, however, had the impact they might have had. Apart from the moral panics in the tabloids there has not been a great deal of sustained public discussion about teenage pregnancy and whether or not it is a direct

response to unemployment. This is surprising since a number of statistical reports recently published point to the trend for teenage mothers to remain single. In 1985, for example, it was estimated that 65 per cent of babies born to teenage mothers were born 'out of wedlock'. In 1988 this had risen to 70 per cent.[2] Of course this can mean any number of things – the preference for young couples to live together and put off marrying; the disappearance of the stigma surrounding 'illegitimacy' (which makes Rhodes Boyson's comment strangely anachronistic); parental pressure on a young couple with a baby on the way *not* to rush into marriage and even to live apart in the first few difficult months; access to legal abortion for young girls, and, finally, the almost complete disappearance of surrendering illegitimate babies for adoption (a cruel practice which was common right up to the late 1960s when pregnant girls would be shunted off to mother-and-baby homes, returning home some weeks later surrounded in secrecy but with their reputations intact) – all these important changes have no doubt played some role in producing the kind of statistics which point to the decision not to marry and the growth in single motherhood amongst the young.

Despite this seeming preference in the 1980s for unmarried motherhood there has been no systematic analysis of what it means and what it feels like. The nation's two best-known young single mothers remain Michelle and Mary from the TV soap opera, *Eastenders*. One is a respectable working-class girl, who, with the help of an extended family copes remarkably well, while the other, a punk, on the run from her Catholic family, does not, and periodically has to be bailed out against her will by a pious and condemning mother. In fact, these profiles are remarkably accurate. The research which has been done, including my own, shows that almost everything, including the health and welfare of mother and child depends on the goodwill and the financial support of the baby's grandparents. As Sue Sharpe points out in the introduction to her series of interviews with young mothers, 'parents . . . proved to be a more sustaining source of support than their baby's father'.[3]

In the early 1980s I conducted a small-scale study based on a group of twelve school-leavers all of whom became pregnant within six months of leaving school. I got to know these girls

slowly over a long period of time. The research was carried out in an informal way. The girls would frequently come to see me and stay for a chat when I had the time. They had all lived in the area for most of their lives. Some had elder sisters who had married and were living with their children close by. Two of the girls were living alone with their fathers. The mothers of both these girls had died some years previously. Only one girl was in a better position financially than the others. Although she came from a large family her father had a small electrical repair shop and this meant she always had a bit more money. Her best friend also benefited from having two parents in work, but she moved out of the area with her parents just as the others were having their pregnancies confirmed.[4]

This was a poor and mostly white area in South Birmingham covering no more than two square miles. Its size meant that it did not figure nationally as an area of major deprivation, particularly since it was flanked on all sides by much more prosperous middle-class neighbourhoods like Bournville, Selly Park, Edgbaston and Northfields. Throughout the duration of the study (1980–3) this part of Selly Oak visibly suffered the real effects of the economic recession. All of the girls were 'non-achievers' at school and spent the last year of their schooling hanging about in the streets, child-minding for local working mothers, and helping out in the local shop. There often seemed to be little or no difference between them and the groups of working-class girls described in all the classic studies of working-class life twenty or even fifty years ago.[5] The critical factor was that their fathers and their boyfriends were experiencing the hard edge of the economic recession. Birmingham's car industry and its light-engineering works were being run down on a massive scale. As Bea Campbell has pointed out, while there are many parts of the country in which work has never been readily available for women, at least there was work for men.[6] In this small working-class area of Birmingham women had tended to work for only a short time before marriage; once their children were older or at least at school they would pick up casual cleaning jobs in the university close-by, or auxiliary jobs in the hospital. Others would do home-work for the local baby-goods factory.[7]

In this respect the girls in my study were not really departing from tradition. Work was something you did once the whole

business of getting married and having children was out of the way. But in the late 1970s and early 1980s, as long as their male counterparts were unlikely to find work, and as many of them slid into petty crime, this expectation was dashed. As Paul Willis commented in an influential series of articles in *New Society* in 1984, the meaning of wagelessness for young working-class people is that it disrupts the whole life-cycle from adolescence to adulthood.[8] It jeopardises the dream of a home of one's own and creates instead a 'new social state'. The consumer-power deriving from the combined wages of the young working couple is replaced by a set of dependencies . . . on benefits, on YTS programmes and on the support of parents and members of the family in work.

Willis's notion of a 'new social state' could with ease be extended to these young girls whom punk and youth culture passed by. Their only involvement in fashion lay in the fashion to get pregnant, which one by one they did. All twelve lived in the three or four streets near where I was living. There were no youth facilities whatsoever. None of the girls had enough money to go into city-centre nightclubs and many of them hardly moved out of the neighbourhood from one week to the next. Occasionally they would go down to the local pub and this was where they got to know the boys who also lived in the area. While a few of the girls found work, often for just a short period in the local shops or at the cash check-out in the 'supermarket' (which specialised in cut-price, out-of-date food), none of the boys had a job throughout this period. Neither the boys nor the girls had any disposable income whatsoever after they had given their families a few pounds for their keep, and so courtship meant pairing off and strolling the streets in summer. In the winter it meant staying in at 'his' or 'her' home. Sex was a preliminary to the real business of life which started with getting pregnant. This was so much taken for granted that my questions about why they wanted a child when they were still so young left them puzzled.

> I've not really thought about it. I suppose I want to know what it's like being pregnant. And if it's a girl then I'll want to dress her up nice and if it's a boy I'll want him to be like his dad. All the usual things. My sister Deirdre has just had

her second and she's only 19. It's nice to be a young mum, you'll still be young when they're at school and that, at they'll like having a mum and dad who knows the things they're interested in.

They all had strong views about staying at home while their babies were young.

I don't believe in going out to work when they're still little. Even if I didn't have the money, I wouldn't leave them with someone. I wouldn't trust anyone with my baby. I don't think it's right, I'd just get through somehow and then take a job for extra things, clothes and presents and that sort of thing when they're at school.

The girls were resigned to expecting some degree of poverty. Although none of their partners were in work the idea of the male breadwinner remained in the background as a distant hope. They had no notion of themselves as breadwinners. The local work which was available for girls was boring and badly paid. Being pregnant was a great deal more interesting than standing in a fruit shop all day long. It gave them a place in whatever small community of women there was in the area. It gave them something to talk about with the older mothers and was recognised as a sign of maturity – indeed, it was the only sign of maturity to which they could legitimately aspire. Being pregnant was an 'honest' expression of being sexually active. Remaining childless could easily be taken as a sign of promiscuity.

From my front window, the girls' pregnancies as they walked up and down chatting and stopping to light a cigarette, came to indicate another potent reminder of a whole area in decline, a forgotten pocket of poverty. Their male partners took up an aggressive skinhead masculinity which then led them to membership of the British Movement.[9] There were few black or Asian youths to drive these activists out, only a handful of Asian shopkeepers who were forced to bear the brunt of the racist attacks. The boys drank, went to meetings, shouted abuse and laid seige to the Asian shops. During the day they harassed old people, stole and gradually became criminalised as well as 'politicised'. This was well before the fact of racial attacks was widely

publicised in the media. An Asian family with five daughters lived in fear for the duration of this period. They were still there when I left but were hoping to move back into the safety of the Asian community in Ballsall Heath or Sparkbrook. There were the same kind of class dynamics on which many other writers have commented in this context. The Asian girls went to the same school which all the teenage mothers had attended. They were staying on for A-levels and hoped to go to university. They worked in the shop after school and at weekends and therefore had access to the idea of a rewarding working life. In this deprived blighted area where any idea of working-class community was a distant folk-memory on the part of the old people, an identity through work for almost everybody else was meaningless. Social status had to be acquired through other channels, like being a mother or an aggressive skinhead with Doc Martens up to the knees, tattooed ears and fingers, and 'Bladerunner' baldness. One girl made the following comment about the boys 'skin' style and their racist views:

> I don't like it myself, I don't feel that way about the coloureds. I've got friends who were at school with me who have half-caste babies now and they're lovely. Round here the boys would beat you up if you even looked at one. It doesn't bother me, but I wouldn't say that in front of him and his mates. I keep it to myself.

The same girl found herself the target of violence before, during and after her pregnancy. It was not uncommon for the boys to feel they could hit their partners as soon as they became involved with them. And as they moved towards parenthood what emerged most clearly was a sense of fluidity and uncertainty on the part of both the young mother and the father. For those girls who were unable to stay at home after the birth of the child, the social services did indeed try to rehouse them nearby. In several cases the girls would move as single parents into a flat or small terraced house quickly to be followed by their male partners and often by his brothers and even by his friends, all of whom, because they were unemployed, were stuck at home with no resources to find a place of their own.

One such house quickly became like a rowdy and unsupervised

youth club where the girl and her baby were the least important members. As the boy moved in, he would claim benefits in his family's name. The young mother would often go hungry. She would have to borrow from her mother and from other neighbours to buy baby milk and other basic necessities. However, when her partner moved back home for a while and the money went direct to her the borrowing would become less frequent. (This also corresponds with Sue Sharpe's study where one young mother complained that when the giro went to her partner he would spend it on clothes and records.)[10]

Not surprisingly these new domestic arrangements, where a 17-or 18-year-old father and his friends joined a young mother in a 'short-life' and run-down two-up, two-down, bought by the council for refurbishment at some distant point in the future, frequently broke down. In a matter of months the gas and electricity would be cut off, mountains of rubbish would collect in the front garden and back yard, the windows would be broken and social workers would begin to fear for the well-being of the children. (Most of the girls had a second child within a couple of years of having their first.) Eviction notices would be served. The girls and babies would move back home and their partners would likewise return to their parental homes. While they were living together there was no way in which these young couples could manage a home, bring up a child or children and simultaneously live through their own late adolescences.

The girls seemed more willing than their partners to forego the pleasures of youth. Their partners continued to drink and have noisy parties. All were reliant on parents (i.e. mothers) for meals at home and for loans to get them through the week. Sometimes back in the parental home and experience some of the tensions produced by this situation. The girl would make another attempt to set up home for herself and the baby. But even if she was able to find a rented flat she would often return home two or three nights a week for the warmth, food and a bath. The few young mothers who had no home to which they could return found themselves in much more difficult circumstances. As their relationships fell apart and they faced eviction they would be moved into bed-and-breakfast accommodation and sometimes with children on the at-risk register would also be threatened with having them taken into care. One mother in this

group escaped a violent relationship by fleeing to a refuge; another with two young children was relieved when her partner was sent to a detention centre, because at least she would have a few months to sort things out.

It was at this point that the research, in which initially the girls had all been interested in because it gave them a chance to talk about their pregnancies and then about their babies and young children, broke down. I had been frightened by their skinhead boyfriends and a climate of fear existed up and down the few streets in which these boys made their presence felt.

Poverty, unemployment and extreme youthfulness combined to catapult the girls into impossible circumstances. From being fresh-faced 16-year-olds they became impoverished-looking clients of the state. Motherhood had pushed them towards a precocious maturity and they had no material means of subsidising their new condition. Few of the girls were completely unattached. But their partners were unable to find work and were therefore incapable of taking on the traditional role of men in the working-class community. Again, as Paul Willis has noted, these conditions can easily create a massive crisis in masculinity in which violence is the easiest way out.[11] While their girlfriends were pushed towards premature middle-age these boys were excluded from the weightiness of adult male responsibility. Without the status of a job they could not allow themselves to become involved in the emotional 'softness' of parenthood. Instead, as the study drew to an end and I prepared to move out of the area, some of them began to abandon skinhead aggro in favour of glue-sniffing. They could be seen, large 18-year-olds, with their heads bent over a bag in the so-called adventure playground. Whether strung out on solvents or detained in detention centres, these youths were suspended in a state of enforced infantilisation, exacerbated by the expectations of fatherhood. The few older boys also seemed to lose some of the hard 'NF' edge but their criminal activities simply meant that they spent more time 'inside'. This pattern coincides both with the findings in Steven Box's recent deviancy study on the links between economic recession and crime and with Paul Willis's comments on how young men, having experienced youth unemployment

over a number of years, tend not to be reintegrated into the adult workforce 'with its social collectivity'.[12]

This was also the process I observed as a group of bright and lively 16-year-olds girls found themselves caught in a situation from which it was difficult to escape. Many remained committed to their relationships even when there was violence involved. For others the relationship was just a way of life which they had entered when they were barely into their adolescences. As one girl said, 'He'd come after me, even if he was inside like, if he thought I'd go off with someone else. I've never been out with another man; I've hardly even known another man apart from his brothers and his friends and he doesn't let me talk much to them.' This girl had become pregnant first when she was 14, but had an abortion. Two years later and pregnant again she insisted this time on keeping the baby.

None of these girls saw themselves as strong and determined go-it-alone single parents like Michelle in *Eastenders*. Supportive mothers with their small wages from cleaning or from working in the hospital were what kept them going and stopped them from becoming entirely dependent on benefits and the social services. Occasionally there was a small supply of stolen goods which was the male contribution to the household. This was just as frequently offset by the bail charges which had to be paid when the boys got picked up by the police, and the bus fares to visit them in the detention centre which was situated several miles away.

The Selly Oak young mothers were a small and perhaps unrepresentative sample. But it is significant perhaps that Paul Willis's comments on youth unemployment in Wolverhampton are so pertinent. (Willis also notes that 'council housing has come into a very particular relationship with new gender relations and family forms'[13].) It may well be that in other parts of the country where youth unemployment has not dug in so deep, it is possible to interpret teenage motherhood in a different light. For example, Sue Sharpe interviews young mothers from London and the regions.[14] She goes to great lengths in her introduction to paint a more positive picture of young single motherhood, arguing that in many cases, having a baby at a young age strengthens the

girl's determination to go back to college and do well enough to get a good job. Against the negative stereotype which prevails in relation to this social group, she seeks to redress the balance. Most of the girls in her sample do cope. Their babies are healthy and well-looked after. With the help of a supportive mother some of the girls go on to gain professional qualifications and only marry their partner when they have finished studying and when they can think about finding their own home. Having a baby young is not the end of the world, nor does it automatically propel the girls in the same direction as it did the Birmingham group.

And yet there are several indicators in Sue Sharpe's book which suggest that dependency on mothers to help with child-care is not necessarily unproblematic. One girl comments that being with the baby during the day made her mother look years younger and encouraged her to give up smoking. Another describes how her parents restrict her movements as though she was still a young teenager rather than a young mother. In both of these cases it is not hard to see the more negative dimensions of the 'advantages' of a supportive family . . . is it such an unam-biguously good thing that a grandmother should so benefit from her teenage daughter's pregnancy? Might this not also suggest that the mothers of pregnant working-class teenage girls actively discourage abortion not because they disapprove, or because they think the girl should go through with it and have the baby for herself, but because they themselves are perhaps experiencing the sharp edge of the economic recession and are having to face up to the prospect of old age and redundancy? In these circumstances a baby is doubly welcome in the sense that it gives the grandmother 'something to do' and fills the vacuum thrown up by her unemployment or semi-employment.

Of course, it is equally possible that a baby is a sign of better things to come, a source of pleasure and of great enjoyment. Nonetheless such dependency on the parents puts the young mother in a powerless position. She may find whatever free time she has more tightly monitored and controlled than it was when she was 14 or 15. Should the parental relationship sour she might well be confronted with recriminations . . . 'If it happened once it could happen again.' And major rows can blow up over how the baby is brought up. Grandmotherly affection can easily tipple

over into power, control and possessiveness in a situation where the girl is tied to the parental home for the good of the baby, and where the only other alternative is bed-and-breakfast.

Anne Phoenix has produced the most sustained study based on a large sample of young single mothers in North London, whom she followed through their pregnancies and into the early years of their children's lives.[15] Phoenix adds an interesting dimension to this debate from both a feminist and an anti-racist perspective. Most of the young mothers in her sample are doing well. Their main problem, and in many cases their only problem, is that of poverty. But despite their poverty they are as good as any other group of mothers. They put off marrying for the reason that their partners are either unreliable or unemployed and therefore of little help as breadwinners. As a result the men come and go. Most of the girls are living in their own accommodation by the time their babies are 18 months though some remain at home.

Phoenix makes a convincing argument against those who would point to early motherhood as the problem. These girls are, after all, only bringing forward what, if they had been at work and if their partners had a good job, they would have done in two or three years time. Most working-class women in our society, and most black women have their first baby in their early 20s. It is anomalous, and atypical to put off motherhood in the way white middle-class women are now doing, often well into their late 30s. It is their class privilege which allows them this prevarication since, for most women, having a baby relatively young is a test and a sign of their adult femininity. For white working-class women fertility is part of the marriage bargain, all the more reason to prove it early on. And for black women who have always expected to have to work for most of their lives (since black men in a racist society have been consistently marginalised from the mainstream labour market and have not been able to become breadwinners) then having children early means that they do not have to give up work later on, especially since the chances are that the work they will be doing is unlikely to provide paid leave and other benefits. It makes sense to get maternity out of the way while young, healthy, and energetic, and while there is a supportive mother and perhaps even an extended family in the background.

Phoenix is quite right in many of these respects. Who is to deny the poor and the unemployed the joys of parenthood, one of the few pleasures to which they have access? And what makes a 'good-enough mother'? Age is not necessarily a major determination. Phoenix presents her readers with an extremely convincing set of arguments. But the problem which remains is the stubborn one of financial dependency. (It should be remembered that financial dependency was one of the major acknowledged sources of gender inequality which feminism addressed from the very beginning. This fact has sometimes been forgotten in the more recent opposition to Mrs Thatcher's ideological use of the concept 'dependency culture' as a means of justifying the running-down of the welfare state.) If men are not to be relied upon, then neither is it satisfactory to have to depend on the state or on a mother and extended family for support as a young single mother. Evidence shows that the state does not provide anything like enough to live on and dependent young mothers either borrow from their extended families or else run up credit which they have difficulties in paying back.

Extended families are frequently *not* supportive. Sometimes, if her parents are strongly religious the girl is thrown out in disgrace. Often there is no mother to turn to as was the case with two of the Birmingham girls. In these circumstances young mothers become part of the new poor or the underclass in our society, living in 'bed-and-breakfasts' for years at a time and bringing up their children in unhealthy and cramped conditions. It is immensely important for the poverty lobby to argue on their behalf. But it is also important to look to ways of avoiding or escaping this poverty trap. For these reasons it is appropriate to recognise the 'dependency' of young working-class mothers as part of the mechanisms of inequality which, in recent years, have produced and reproduced new stigmatised and disadvantaged groups. The irony is that the decision to remain single is also reflective of the way in which feminist ideas (against marriage for the sake of it; against female status requiring the presence of a husband; against remaining in a violent relationship, etc.) have spread right across society, influencing the way women think, and the kind of decisions they are able to make about their own lives.

It is easy to point to solutions to social problems while failing

to take into account the enormous effort and funding needed to put these into practice, as well as the time this would take even under the most advantageous conditions. Nonetheless, if girls and young women at school and in the home were brought up to think of themselves as future wage-earners, as well as future mothers, and if this was done in a positive spirit as an enabling and rewarding prospect where they would be able to look forward to making a good living alone *or* with a partner, for themselves *and* for their children, then there would be less likelihood of the unabated growth of the 'feminisation of poverty'.[16]

It is also too easy to portray those in poverty as victims, as social unfortunates caught up in wider social circumstances over which they have little or no control. Additional characterisations of the 'new poor' are those images, much loved by figures like Rhodes Boyson, of the social-security scrounger and the amoral teenage girl bent on beating the system and getting herself housed 'on the state'. Neither of these stereotypes is useful or accurate. The longer-term social and economic trends which have created the conditions whereby young people like those described above are forced to adopt 'survivalist strategies' simply to participate, as young adults, in a meaningful way in the broader 'sociality', need to be spelled out more clearly. We have to look in more detail at what is meant by the feminisation of poverty and at what combination of factors has worked to produce a situation which is not for example, just specific to south Birmingham in the early 1980s, but which has a wider currency in terms of the shifting parameters of social inequality in Britain today.[17]

On the one hand the girls described above were following a not unusual working-class route into adult femininity. School qualifications were not deemed important because the kind of jobs they would pick up did not require paper qualifications. This was a situation they shared in common with their male counterparts. Neither the boys in this study nor their fathers associated getting work with passing exams. As has been the case in most traditional working-class communities, work was found through word of mouth. When the girls did a few weeks work behind the counter in a local shop during the summer, for example, they heard about it through neighbours or friends. There was, therefore, at the level of job expectations, a direct continuity between these young people and their parent-culture.

As school-leavers they were not adopting some strange new amoral stance but were instead acting exactly as might otherwise have been expected. The boys would have taken work if it had been available in the local factories, or in the light engineering works a few miles down the road. They would have taken casual work like roofing or insulating if it had come their way. But at that point in time there were no jobs in the area for young unqualified school-leavers. There were no YTS schemes and there were certainly no 'return-to-learn' schemes (though it is doubtful if the boys would have been encouraged back into education, the evidence that exists shows this to be an option overwhelmingly favoured by women).[18]

What happened to both the young men and the women was that they were pushed downwards from the lower ranks of the traditional working class who in the 1950s and 1960s in a city like Birmingham had managed to make a decent living. For men, there had been factory work followed by opportunities in the hospital and the university to do caretaking jobs when they got too old for the factory floor. Women moved in and out of employment according to the demands of family life.

As these jobs disappeared and as the older people died off, the traditional working-class population living in this area shrank dramatically in size leaving behind a newly impoverished under-class consisting of the very young, a few other single-parent families who through divorce or separation had lost their primary breadwinner and were often waiting to be rehoused by the council in one of the modern estates a few miles away and, finally, the even-smaller number of retired working-class people who had been in work throughout most of their lives but with no occupational pensions and few savings were also pushed downwards into poverty. It is not so much that the young people described earlier and the young mothers in particular were feckless and irresponsible individuals. In fact they were behaving within the parameters of expectation laid down by class-culture in much the same way as middle-class young people automatically gear themselves up for A-levels and universities.[19] The dramatic mismatch in this respect took them by surprise. They were ill-equipped to deal with it and responded not by cold-blooded calculation that they could get a council house by getting pregnant, but rather by desperately searching for an identity, by

accelerating the path to motherhood in circumstances so adverse that even with a council house (and most of the young mothers were not in fact offered council accommodation) they had insufficient resources to live in it.

These events in Selly Oak were, then, reflective of much broader trends described in detail by sociologists like John Urry and others who are concerned with the question of the restructuring and recomposition of the working class in the past twenty years, the downward push into poverty for some, and the consolidation at the other end of the working-class spectrum, of a class fraction enjoying the fruits of Thatcherism through full participation in the consumer culture of the late 1980s.[20]

The feminisation of poverty adds a new dimension to this process of redrawing the lines of class in contemporary Britain. Few would dispute that one element in the appearance of female-headed households can be traced back – ironically perhaps – to the increasing independence of women in the past twenty years, their unwillingness to remain in unhappy marriages, and perhaps also their perception that the effects of poverty can be intensified with a man unemployed or semi-employed and permanently around the house. The emergence of young single-parenthood can be seen therefore as a kind of preemptive strike based on this recognition. In Selly Oak the girls moved in and out of a relationship with their original partner. By not getting married and by returning home when the relationship deteriorated the girls were aware of the possible precariousness of the relationship. Perhaps they also saw quite clearly that in contrast with other young couples they were setting up home 'in adversity'.

Or perhaps the brute facts are that getting married or even 'living together' in practice are conceived of, and looked forward to, within the prevailing language not just of love but also of consumerism. The catalogues, the Saturday trips to MFI or IKEA warehouses, the conversations with parents about what colour to paint the sitting-room and what kind of fitted kitchen to order, all these cosy and familiar interactions simply have no place within the landscape of absolute need. In this context there is no place for wedding plans. Bea Campbell made the following remark about the circumstances in which one of the young mothers she interviewed lived.

It was a home, her own home even though everything was scavenged second hand, except for some net curtains, a coffee table and a picture on the wall . . . It was the only decoration in the room, a picture that hangs over thousands of mantle-pieces, bought in chain store . . . The painting showed a child's face with a teardrop falling like a pearl from its cheek.[21]

This exclusion from consumerism still does not fully unravel the cultural and economic logic which pushed the Selly Oak girls towards immersion in the 'feminisation of poverty'. It is not sufficient to characterise them as being trapped or enmeshed within a culture of deprivation. They were doubly disadvantaged by both the labour market and the system of social security. There are two simple characteristics of the labour market which keep working-class women and girls in low-paid, insecure work. These are, first, job segregation, and second, the limited avail-ability of apprenticeships and training schemes in traditionally feminine fields of work. Job segregation refers to the way in which women and girl school-leavers tend to be 'crowded' into a much narrower range of jobs than their similarly qualified male counterparts in such a way as to suggest the existence of a gender-segregated labour market. There is more of the same work for women. And despite the Equal Pay Act and the Sex Discrimination Act, as Mandy Snell has shown, the male wage-earning differential means that women in these jobs, where there are few opportunities for promotion or for aquiring further quali-fications or even for doing overtime, not only earn less than men but are not earning a sufficient wage to cover the cost of their own reproduction.[22] It is the joint earning power of the working-class couple which allows them to enter into the consumer society of the 1980s. As Paul Willis has pointed out, the weaker earning power of the woman is 'compensated' by her willingness to per-form the domestic labour which is necessary to keep the house-hold going from one week to the other.[23]

What this means is that working-class girls in work require not just marriage or living together to take them out of their family of origin and bring them into (or at least close to) the 'property-owning democracy', they need a partnership with a man in per-manent full-time work. Without any one of these the fragility of a 'decent standard of living' is revealed in all its totality. Wor-

king-class women need this male economic buoyancy because they will expect to take time off to have children sooner rather than later in their married lives and the kind of jobs they have will neither allow for this lost time nor be held open for their return. When young male partners are out of work and are unlikely to find full-time work, a sequence of events like that described in Selly Oak becomes the only way for young men and women to participate in everyday life outside the workplace, as parents in the broader society.

For working-class women at home with young children, whose marriages or living-together arrangements break down, the feminisation of poverty also becomes a reality. This situation, well-documented by the contributors to Brannen and Wilson's *Give and Take In Families*, also reveals the differences between perceived and real poverty.[24] The single-parent family, headed by a woman at home might indeed have suffered a dramatic drop in standard of living, pushing them into poverty. But for many of the women interviewed by Hilary Graham who were at home with children under 5 years old, the feminisation of poverty felt better than the poverty of marriage where they were entirely reliant on the male wage and where the man had control of the household budget leaving the women to manage it.[25] Where many of these men felt entitled to spend substantial amounts of money on themselves for leisure items like fishing tackle or photographic equipment, their wives were left to spread the weekly income around, ensuring that the male breadwinner was well-fed according to his needs and appetite, even when this was perceived as excessive, unimaginative, unhealthy or too expensive.

The feminisation of poverty produces and reflects a number of different social responses. There is an assertion of a degree of independence in a situation otherwise characterised by great dependency. This is perhaps reflective of the way in which ideas about the changing position of women in society have affected some of the most under-privileged groups of women. There is a recognition that women can manage with children without the permanent attachment of a male partner – indeed they can perceive themselves as better-off with him living elsewhere, though not necessarily completely removed from the orbit of the family.

What remains, however, is an unchanged status in relation to

the labour market which condemns women to work which does not pay them enough to cover the cost of the child-care arrangements necessary to be able to work. Linked with this are the regulations laid down by the Department of Health and Social Security which do not allow them to earn anything more than a tiny amount in addition to their benefit as single-parent families without threatening to withdraw these payments. The well-documented 'catch' in the system then is that not only does it not pay to work because so many female sector jobs pay little more than benefit; not only does going out to work involve finding and paying for good quality child-care, but in addition to these material disincentives is the regulation wherein they can be threatened with losing benefits by even testing the waters of work with a part-time job which is, after all, more compatible with looking after children and easier to arrange.

It is, finally, in these terms that the so-called 'dependency culture' has got to be seen. The mothers in my study wanted to be able to stay at home while their children were young. But as they fell deeper into poverty and debt, as it became clearer that their partners were unlikely to find regular work, and as their young children began to make greater demands on the weekly 'giro' payment, there was not one of them who would have turned down the opportunity of a decent job if they had been able to arrange reliable child-care with somebody they trusted. Cheap, reliable child-care is something which the great majority of working mothers require. No mother can easily go out to work if she is worried about what is happening to her child while she is away. Most mothers would put their child's well-being before the importance of a pay packet. They would rather be poor than see their children at risk.

At the same time there are very few jobs open to women which pay them enough to keep house as single parents and pay a child-minder at the same time. Such jobs are almost wholly in the professions, making it relatively easier for middle-class women than their working-class counterparts to become single mothers. In recognition of this 'advantage' of middle-class single mothers and on the disproportionate number of black and immigrant single mothers in the USA Nancy Fraser, in an important contribution to the 'feminisation of poverty' debate, argues that while it is important to get women out of the dependency culture

and into work, the broader constraints and inequalities of the welfare state apparatus inscribe working-class and black women as female subjects in such a way as to make this transition extremely difficult, if not impossible.[26] The 'judicial, administrative and therapeutic apparatus' (JAT) with its legally defined, bureacratically administered and therapeutically oriented focus (the lone single mother as suffering from emotional problems, etc.) works as a set of interlocking discourses which despite a formal commitment to equality and to gender or race 'neutrality' nonetheless, through their mechanisms, locate women in a different category from men.

Much of what Fraser argues can also be applied to the 'JAT' (i.e. broadly, the DHSS) in this country. Women claimants are defined and categorised by virtue of their status as mothers. This immediately puts them into a different system of claiming than that typically occupied by men who are first and foremost defined as would-be wage earners. The conditions which prevail in the 'feminine sector' not only include a greater degree of surveillance and control (against cohabitation, etc.) but they also involve a different relation to the benefit system as a whole. Women as mothers are placed overwhelmingly in the non-contributory sector. They have not earned their benefit through national insurance contributions and therefore are not treated or processed in the same way as are unemployed men. Their benefits are more likely to be means-tested (in the USA they receive food stamps or payment in kind) and they find themselves more stigmatised as a social category than their male counterparts who, it is assumed, are often only temporarily unemployed.

All this leaves young single mothers disadvantaged in the extreme. With almost no access to decent well-paid jobs they are forced to remain dependent on the welfare state. The terms of this dependency are, however, defined in advance and the jobs that might eventually become available to them do little to shift their position as female subjects within the JAT. Part-time jobs, for example, do not offer women any opportunity for building-up enough national insurance stamps to entitle them to unemployment benefit, which would ensure them the less stigmatised treatment which unemployed men receive in relation to the benefit system. Instead of being temporarily unemployed women, they return to being single mothers. In the USA the kind of

'workfare' programmes being introduced for single mothers have the same effect as job-creation schemes in this country. Rarely do they lead to a full-time job, the training facilities they offer are patchy and frequently disorganised and the jobs last only for a set period of time, insufficient to entitle those participating to claim unemployment benefit later.

The point Fraser is making is that not only do women need access to the kind of training which will bring them into better-paid jobs with long-term security and the kind of benefits which men have long enjoyed, (including full pension rights), so also should the system of benefit allocation and distribution be over-hauled so as to eliminate these gender anomalies. The welfare state and the labour market each contribute to the disproportionate concentration of women in the poverty statistics of the past few years. Along with these the education system and the provision of training opportunities for those young people not destined for higher education should also be reassessed in relation to their commitment to 'equal opportunities'. While it is more generally accepted across the broad social spectrum, that women will need to take some 'time out' from work for having children there has been no recognition that some women might do this sooner rather than later. Teenage mothers are a stigmatised category who, it is assumed, have enough to contend with, never mind getting a training with the view to finding a proper job. This pathologisation merely creates a kind of self-fulfilling prophecy. There is no doubt, for example, that the Selly Oak girls had a variety of social needs which were not being met. They needed decent living accommodation near enough to their parents (where they were available) so that they could rely on their help in bringing up the children. They needed confidence and support in extricating themselves from relationships which had become violent. Their greatest long-term need, however, was for a training leading to the kind of job which could be combined with bringing up their children and which would pay them enough to lift them out of poverty and dependency.

In some parts of the country teenage mothers are encouraged to continue with their schooling up to and after the birth of their child. Even continuing with part-time education, however, depends on the financial support of parents. Local authority grants are 'discretionary' and in some cases are not available at

all. For the most needy category, the sort of girls who had failed at school and who had experienced the school as an institution far removed from the values of working-class life in which they had grown up, academic qualifications are not necessarily the right or the most realistic target to set. These girls, like their male counterparts, need jobs and training which would lead to *permanent* jobs. However, as Cynthia Cockburn has argued, the odds are set against girls who train on YTS programmes, in non-traditional areas of work (painting and decorating, for example) which offer them better long-term economic prospects. In these 'masculine' fields a variety of pressures act to discourage them from completing their training, including the attitudes of the male supervisors, the boys with whom they are training, and in one case quoted by Cockburn, a girl's father who did not like admitting to his friends that his daughter was doing a 'boy's' job.[27] These informal discriminatory factors put back even further the possibility of economic change for working-class girls and women who are not able, or do not want, to rely on the earning power of a male partner.

Poverty does not destroy all relationships. But 'love on the dole' puts unbearable pressure on teenage families. In one of the households described earlier there was an occasion where the boy found a job in a warehouse for a couple of months, during which time the girl also got a job covering for a friend of her mother on the cleaning shift at the local hospital. During this short time the atmosphere in their house lifted. Both partners looked younger and happier. The boy was picked up in the morning at 6, the girl left her two young children with her mother during the late afternoon shift and the young couple walked home with the babies in the early evening. But neither of the jobs was expected to last and when they came to an end, the same punitive patterns of dependency and despair quickly returned. This young father found himself almost permanently criminalised while his wife feared that the children would be taken into care. In the early 1980s, as a result of youth unemployment, this couple were victims of the newly elected Thatcher Government. By the late 1980s they were adult members of the underclass.

Notes and references

1. A. Phoenix, 'Gender and Black Families', in G. Weiner and M. Arnot (eds) *Gender Under Scrutiny*, London: Hutchinson, 1987.
2. *Social Research.*
3. S. Sharpe, *Falling For Love: Teenage Mothers Talk*, London, Virago, 1987.
4. When she returned for a visit a few months later she was married to a soldier she had met and she too was expecting a baby.
5. See, for example, R. Robert, *The Classic Slum*, Harmondsworth, Penguin, 1971; and R. Hoggart, *The Uses of Literacy*, Harmondsworth, Penguin, 1956.
6. B. Campbell, *Wigan Pier Revisited: Poverty and Politics in the '80s*, London, Virago, 1984.
7. Many of the older single mothers in the neighbourhood, i.e. women in their late 20s and early 30s, were employed as home-workers by the local baby-goods factory. They would leave their houses early in the morning with prams which would then be filled up with the day's work to be taken home and assembled while their children were at school.
8. P. Willis, 'Youth Unemployment: 1, In a New Social State' and 'Youth Unemployment: 2, Ways of Living' in *New Society*, 29 March 1984 and 5 April 1984.
9. An extremely interesting point was drawn to my attention when I presented this work as a paper to a group of 2nd-year fashion students at St Martin's School of Art. One boy had gone to school in this part of Birmingham during the time when the National Front and the British Movement were recruiting in the area. According to him, the skinheads would assemble outside the school and give out their literature every day for several months at a time. Throughout this period one of the leaflets emphasised that members should have children, become parents and thereby sustain the supremacy of the white race. Badges accompanied these leaflets with the same kind of message.
10. Sharpe, *Falling for Love.*
11. Willis, 'Youth Unemployment', 1 and 2.
12. Ibid, and S. Box, *Crime Recession and Society*, London, Routledge, 1987.
13. P. Willis, 'Youth Unemployment', 1 and 2.
14. Sharpe, *Falling for Love.*
15. A. Phoenix, 'Young Mothers', *Polity* (forthcoming).
16. This is a term which has only recently entered into the British sociological vocabulary. In the USA however it has been used for several years to describe the poverty of female-headed households dependent on welfare benefits as a result of the absence of a male breadwinner.

17. See, for example, J. Urry, 'Disorganised Capitalism' in *New Times*, ed. M. Jaques, London, Verso, 1989.
18. See A. Phoenix, 'Gender and Black Families'.
19. See, for example, the classic study by P. Willmott and M. Young, *Family and Kinship in East London*, Harmondsworth, Penguin, 1964, where it is argued that women experience less social mobility through job opportunities than men, with the result that generational differences between mothers and daughters are less pronounced than those between fathers and sons.
20. J. Urry, 'The End of Organised Capitalism' in *New Times,* ed. S. Hall & M. Jaques, London, Lawrence & Wishout, 1989.
21. Campbell, *Wigan Pier Revisited.*
22. M. Snell, 'Equal Pay and Sex Discrimination', in Feminist Review (eds) *Waged Work*, London, Virago, 1986.
23. Willis, 'Youth Unemployment', 1 and 2.
24. J. Brannen and G. Wilson (eds) *Give and Take in Families*, London, Allen & Unwin, 1987.
25. H. Graham, 'Being Poor: Perceptions and Coping Strategies of Lone Mothers' in Brannen and Wilson (eds) *Give and Take.*
26. N. Fraser, 'Women, Welfare and the Politics of Need Interpretation' in *Thesis*, 11, no 17, 1987.
27. C. Cockburn, *Two-Track Training: Sex Inequalities and the YTS*, London, Macmillan, 1986.

Index

243

THE
NORTHERN COLLEGE
LIBRARY
52241
BARNSLEY

Advertisement

More youth questions — and some answers

Whether you're a teacher, youth worker, social worker, employer or parent, you'll know that young people and their needs have never been more important.

YOUTH IN SOCIETY, the National Youth Bureau's interprofessional magazine for everyone concerned with and about young people, puts issues like juvenile crime, leisure and community involvement into perspective.

Every month, experienced practitioners offer insights into their own approach to work with young people and suggest ways in which you can apply their techniques and learn from their successes and mistakes.

And the Bureau's information team provides details of the latest books and resources, courses and conferences — essential information for everyone responding to the needs of youth in society.

YOUTH SERVICE SCENE, the Bureau's monthly newspaper, contains the latest news, information and resources for youth workers and others concerned with youth affairs and social education.

Whether you work full-time or part-time, in the statutory or the voluntary sector, *Scene* keeps you in touch with what's happening nationally and in other areas, and up to date with the latest theory and practice.

We'll gladly send you sample copies and subscription order forms if you contact us at

National Youth Bureau, 17-23 Albion Street, Leicester LE1 6GD. Telephone 0533.471200.

Advertisement

Advertisement

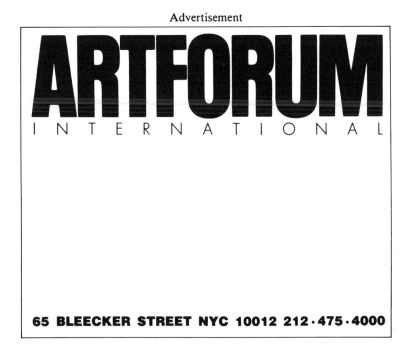

65 BLEECKER STREET NYC 10012 212·475·4000